IMAGES
of America

ROMAN CATHOLIC
ARCHDIOCESE
OF NEWARK

The Archdiocese of Newark
Statistics and Facts

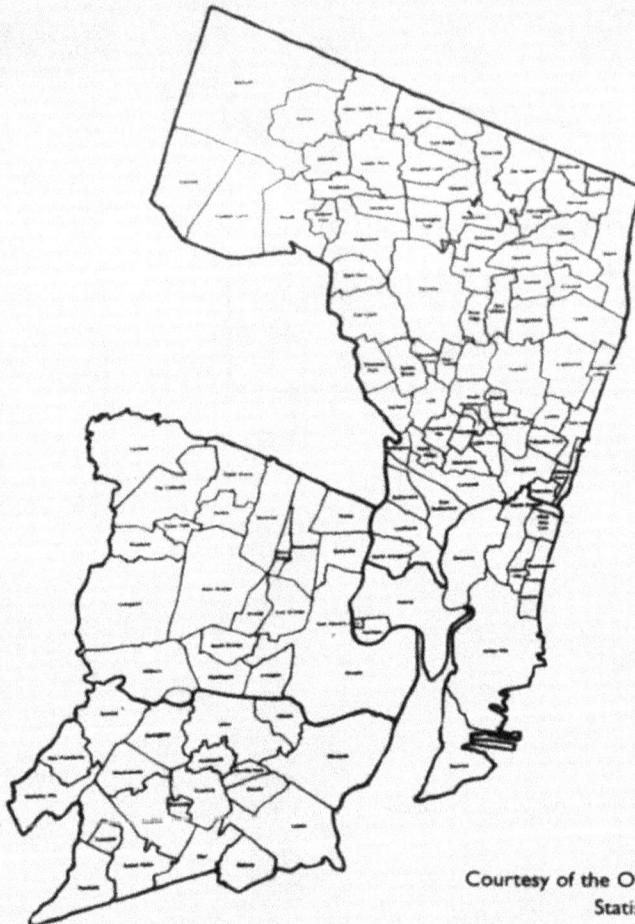

511 square miles
234 parishes
54,700 children in religious education
42,338 elementary school students
16,196 high school students

Total population of the four-county area:
2,809,267
Total Catholic population of the Archdiocese:
1,319,558

Bergen County
(78 parishes)
475,041 Catholics
54% of total county population

Essex County
(62 parishes)
277,107 Catholics
35% of total county population

Hudson County
(52 parishes)
316,694 Catholics
52% of total county population

Union County
(42 parishes)
250,716 Catholics
48% of total county population

Priests 969
- Archdiocesan 742
- Religious 227

Deacons 248

Sisters 1,216

Brothers 104

Courtesy of the Office of Research and Planning
Statistics as of 2003

SPIRITUAL GEOGRAPHY. This image illustrates the civil and parish boundaries that constitute the organizational and administrative center of Catholicism in northern New Jersey. Throughout its history, the Archdiocese of Newark, in terms of landscape, has always been the largest See in the state and the fifth largest of its kind in the nation, encompassing 541 square miles, 124 towns, and over 1.3 million adherents on the eve of its sesquicentennial in 2003. (Courtesy of the Archdiocese of Newark.)

ON THE COVER. This scene from the elevation of Thomas Aloysius Boland, then auxiliary bishop, on July 25, 1940, coincided with the anniversary of the consecration for Archbishop Thomas Joseph Walsh. Boland is in the center of the adoring crowd with his contemporaries, including Monsignors Joseph Brady, Joseph Dooling, John McHenry, James Owens, and James Stone in step with fellow prelates George Ahr, Bartholomew Eustace, William Griffin, Justin McCarthy, and Martin Stanton. (Courtesy Monsignor William Noé Field Archives & Special Collections Center.)

IMAGES
of America

ROMAN CATHOLIC ARCHDIOCESE OF NEWARK

Alan Bernard Delozier

ARCADIA
PUBLISHING

Published by Arcadia Publishing
Charleston, South Carolina

Library of Congress Control Number: 2011926557

For all general information, please contact Arcadia Publishing:
Telephone 843-853-2070
Fax 843-853-0044
E-mail sales@arcadiapublishing.com
For customer service and orders:
Toll-Free 1-888-313-2665

Visit us on the Internet at www.arcadiapublishing.com

To my beloved family, the Deloziers—Rosemary, Bernard, and Gregory—and Amy and Ian Malik, with further respect to all individuals who made the Archdiocese of Newark, past, present, and future.

CONTENTS

ACKNOWLEDGMENTS

No work of this kind is accomplished alone and without the aid of a multitude of selfless individuals who contribute to the wonders of historical discovery.

A sincere thank-you to the current Archbishop of Newark, John Joseph Myers, and emeritus leaders Theodore Cardinal McCarrick and Archbishop Peter Gerety for their kindness and words of reflection for this volume.

Deepest gratitude goes to Monsignor Francis Seymour, archivist for the archdiocese, whose encouragement has been invaluable throughout this project, as well as to longtime colleague Monsignor Robert Wister for his generous observations, Monsignor Michael Andreano for his support, and Father Chris Ciccarino, whose own excellent book provided necessary inspiration.

This project would not have moved forward without the thoughtful efforts of Jim Goodness, director of archdiocesan communications, in conjunction with other individuals, including Michael Gabriele, Marge Pearson-McCue, and Marilyn Smith of the *Catholic Advocate*, and Troy Simmons, architectural historian.

Thank you to the administrators from Seton Hall University, especially dean Chrys Grieco and Catriona Hill, operations manager for Walsh Library, for their gracious efforts. Continued gratitude is extended to my associates in the Monsignor William Noé Field Special Collections Center, Seton Hall University Libraries, and those on the New Jersey Catholic Historical Commission. Other friends and colleagues who offered solace and the gift of knowledge include Fran Becker; Rob Carbonneau, CP; Jere Cole; Augustine Curley, OSB; Denise D'Agostino; Anthony De Palma; Kate Dodds; Lauretta Farrell; Al Frank; Bob Golon; Laura Graber; John Hallanan; Leonard Iannaccone; Mary Kinahan-Ockay; Christine Kinealy; Monsignor Raymond Kupke, Monsignor Richard Liddy; Terry Liddy; Jim Lowney; Ed and Allison Lucas; Karen McNanna and family; Cindy Maissen; Regina Novicky; Sean Peragene; Gina and Jim Petrecca; Christopher Petruzzi; Eileen Poiani; Gerald O'Connor; Laura Poll; Amy Skinner; Robert Sievers; Albina Spatola; Anita Talar; Greg Tobin; Frank Wagner; and John Wrynn, SJ.

Appreciation goes to my editors at Arcadia Publishing: Erin Rocha, who guided this project from start and middle with Abby Henry, who saw it through to completion, along with Erin Vosgien, David Mandel, and everyone who polished these proofs.

As noted in the dedication, my family has been a tremendous presence. Any omissions are unintentional, and everyone else who provided express or indirect aid is appreciated in spirit. Thank you in advance to the reader for your interest!

Unless otherwise noted, all images are from the Monsignor William Noé Field Archives & Special Collections Center and part of the Archdiocese of Newark Collection.

INTRODUCTION

The Archdiocese of Newark is the longest serving, highest populated, and most ethnically diverse center of Roman Catholicism in the state of New Jersey. Prior to its founding date and throughout its formative years, the archdiocese has experienced a memorable period of spiritual and administrative growth, as illustrated in this volume.

Before there was an archdiocese, the first Catholics to settle in New Jersey resided in the proximity of Woodbridge and Elizabethtown (modern day Somerset and Union Counties) within the colony of East Jersey during the mid-to-late 17th century. The first documented follower of the faith was William Douglass of Bergen (now Jersey City) who made known his allegiance prior to his expulsion from the Colonial General Assembly in 1680. The New Jersey Constitution of 1776 disallowed religious freedom to any who subscribed to the "Romish Religion" until a revised charter allowing for more flexible rights was approved in 1844. The earliest presence of Catholic clergy in New Jersey came via visiting Jesuit and Augustinian missionaries from Philadelphia who traversed the countryside to administer sacraments to those scattered in such areas as Burlington, Trenton, Macopin, Paterson, and even New York, among other locales throughout the mid-18th and early 19th centuries.

The earliest seeds planted towards administrative development for the Archdiocese of Newark followed in the wake of the American Revolution when New Jersey and the rest of the United States came under the auspices of the See of Baltimore and its first bishop, John Carroll, in 1789. From this point, the Garden State was divided twice more with the establishment of the Dioceses of Philadelphia and New York in 1808. The northern part of New Jersey would, therefore, receive its spiritual directives from across the Hudson River for the next four and a half decades. The formal establishment of the then Diocese of Newark came in 1853. Geographically, this metropolitan See covered the entire state from High Point to Cape May and all other cities, towns, and villages in-between. Newark became the selection as the first diocesan seat because its residential base was, (and still remains) the largest metropolitan area in New Jersey during the 1800s. Neighboring cities that include Jersey City, Bayonne, Elizabeth, Linden, Hackensack, Englewood, and others have also shown favorable and impressive growth in regard to their own respective Catholic residential communities throughout the mid-19th century. Church affiliation and geographical proximity alike helped to bring cohesion to the See of Newark during its earliest years of operation.

The Papal Bull issued by Pius IX on July 29, 1853, officially established and outlined its mission. "For a testimony unto prosperity. The nature of the Apostolic office demands that We erect new dioceses throughout the Catholic world when it contributes to the good of religion and the salvation of souls . . . it would be greatly beneficial to the rule of Christ's faithful if the entire State of New Jersey . . . were separated from them and erected into a distinct diocese with its Episcopal See established in the City of Newark, have besought Us that this, so highly useful for the growth of religion, be done by Our Apostolic authority . . . We wish and understand that all faculties, honors, privileges, and duties are granted which by law or by custom belong to Episcopal Sees and to Bishops. This We wish and order, despite Our rule, and that of the Apostolic Chancery, concerning the inviolability of an established right."

Over the next few decades, due to large population increases and growing urban development, the landscape of Catholic New Jersey was divided yet further. The Diocese of Trenton was established in 1881 and covers the state capital along with the central and southern portions of New Jersey. A further split came in 1937 when the Dioceses of Paterson (which subsumed the northwestern counties of Morris, Passaic, and Sussex from Newark) and Camden were created, consituting the last major shift until 1981 when the Diocese of Metuchen was formed.

The modern age for the See of Newark began on December 10, 1937, when it attained archdiocesan status. The affixed Apostolic Letter proclaiming its creation vividly states the need for this elevation:

"In order that the welfare and rule of Christ's faithful may be more usefully and beneficially provided for in the ecclesiastical province of New York, which seems to extend over too great a territory, it is thought very opportune to divide it, and to erect therefrom a new province . . . To the Metropolitans of Newark . . . We especially grant the right of having the Cross carried before them within the limits of their province, and of using the Pallium according to the laws of the liturgy, after, of course, it has been properly asked for and obtained in a Sacred Consistory."

Over its first 150 years, the Archdiocese of Newark has shown a tangible rate of evolution and advancement as demonstrated through historical statistics. In 1800, there were just under 1,000 known Catholics within the borders of New Jersey, but by 2003 over 1.3 million belong to the Church within the archdiocese alone. Otherwise, the first *Metropolitan Catholic Almanac*, published in 1854, listed 33 churches statewide, with Newark having three parishes (the most in one locale), followed by Trenton with two. A total of 30 priests and 14 designated mission stations "without church" were also in evidence and available for worship among the approximately 50,000 Catholics in the Garden State at this time and place.

Most of the earliest faithful were of English, Irish, German, or French origin and led the way for those from Italy, Poland, Eastern Europe, Africa, Asia, and Latin America. Each of these groups and others enhanced the depth and spirit of worship within the Archdiocese of Newark as it reached its centennial year and beyond. The archdiocese expanded exponentially in 1953 with a population topping 1.1 million guided by 893 priests and over 2,957 religious sisters who staffed the 223 parishes, 246 chapels, three colleges, 47 high schools (both diocesan and private), 185 elementary schools (both parochial and private), along with nine hospitals, 14 infant asylums, and other institutions of note. During its sesquicentennial feast, the Archdiocese of Newark served as home to over 300 different parishes, institutions, schools, and related entities during this milestone year alone.

The principal landmarks covered in this book are mainly restricted to the four counties that constitute the current Archdiocese of Newark, unless otherwise noted. This volume is arranged thematically in order to represent the major symbols of the Catholic Church and provide a basic pictorial introduction to the development of the Archdiocese of Newark over time. Of special note are the "firsts" and origin points, including individuals, institutions, and parishes, whose start dates appear in parenthesis. Unfortunately, every individual, institution, and inspiration cannot be covered in full form, but all are implied in spirit if not illustrated or noted within the captions proper. With this in mind, I hope this book provides not only a general introduction for those learning about this subject for the first time, but also evokes specific memories of your own life in the Archdiocese of Newark over the years and how it has impacted on those of family and friends alike. Thank you in advance for your interest and observations.

One

SYMBOLISM

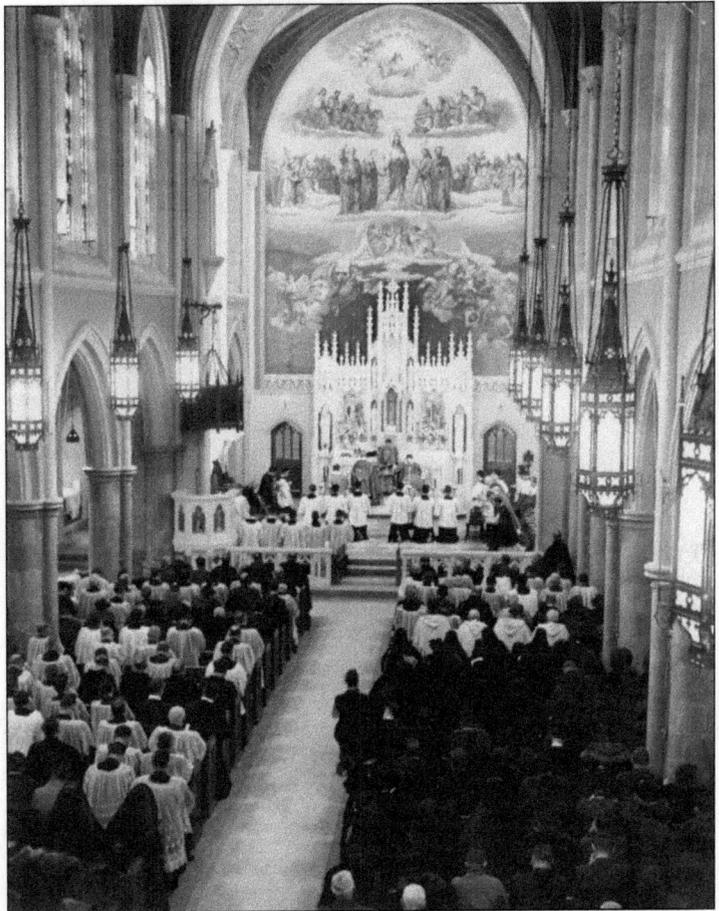

ROMAN CATHOLICISM. The Catholic Church is based on the example of Jesus Christ, Son of God, who motivated a devout body of adherents to follow His example. Members belong to a global society celebrated in local neighborhoods and ancestral homelands alike. In homage to its patron, the background mural of the chapel within the Immaculate Conception Seminary (formerly at Mahwah) honors the life of Christ the King.

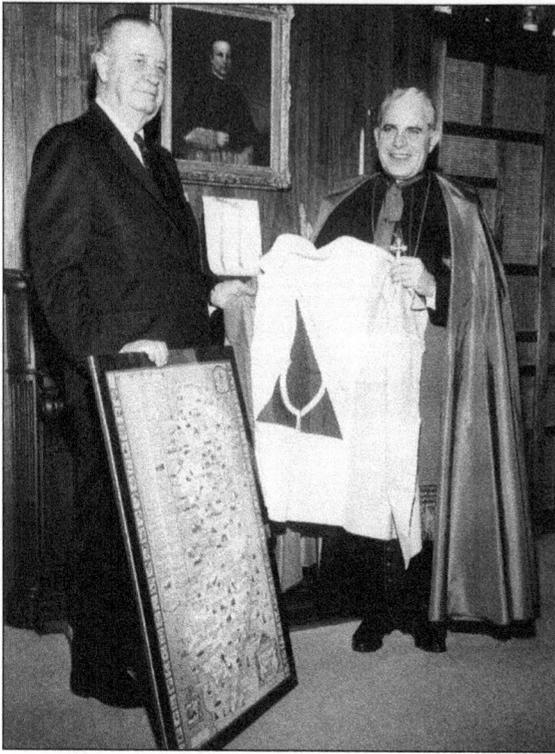

STATE OF FAITH. Bishop John Dougherty is presented with commemoratives honoring the tercentenary of New Jersey by former chairman of the New Jersey Turnpike Authority Paul Troast. There has been a Catholic presence in the colony from around the 1660s forward, and Catholicism became the largest religious denomination statewide by 1964. The symbolic context of these gifts show an atlas of Garden State historical highlights and James Roosevelt Bayley, the first Bishop of Newark, framed above in this image.

STATUS SYMBOLS. Newark achieved archdiocesan status on December 10, 1937. At this point, the four counties of northeastern New Jersey became the cornerstone of this spiritual sector, and the previously connected counties joined the Diocese of Paterson. The upper quadrant on this cover features the personal arms of Thomas Walsh, the first Archbishop of Newark. Below is a depiction of the Immaculate Conception Seminary. In the left foreground is a red oak, the state tree and a symbol of rapid growth.

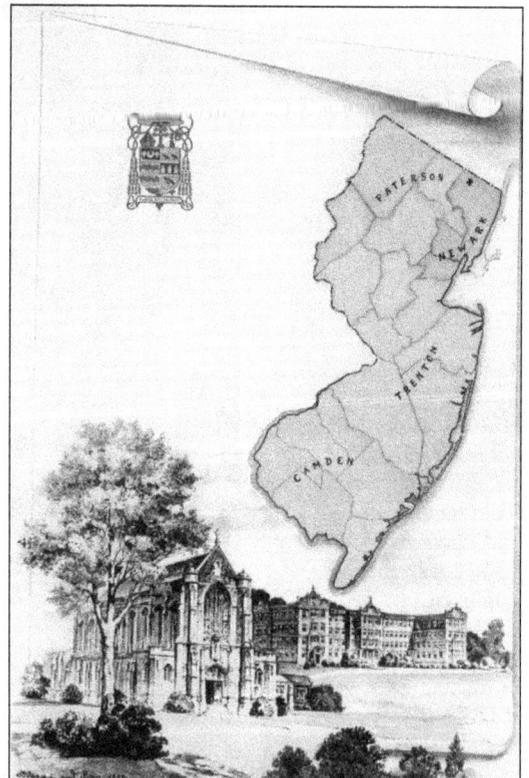

PATRONESSES. The long-standing patron saints for the Archdiocese of Newark and the state of New Jersey are Our Lady of the Immaculate Conception (Virgin Mary) and Our Lady of Fatima, respectively. According to Catholic doctrine, "Immaculata" is without original sin, as defined by Pius IX, the papal benefactor of Newark, who made this proclamation in 1854. Pictured here is Monsignor Cornelius Boyle with two young devotees during the mid-1950s. The feast day for Our Lady of the Immaculate Conception is December 8, and May 13 for Our Lady of Fatima.

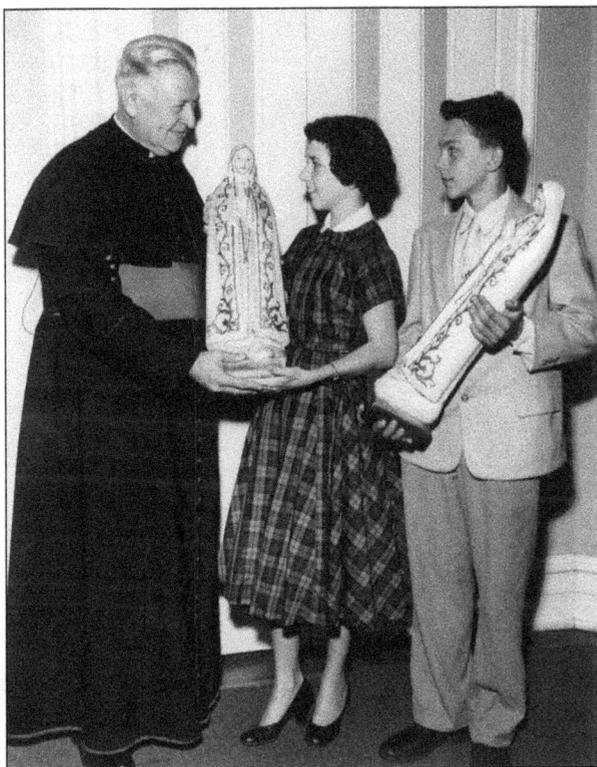

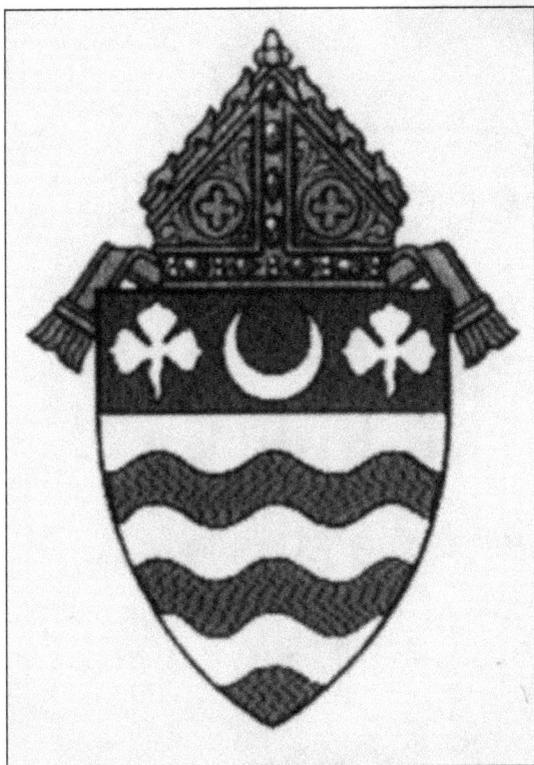

EMBLEMATIC. The seal of the Archdiocese of Newark is derived from spiritual and environmental elements, including the wavy blue and silver bands, denoting its ancestral English roots and representing the Hackensack, Hudson, Passaic, Rahway, Raritan, and Saddle Brook Rivers that "flow through the See." The red chief symbolizes the Sacred Heart; shamrocks honor St. Patrick, patron of the Pro-Cathedral; and the Immaculate Conception is symbolized by the crescent.

SYNOD. The inaugural conference among priests representing the then Diocese of Newark, convened by Bishop Bayley, was held between August 22 and 23, 1856, and was attended by 28 priests at Seton Hall College (formerly located in Madison). General legislation and the creation of a board of consultors, rules for sacraments promulgated, safeguards for church property, and the establishment of parochial schools were specific highlights as prelude to a subsequent synodal gathering two years later.

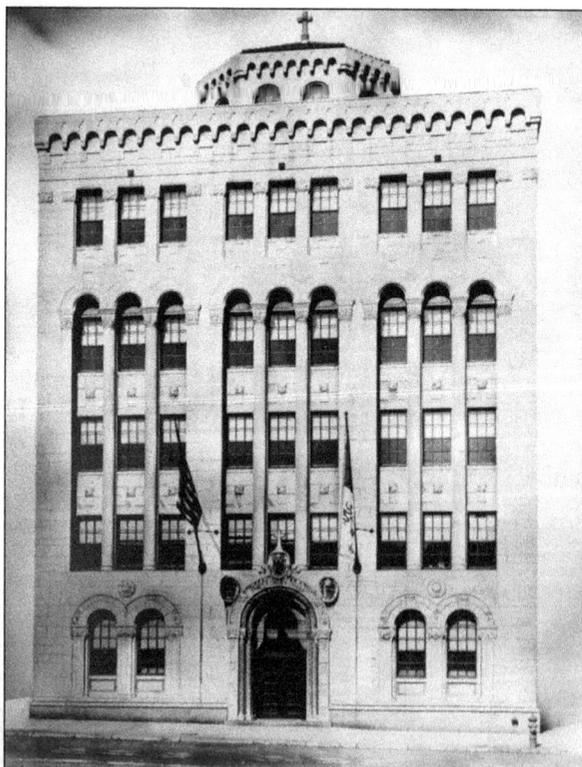

CHANCERY. This temporal structure served as the administrative complex for the See of Newark. The first center of its kind was located in the schoolhouse of St. John's, Newark, prior to the opening of this edifice in 1931 under the direction of then Bishop Walsh. Located at 31 Mulberry Street, this site served as the focal point of church activity for decades prior to a move to its present location on Clifton Avenue across from the Cathedral Basilica.

Two

RITUALS

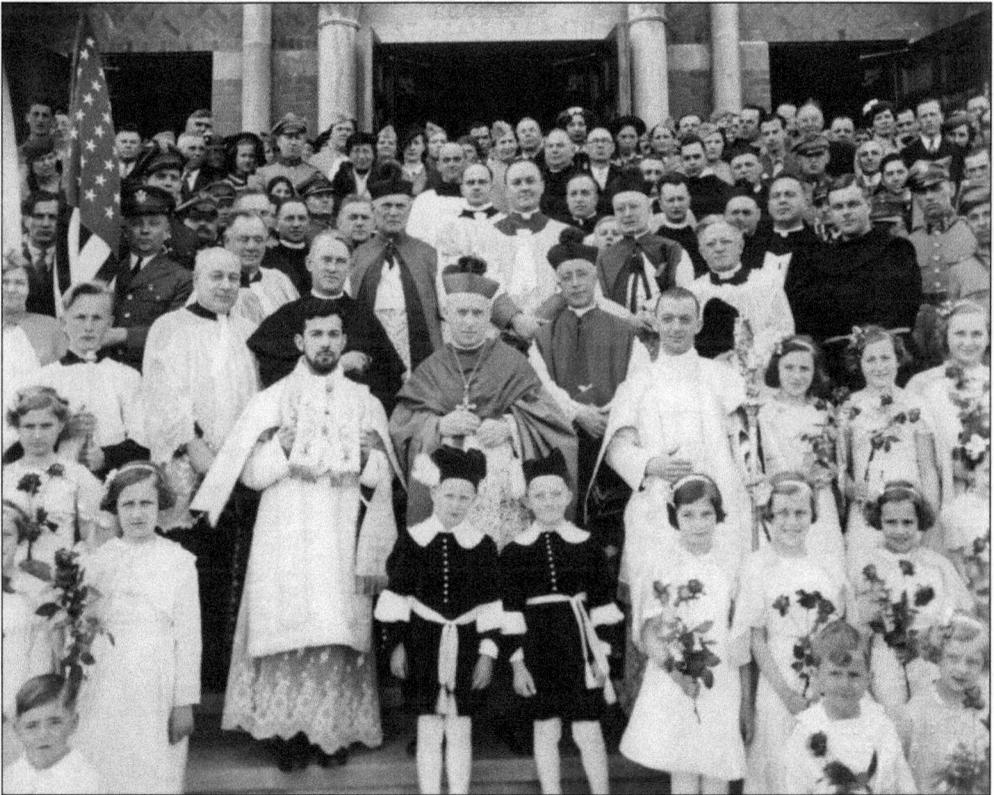

CEREMONIAL PANORAMA. Within the broader scope of Catholic tradition, the public show of piety is evident in prayer, observances, rules, and shared moments that encompass the proper focus of communal worship. This early 1930s photograph demonstrates the nature of kinship among the laity, hierarchy, and others who followed the faith as does this diverse group of adherents from the Polish parish of St. John Kanty, Clifton.

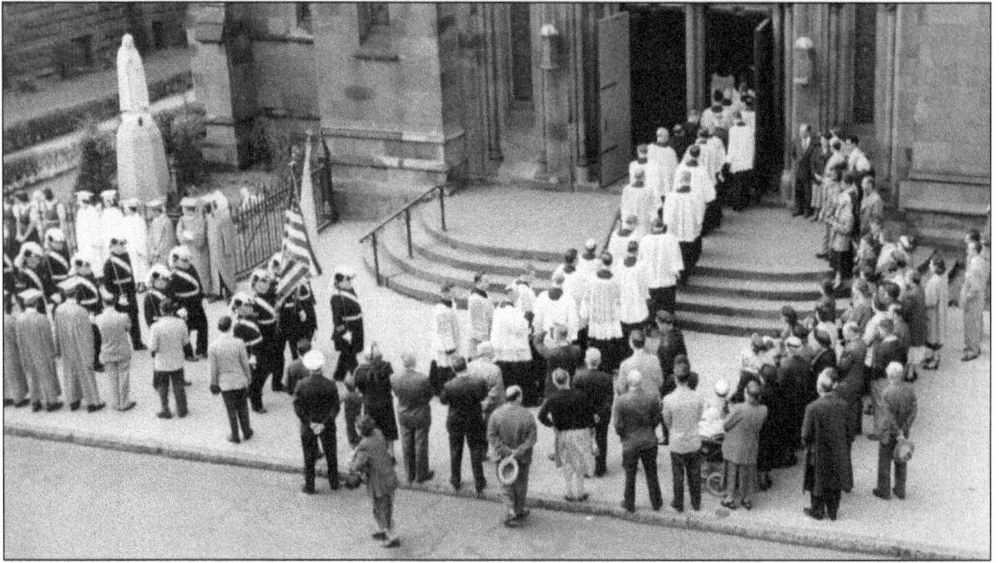

HOLY MASS. This particular ceremony is often viewed as the most expressive and familiar means of devotion among those who profess the Catholic faith. The following introductory sequences signal the beginning procession that joins congregants together in a spirit of mutual rejoicing and communion. Throughout much of the early history of the Archdiocese of Newark, there were three special types of Mass celebrated beyond the Tridentine, depending upon the hour and the circumstance: the Pontifical, as shown above in this c. 1948 frame, High (Solemn), and Low (Conventual or Requiem). The first documented Catholic services celebrated within New Jersey came during the 1700s via the visits of missionaries Theodore Schneider, SJ; Ferdinand Farmer SJ; and others who traversed the colony of New Jersey from Philadelphia at regular intervals. Countless Masses have since been celebrated before and since this time among congregants within the state and beyond.

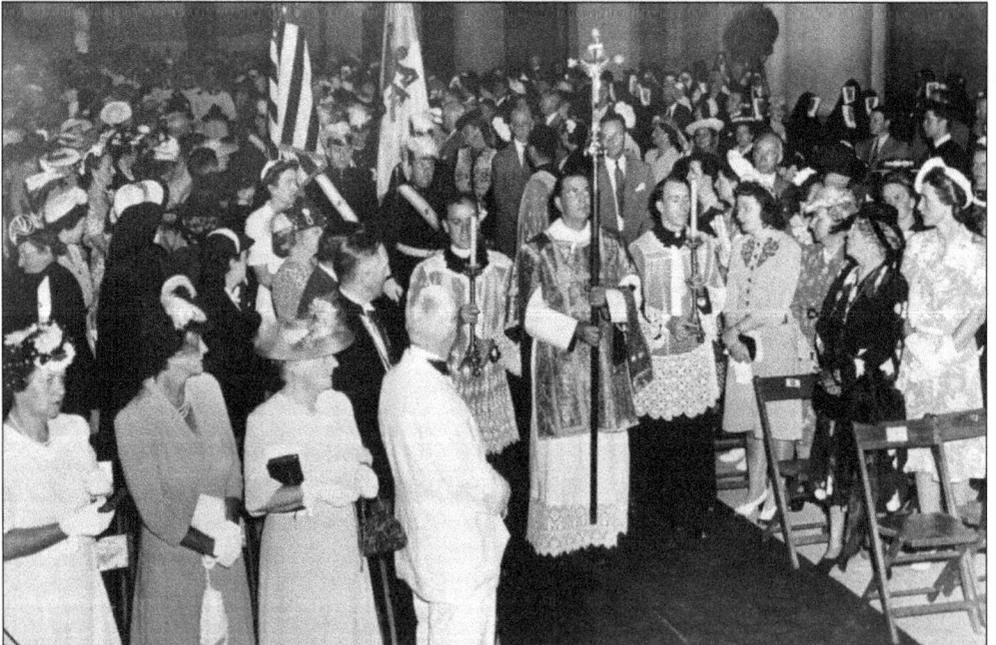

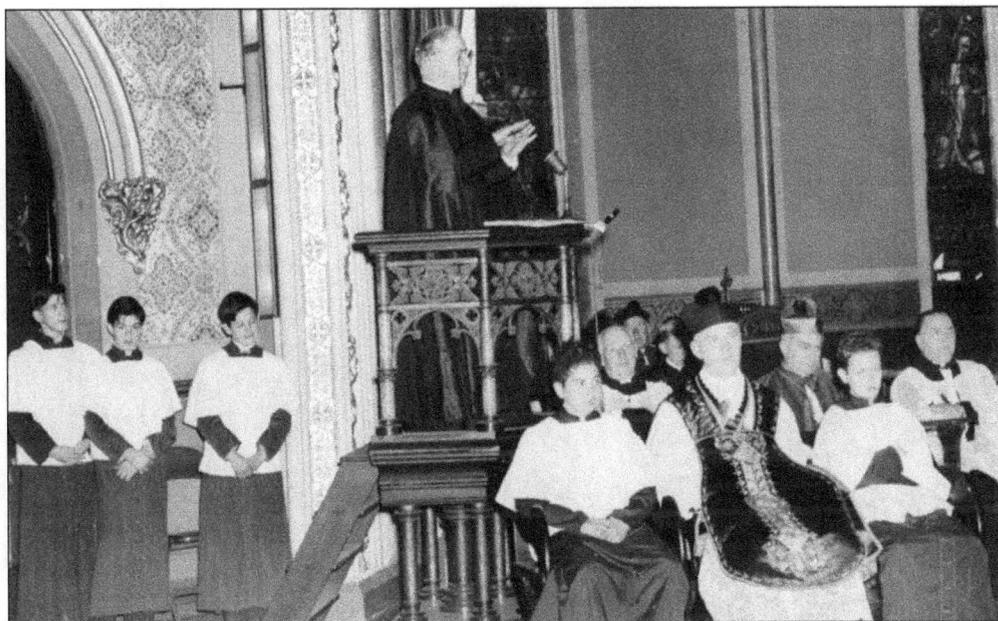

GOSPEL AND SERMON. Within the course of Mass from the greeting to the readings, these orations help the celebrant establish a rapport with the congregation, especially the sermon portion, as shown during this early 1940s service. Passages for the Gospel are taken from the Scriptures, and appropriateness is dependent upon the liturgical calendar. The words intoned through the Gospels are often followed in accord by parishioners in text form through *Missale Romanum* primers.

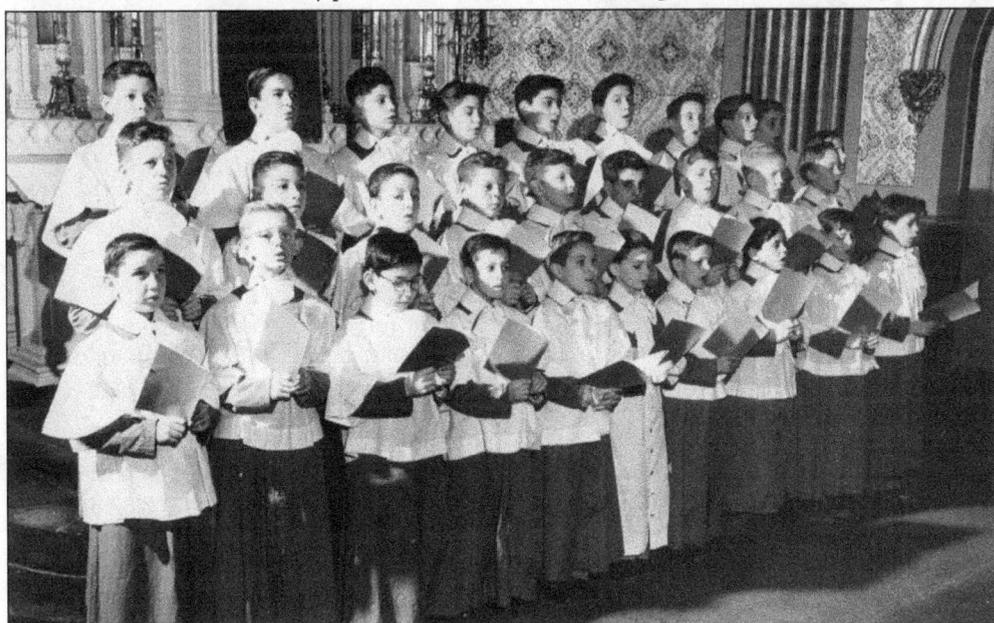

MUSICAL INTERLUDE. From the 13th century onward, through the Second Vatican Council of the 1960s, the music selected for a Catholic Mass has to be in accord with its ritual focus. Here, the choir from St. Patrick's Pro-Cathedral, Newark, is offering their voices skyward in melodic praise of the Lord, as witnessed by proud parents and other parishioners in attendance at this c. 1940s Mass.

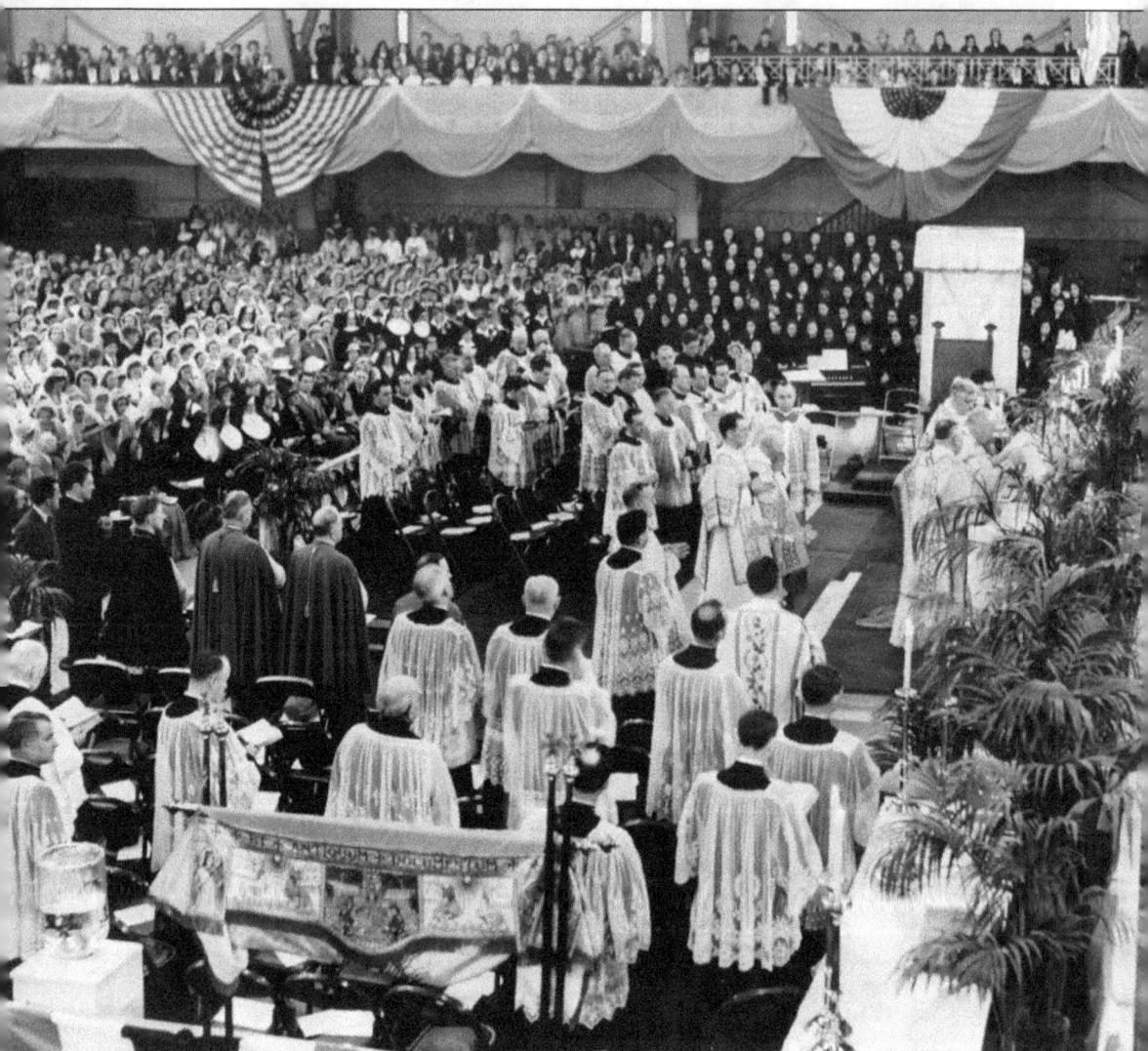

DEMONSTRATION MASS. An example of instructional devotion in action, as seen in this 1930s photograph, was conducted on an annual basis under the auspices of the Archdiocesan Institute of Sacred Music. This popular encounter blended active participation and educational overtones to help the parishioner learn the proper protocol for celebrating the finer points of Mass. A regular plan came into effect so that youngsters could learn the art of music, to give "the child in germinal form the basic principles of the great and subtle art of musical prayer . . . [and] enrich the child's devotional life by an understanding of the liturgical prayer of the Church." Such textual aids as the *Kyriale, St. Gregory Hymnal,* and *Heart of Jesus Hear!* were considered staples of this program, which tied into the full spirit and desire of church leaders to start with parochial school students and expand their spiritual development as a result of inspired exposure and repetition.

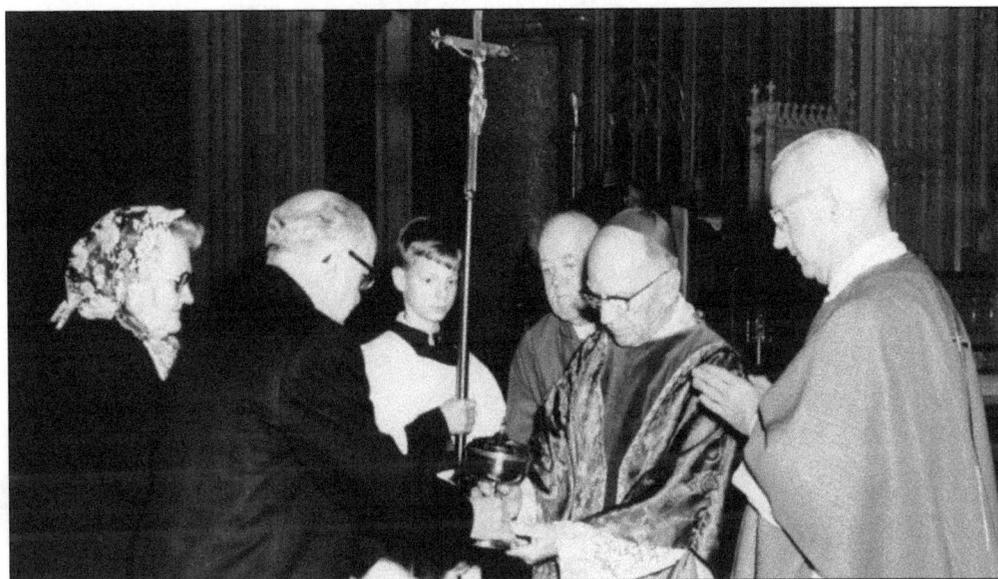

GIFT ACKNOWLEDGMENT. Avid participants in Mass follow in the footsteps of the three wise men who bore offerings of tribute at the birth of Christ. Modern-day parishioners who travel this path usually carry a ciborium and chalice containing Communion hosts and sacramental wine, respectively, to the altar, where these gifts are received in turn by the clergy. In this 1970s image are Archbishop Thomas Boland, along with Monsignors Eugene Sullivan and John Ansbro. An altar boy bears a processional cross to guide gift bearers to this exchange point.

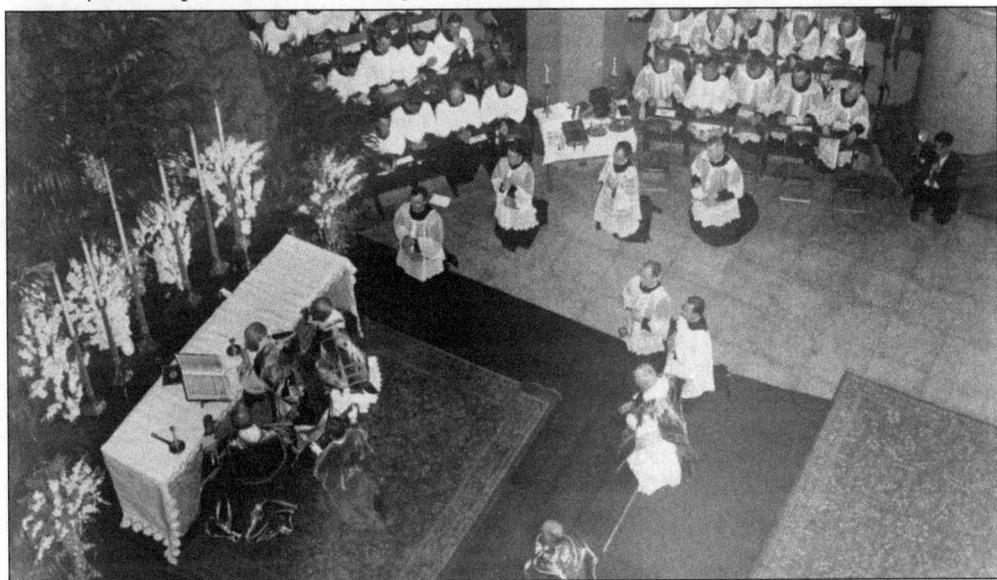

PREPARATION FORWARD. The celebration of Mass is often seen as a drama of passion in which those who share the experience can anticipate a consistent order of observation and devotional interludes. A typical Mass is divided into special tributes, including the Liturgy of the Word (formerly Mass of the Catechumens) constituting an introductory portion followed by the Liturgy of the Eucharist (formerly Mass of the Faithful) that is further broken down to include the Offertory, Consecration, Communion, and Conclusion. This particular tableau shows scenes of the Consecration from the Silver Jubilee Mass for Archbishop Walsh in 1943.

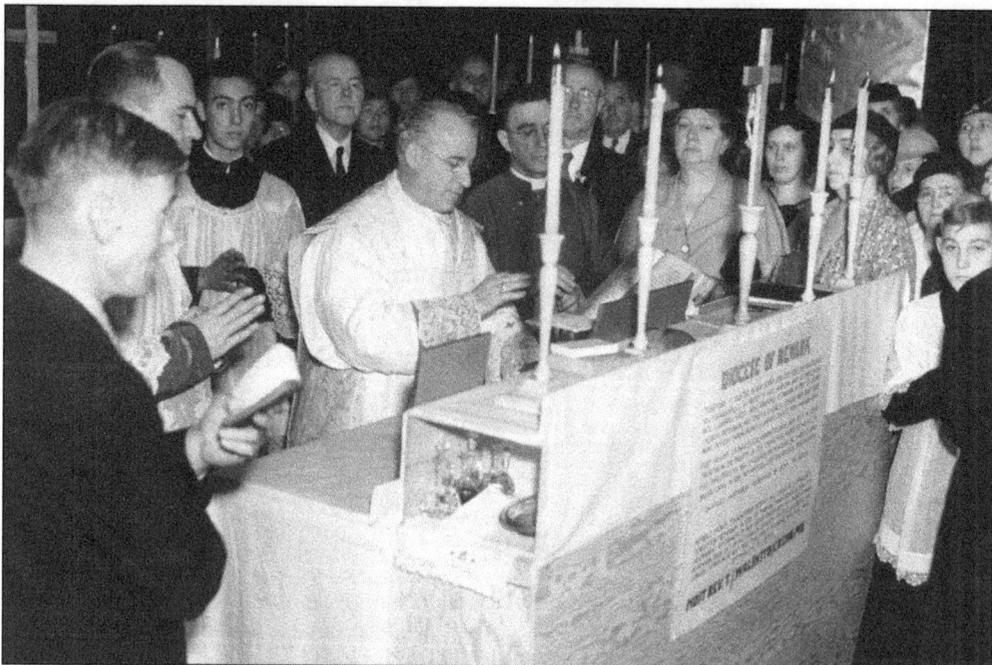

SEE AFAR. Oftentimes, clergy within the Archdiocese of Newark had to travel for various purposes and serve as spiritual goodwill ambassadors by extension. In this spirit, the Eucharistic Congress is a popular event that is celebrated on both a national and international level. Bishop Walsh is shown at the September 22, 1935, ceremonial held in Cleveland with several individuals from New Jersey who were counted among the 500,000 in attendance on this day.

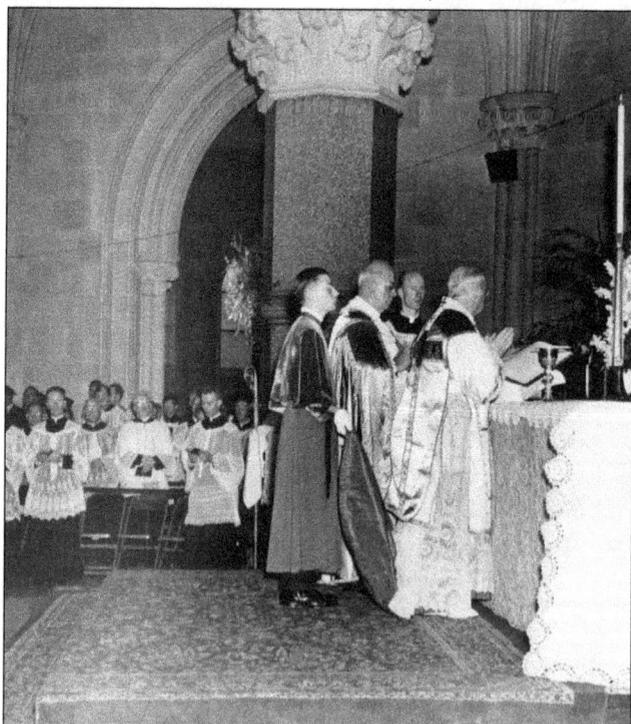

TRIDENTINE MASS. Named in honor of the Council of Trent, a Tridentine service is remembered by many lay Catholics who attended Church prior to the Second Vatican Council as the Roman, or "Traditional Latin," Mass depicted in this c. 1950s image. The most distinguishing feature of this version showed the celebrant facing the tabernacle and intoning prayers in Latin, which were standard in each parish throughout the Archdiocese of Newark prior to the mid-1960s. After this time, the chosen vernacular varied from English, Spanish, French, or Korean to others that were all deemed acceptable according to the audience in attendance.

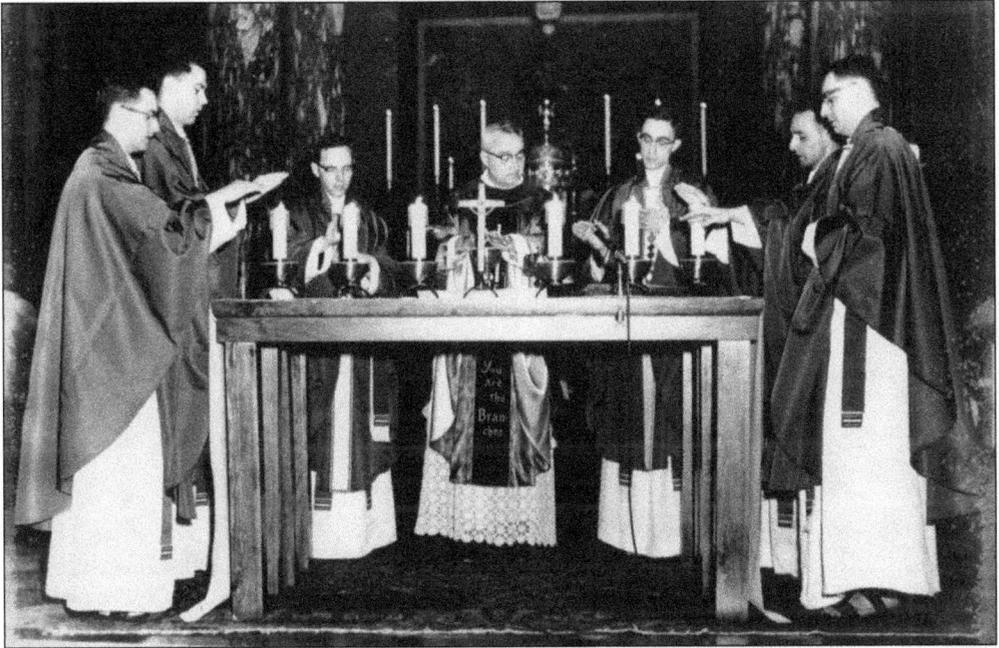

MASS APPEAL. The essential component of this particular act of spiritual homage is the sacrifice that includes the Offertory, Consecration, and Communion. Note the vestments worn by celebrants Archbishop Peter Gerety, Father Michael Moran, Father Frank Rheinbold, and other members of the archdiocesan clergy shown in these joint scenes of devotion. Within the days that preceded and followed the Second Vatican Council of the 1960s, the typical vestment colors included violet, white, red, rose, and black, depending upon the nature of a particular commemoration.

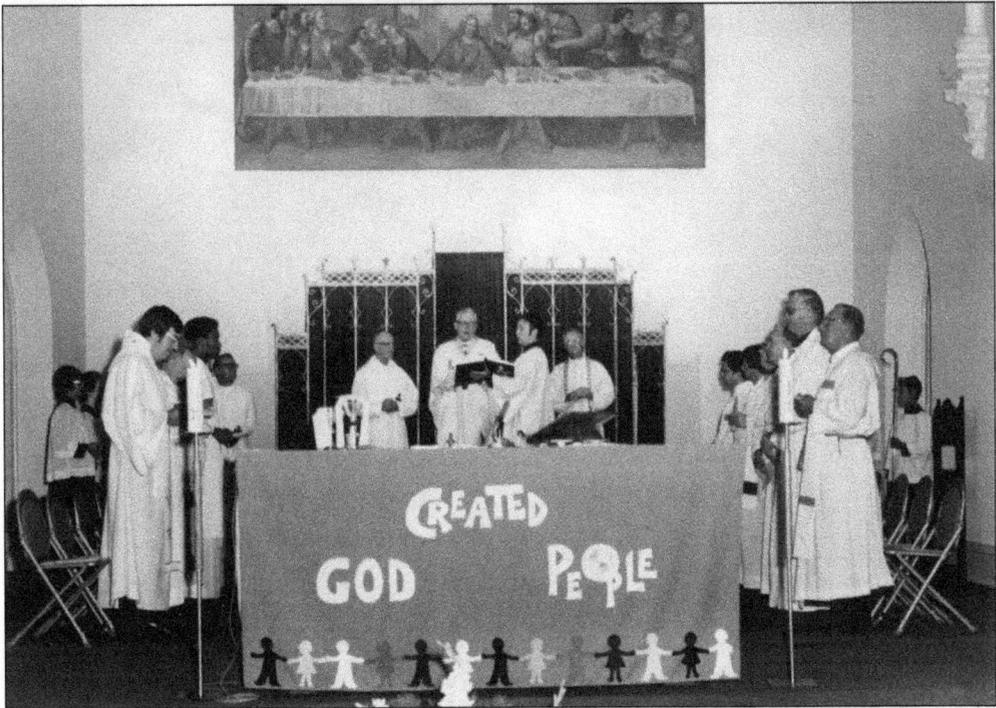

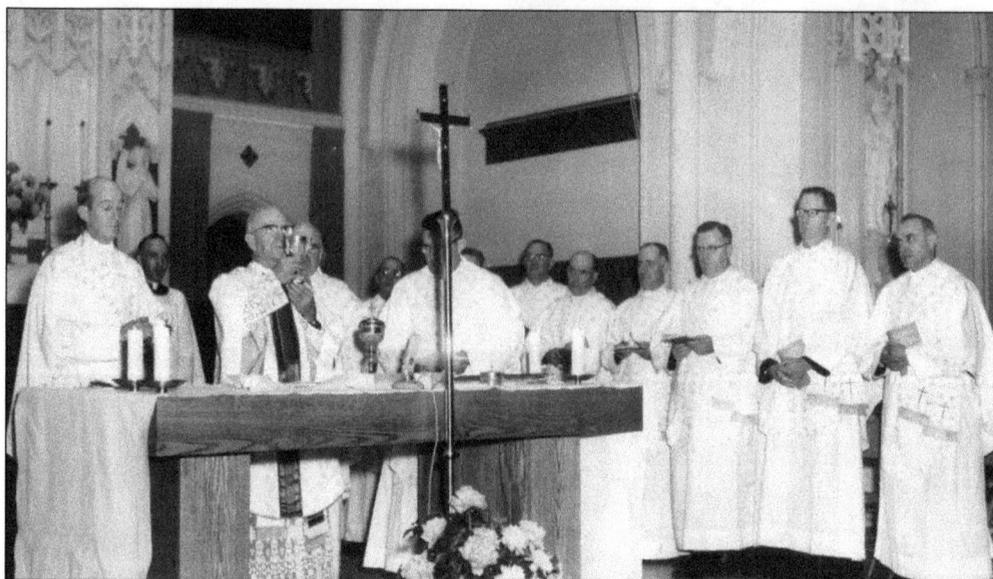

CONSECRATION. The act of sanctifying the Body and Blood of Christ prior to the sharing of Communion with congregants is an essential aspect of worship. As the priest stands and raises the host and chalice to the heavens, the faithful genuflect as they hear the bells and share in the solemnity of the act as they kneel, stand, or sit, depending upon the part of Mass that is presently at hand.

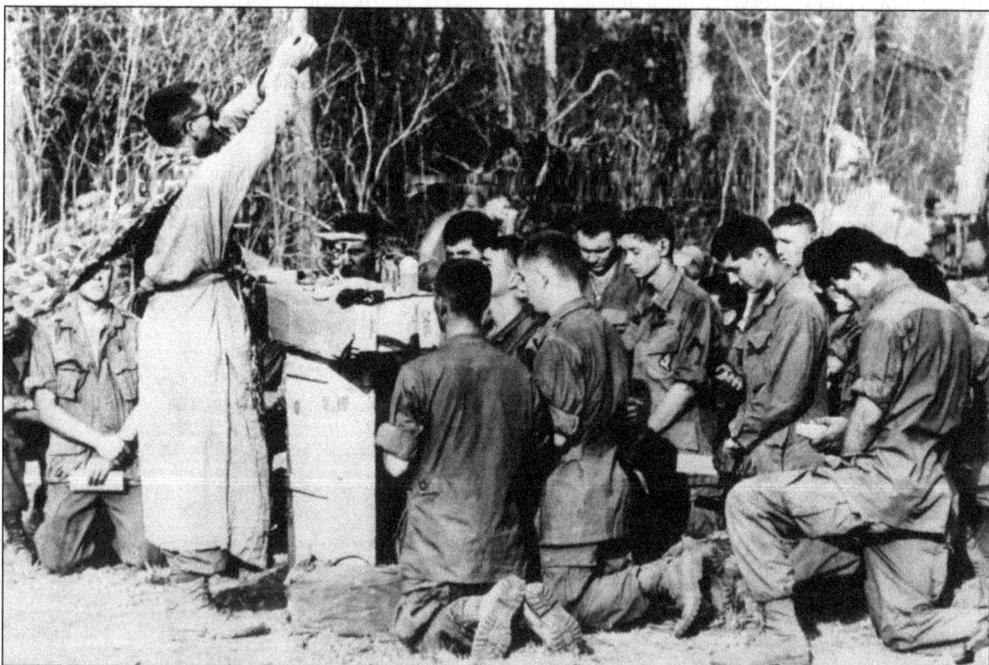

GLOBAL PRAISE. This image shows the piety of Father Charles Watters as he celebrated a field Mass in Vietnam with soldiers prior to his death on November 19, 1967. A native of Jersey City, Father Watters was honored for his heroism in Southeast Asia as a recipient of the Congressional Medal of Honor and was given further tribute with a bridge that stands in his honor over the Passaic River in Rutherford.

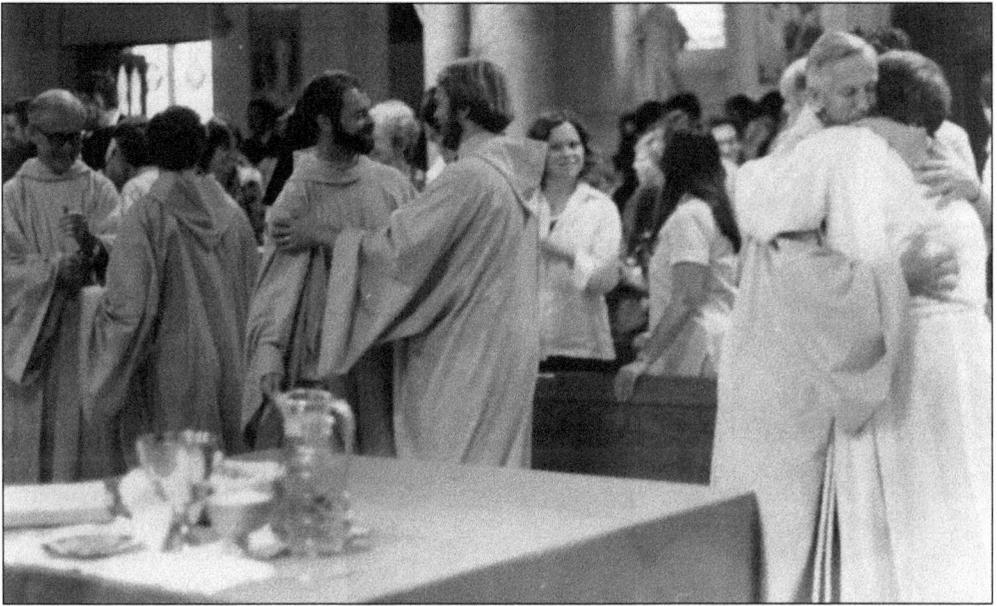

PEACE. The expression of respect between the faithful reaches from Sparta to Springfield and all points in between and beyond. A congregation in its formal and geographically based structure is part of a parish territory as directed by its bishop. This 1970s image from the Immaculate Conception Seminary shows the hug, handshake, or nod as a sign of mutual respect among those who belong to a particular parish community.

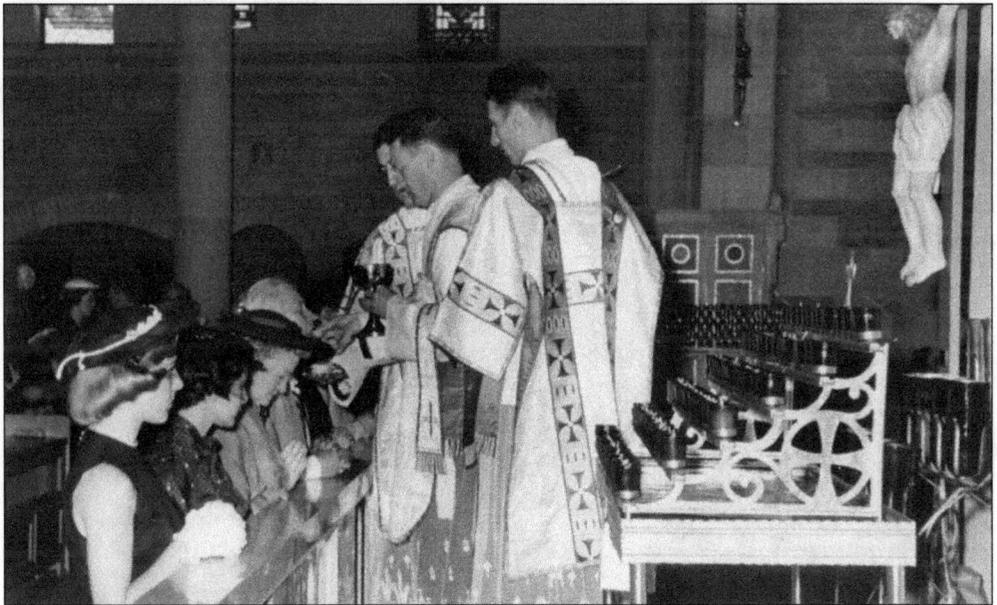

COMMUNION. At the Eucharistic banquet, praise is offered in honor of the sacrifice made by Christ on the cross. Consecrated bread in the form of a round wafer is typically offered to the laity after the priest and those around the altar first receive the gift. This scene shows an old-fashioned Communion rail where adherents lined up and knelt to directly participate and show due respect through their actions. Those featured in this scene are also sharing in the first Mass, celebrated by Father Harold Hermann on May 30, 1954, at St. Mary's, Nutley.

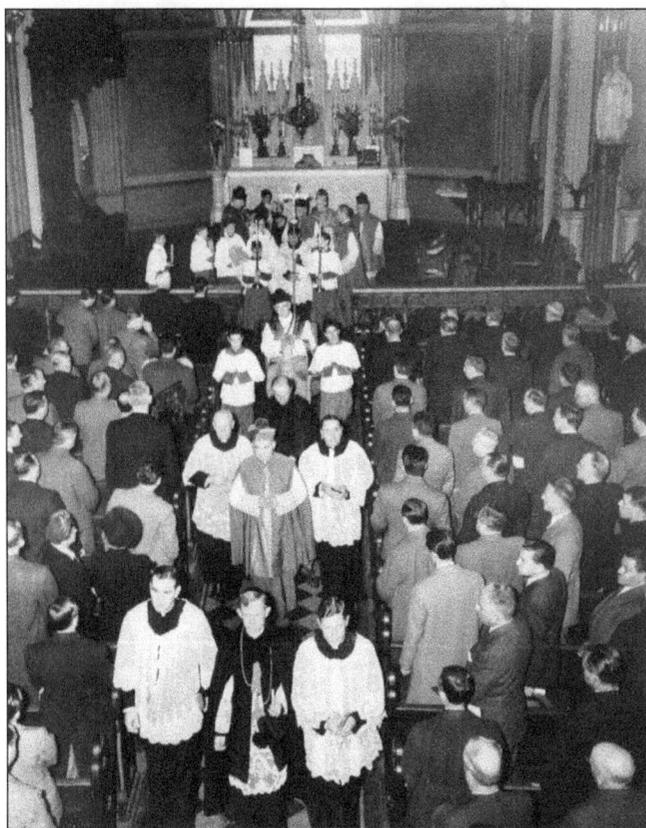

RECESSIONAL. This word signals the close of a Mass, as these scenes from the 1940s show in detail from above. The celebrant wishes all in attendance to "go in peace" or some similar variation as the procession heads from the sanctuary towards the narthex until the next commemoration takes place. Usually, the priest is last in line, with acolytes, lectors, and others leading the way. On special occasions, an honor guard from the Knights of Columbus and others are positioned in front of a solemn procession. Mass is typically celebrated each day, including Saturdays after sundown and Sundays, when multiple services are conducted in addition to special ones for Holy Days of obligation and to observe the Sacraments.

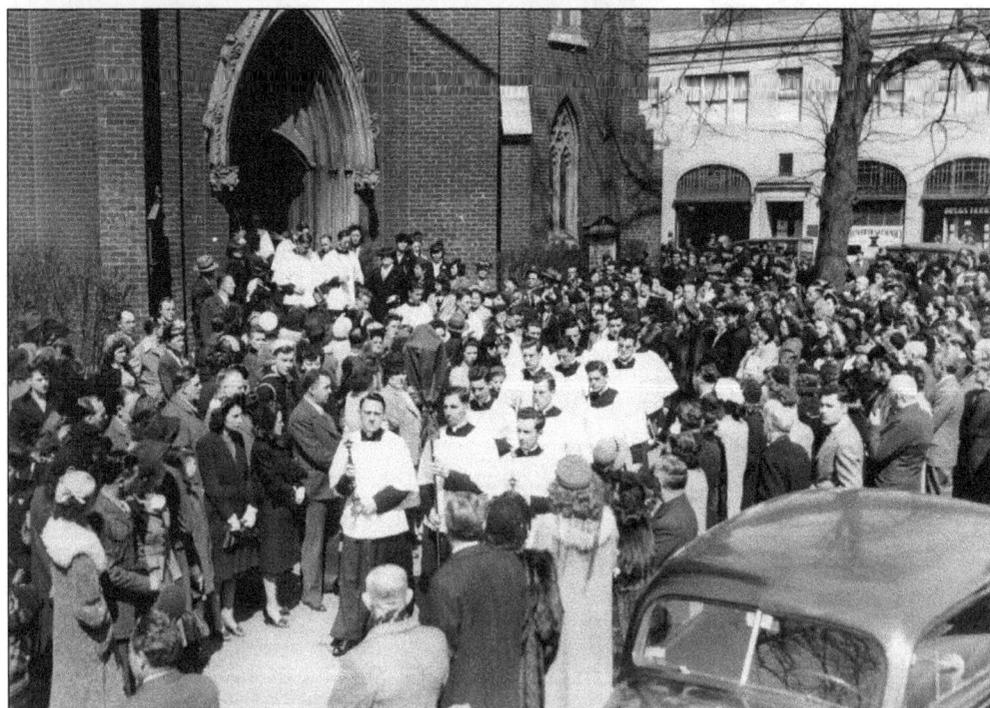

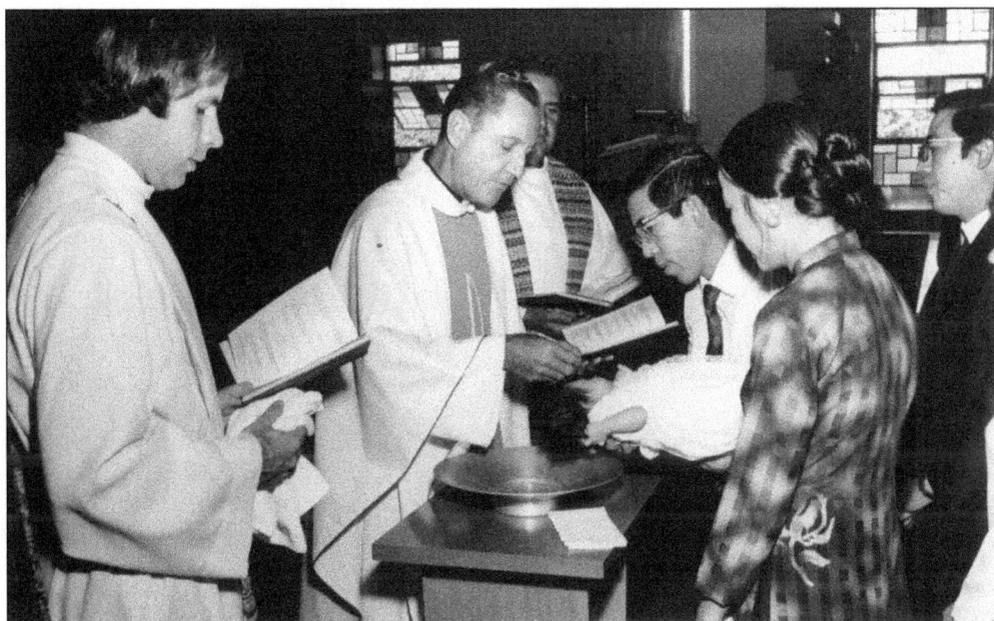

CHRISTENING. The first sacrament that impacts on the individual within the practice of Catholicism is that of baptism. This is usually performed within three months from the birth of a child and designed to rid one of original sin through the pouring of water and subsequent blessing by the administering priest, along with well-wishing parents, godparents, family, friends, and attendants.

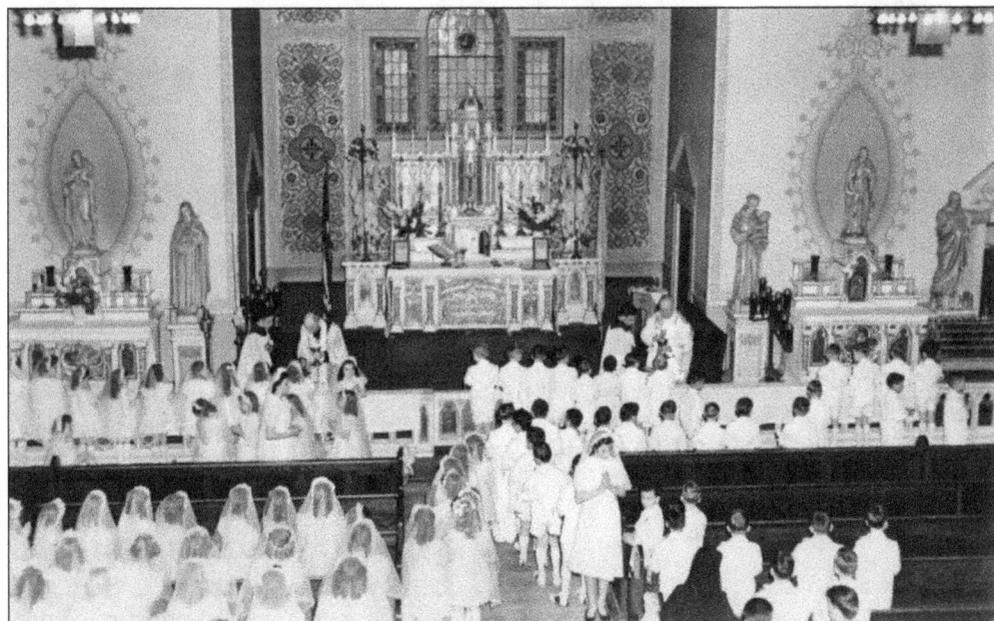

FIRST COMMUNION. This sacrament is bestowed on those who are first baptized into the Church. The spirit of this milestone in the life of a communicant is captured through the words of Eileen Poiani from Holy Family, Nutley, who recollected, "Coming in touch with God in First Communion is an uplifting yet daunting experience . . . The indelible memory of that day long ago reminds me that Mother Superior required us to wear floor length long dresses."

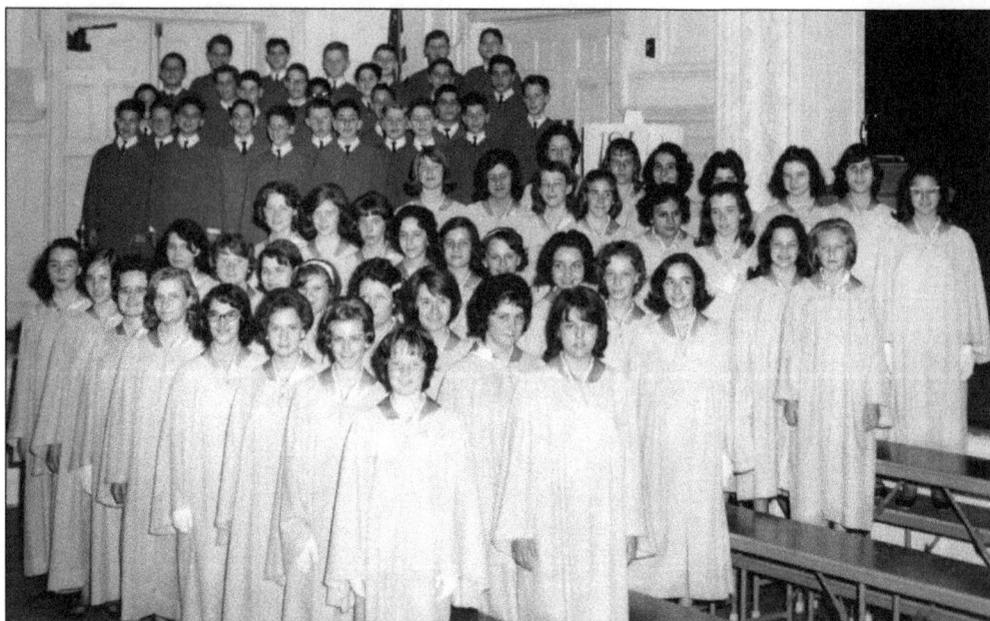

CONFIRMATION. The stage at which Catholic Church teachings are accepted in full measure by an individual after careful instruction and study is confirmation. Typically, a bishop administers this grace to a recipient in the form of chrism, a mixture of oil and balsam that is applied to the candidates in order. The confirmed usually has a sponsor and takes a name in honor of some loved one or saint, depending on individual preference, as this group from the 1960s can attest.

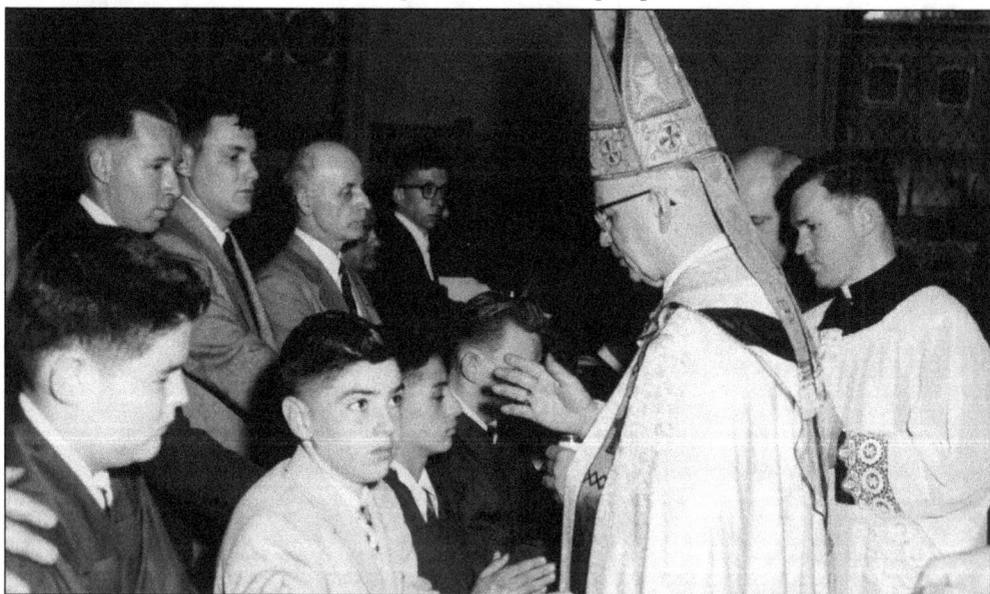

SACRAMENTS. Baptism, Holy Communion, and Confirmation are the major formative rites for a young Catholic or convert to the faith, but as one matures they might choose to follow an important life path such as marriage or Holy Orders. A first confession, or penance, is the confidential exchange between penitent and priest, which is encouraged to begin at an early age. Anointing of the Sick is the final act in the cycle of faith. This particular scene shows the process of Confirmation from St. Bridget's, Newark, in 1956 and the overall spirit of Catholicism.

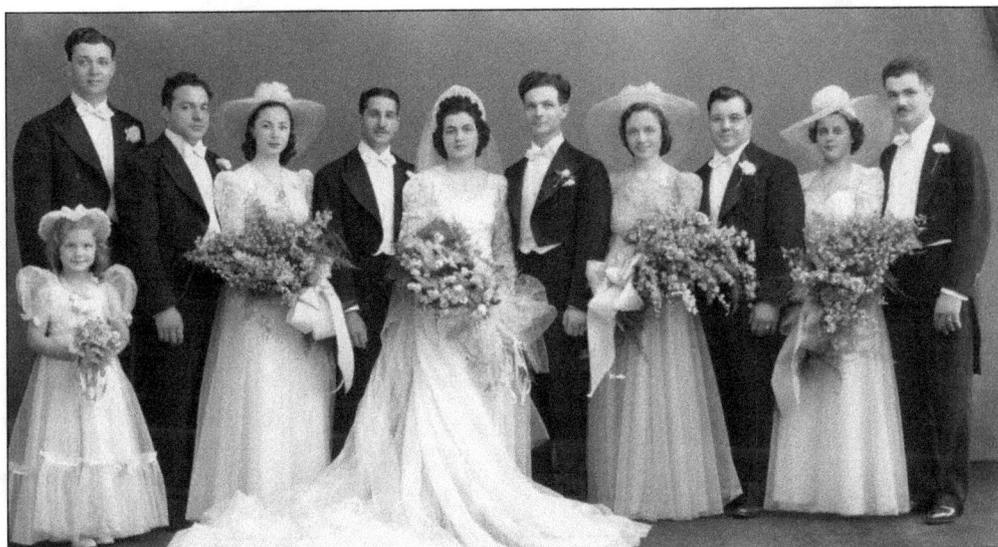

MARRIAGE. Within the Catholic Church, this sacrament is viewed as a spiritual contract between two baptized individuals. Vows and a ring exchange are often key to forming a symbolic bond that makes these nuptials complete. Scores of anniversary toasts have ensued over the last several decades in honor of married couples across the area. These photographs show the love and beauty of ceremony between the bride and groom, with party in tow. Pictured above is a chic wedding party for Eileen and Hugo Poiani at St. Thomas the Apostle, Bloomfield, on June 7, 1941. Below in an equally stylish portrait of John Golon and Olga Zylinski at Holy Cross, Harrison, on April 6, 1940. The 1942 Catholic Directory section for the Archdiocese of Newark reported that 11,111 weddings were performed during this period, making for one particularly ardor-filled era. (Courtesy of Bob Golon and Eileen Poiani.)

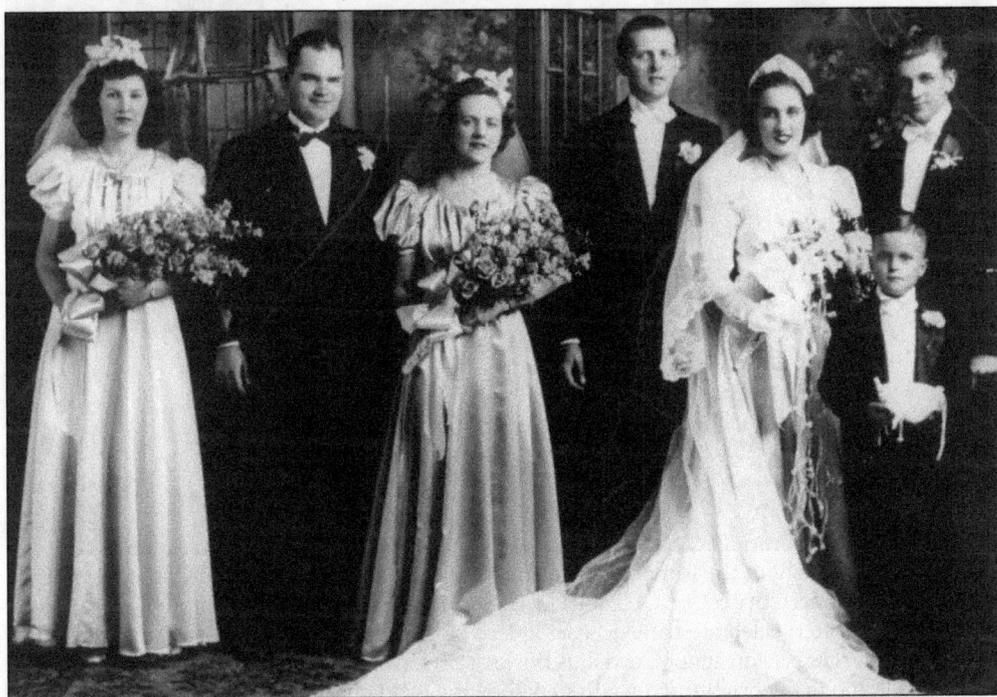

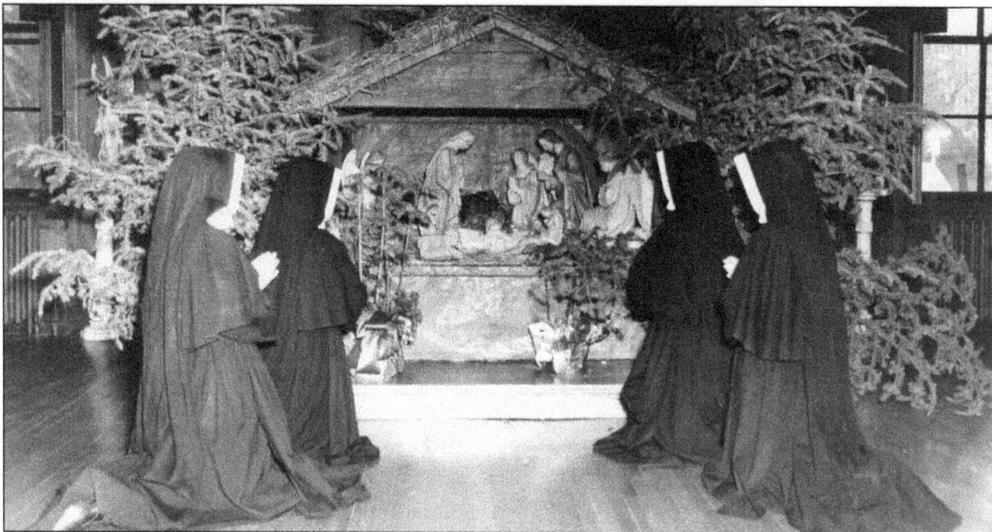

ADVENT. Derived from the Latin word for "coming," this is the liturgical season that christens every new Church calendar. This celebration encompasses a four-week period that includes the Sunday after the Solemnity of Christ the King followed by preparation for the Feast of the Nativity, Gaudete Sunday, and finally the birth of Christ, or Christmas. These Sisters of Charity show their keen attachment to the symbolism of Christmas by praying at the *crèche*, or Nativity scene, during the 1950s.

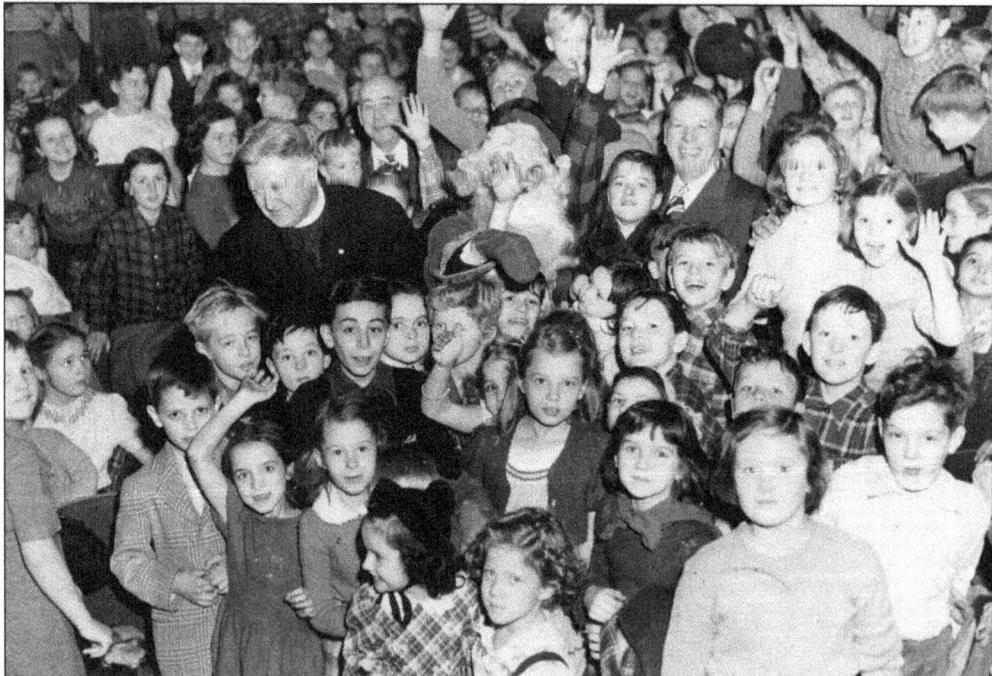

CHRISTMAS. Throughout the world, December 25th is the day most Latin Rite Catholics observe the Nativity of Jesus Christ. On a religious level, remembrance of the Holy Family is honored by the clergy who often celebrate three Masses apiece on this day. It is also known universally as a time for giving. Here, Monsignor Cornelius Boyle of St. Lawrence, Weehawken, is surrounded by Santa Claus and many bright-eyed youngsters showing good cheer this gleeful time of year!

26

LENTEN SEASON. The period between Ash Wednesday and Easter comprise the 40 days known as Lent, marked by a remembrance of baptism and the spirit of sacrifice among the faithful. On the first day of Lent, ashes are placed on the forehead as a physical reminder of mourning and repentance. Church guidelines on proper protocol are often voiced in advance of the season during Mass, along with official written pronouncements of rules and regulations as quoted in this 1873 circular on how to accurately celebrate this devotion.

HOLY WEEK. Often called Palm Sunday, this pre-Easter feast is marked by the blessing of fronds in a traditional practice that recalls the visitation of Jesus to Jerusalem, as described by priest to altar boys in this c. 1950s image. Later in the week, Holy Thursday, when the Last Supper took place, is observed with a Chrism Mass. A mixture of olive oil and balsam is blessed by a bishop for later use in various sacramental observances.

DIOCESE OF NEWARK.

REGULATIONS FOR LENT.

Ash Wednesday, the first day of Lent, will fall, in this year, on the twenty-sixth day of February.

1. Every day during Lent, except Sunday, is a day of fast on one meal, which should not be taken before mid-day, with the allowance of a moderate collation in the evening.

2. The precept of fasting implies also that of abstinence from the use of flesh meat, but by *dispensation*, the use of flesh meat is allowed in this Diocese at every meal on Sunday, and at the principal meal on Mondays, Tuesdays and Thursdays, of Lent except Holy Thursday.

3. There is no prohibition to use eggs, butter or cheese, provided the rules of quantity prescribed by the fast be complied with. Fish is not to be used at the same meals at which flesh meat is allowed. Butter, or if necessary, lard may be used in dressing fish or vegetables.

4. All persons over seven years of age are bound to abstain from the use of flesh meat, and all over twenty-one to fast according to the above regulations unless there be a legitimate cause of exemption. The Church excuses from the obligations of fasting, but not from that of abstinence from flesh meat, except in special cases of sickness or the like, the following classes of persons: 1st, the infirm; 2nd, those whose duties are of an exhausting or laborious character; 3rd, women in pregnancy, or nursing infants; 4th, those who are enfeebled by old age. In case of doubt in regard to any of the above exemptions, recourse must be had to one's spiritual director, or physician.

All alike, however, should enter into the spirit of this holy season, which is, in a special manner, a time of prayer, and sorrow for sin, of almsgiving, and mortification.

The faithful are reminded that by a special privilege granted by the Holy See to the faithful of this Diocese, a Plenary Indulgence may be gained on the usual conditions, on St. Patrick's Day or any day, within the Octave.

By order of the Very Reverend Administrator,

GEORGE H. DOANE, Secretary.

BISHOP'S HOUSE, NEWARK, Feb. 6, A.D. 1873.

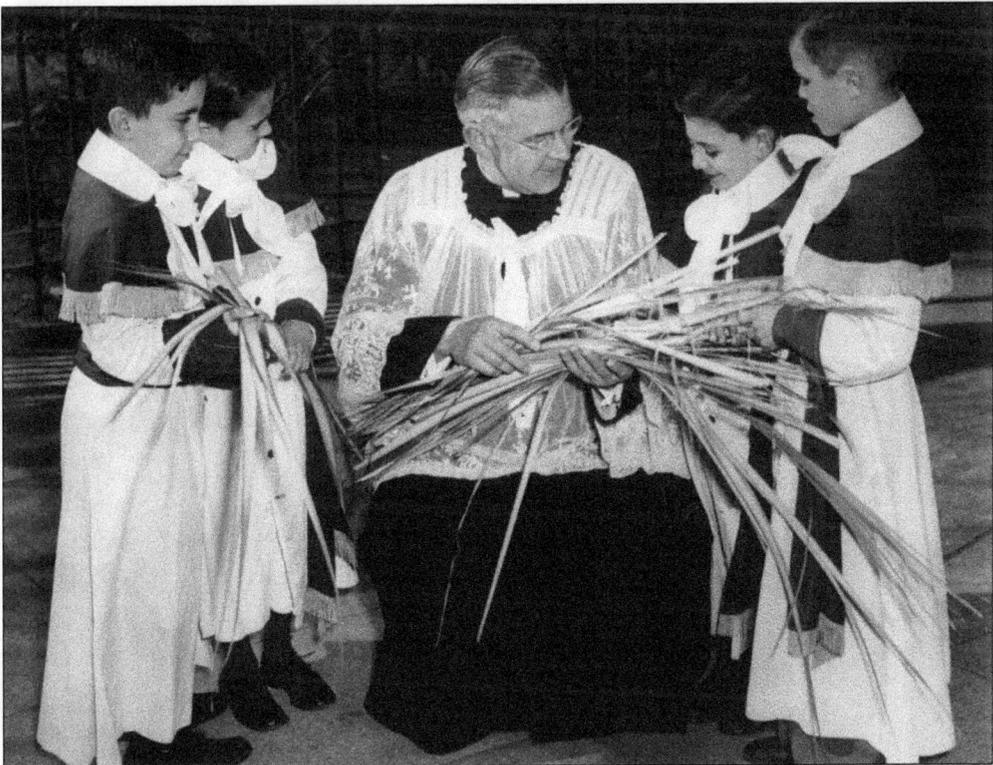

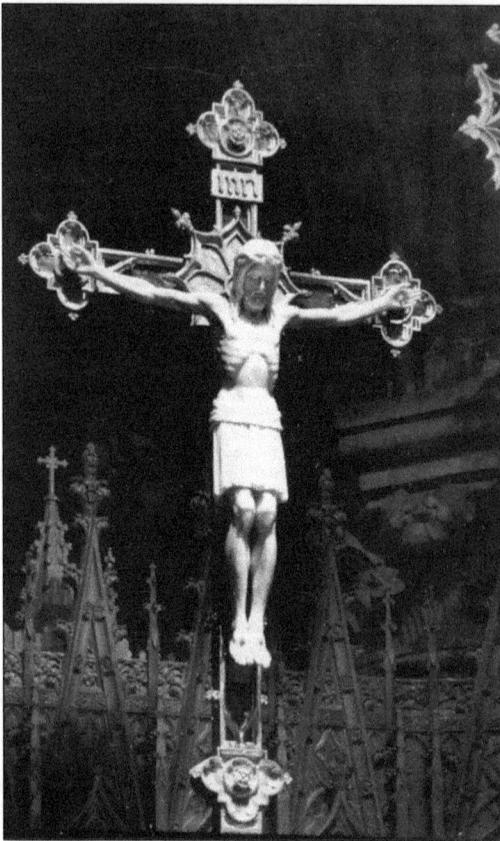

GOOD FRIDAY. In homage to the crucifixion of Christ, Good Friday is the one day within the Church calendar when altars are laid bare of candles, crosses, and ceremonial cloth, as Holy Mass is not celebrated. A reenactment of the Stations of the Cross is made in honor of the Lord Jesus, as depicted here in this example from the Cathedral Basilica of the Sacred Heart. Smaller crucifixes remain a symbolic presence in all parishes and parochial schools throughout the Archdiocese of Newark.

EASTER VIGIL. Reflective of the Holy Saturday Mass, candles are aglow to honor the impending spirit of Resurrection. Here, adherents are shown holding beeswax tapers that are commonly a part of the "Service of Light" that illuminate brightly during this 1970s observance. These lighted wicks shadow a larger Paschal Candle that is blessed and imbedded with mounted grains of incense to represent the wounds of Christ and symbolize the sacrament of baptism for all archdiocesan congregations.

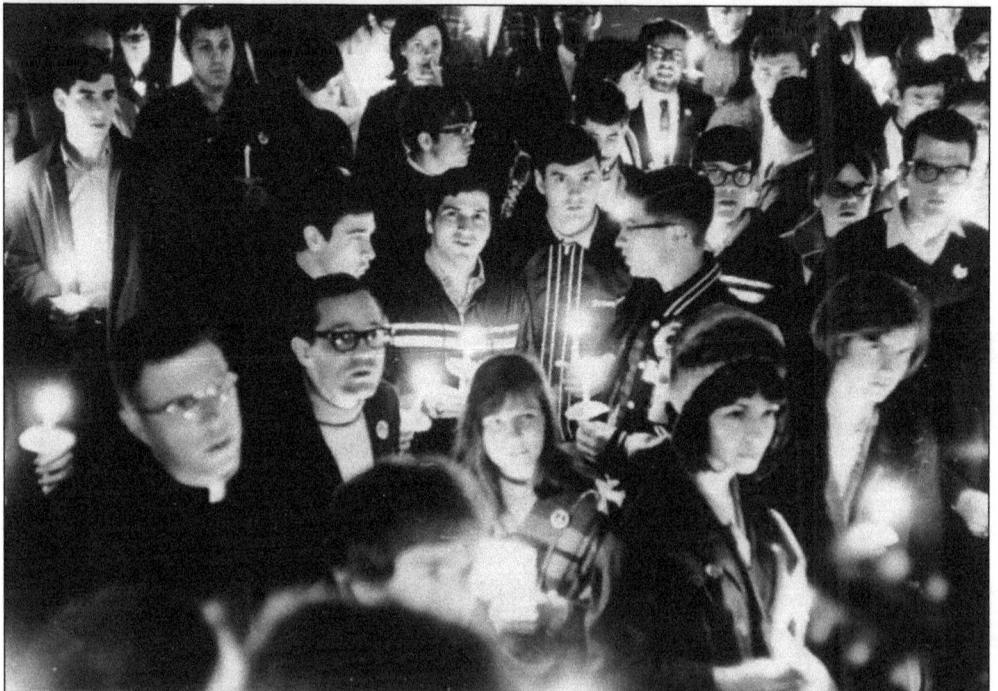

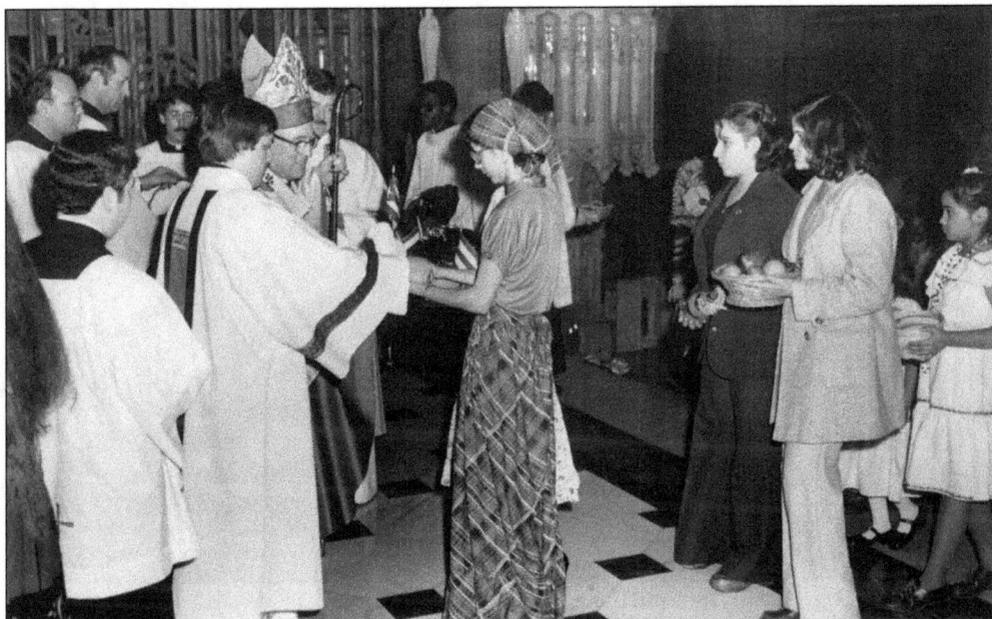

HOLY SATURDAY. This observance is celebrated on the eve of Easter Sunday. The blessing of bread is a manifestation of the spirit of life and has remained an especially popular staple among various cultures, especially those who hail from Poland and Eastern Europe. Monsignors Seymour, Gronki, Ortryl, and Durand attend to the ritual above with Archbishop Gerety. The vigil ceremony is observable on the day preceding this feast in which the faithful make acts of penance and devotion in preparation.

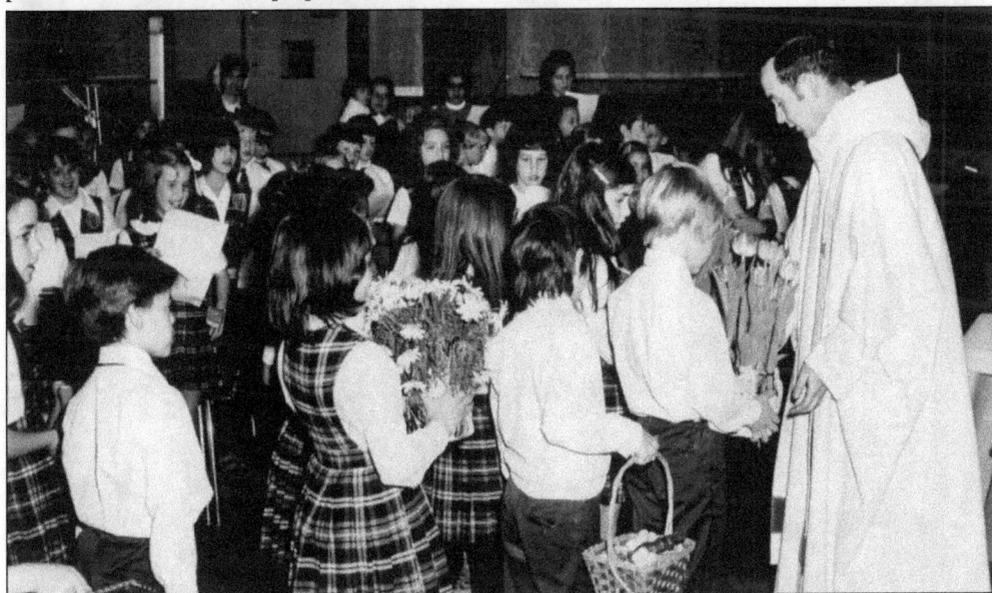

EASTER. This most sacred of commemorations among Christians is celebrated on the first Sunday after the vernal equinox, as established at the Council of Nicea in 325 AD. The word Easter derives from the Anglo-Saxon word for the pagan goddess of the dawn. This Holy Day of Obligation is often marked by brightly colored flowers and eggs painted by children, who often had them blessed by their parish priest, as pictured here in the 1970s.

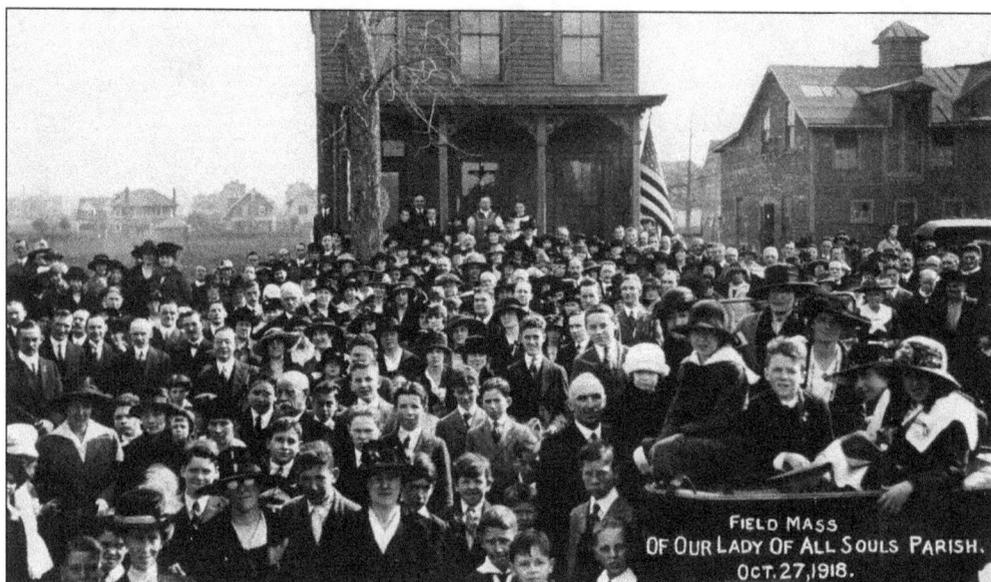

FIELD MASS
OF OUR LADY OF ALL SOULS PARISH.
OCT. 27, 1918.

SOULS AND SAINTS. A feast of solemn prayer for departed individuals is observed on November 2 each year. This image shows parishioners from this aptly named East Orange edifice observing a day of remembrance for all mothers, fathers, sisters, brothers, relatives, neighbors, friends, and others alike. All Saints Day is celebrated 24 hours beforehand, where the non-canonized, blessed, beatified, and venerated alike are so honored. Special attention is further paid to those holy beings with no individual feast date of their own.

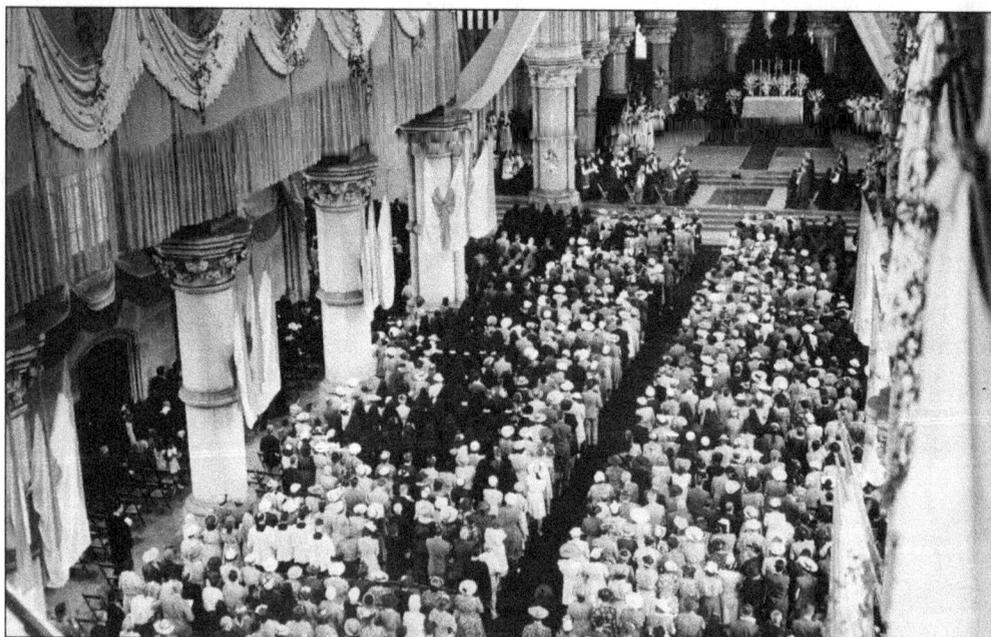

LITURGICAL CALENDAR. In line with aforementioned feast days, there are other Holy Days of Obligation, including all Sundays; Solemnity of Mary, Mother of God (celebrated on New Year's Day); Assumption of the Blessed Virgin Mary; and the Solemnity of the Ascension, among other dates of praise. Attendance at church and celebrations ensue, as demonstrated in this image of worship in action that is echoed inside churches across New Jersey and throughout the world.

Three

HIERARCHY

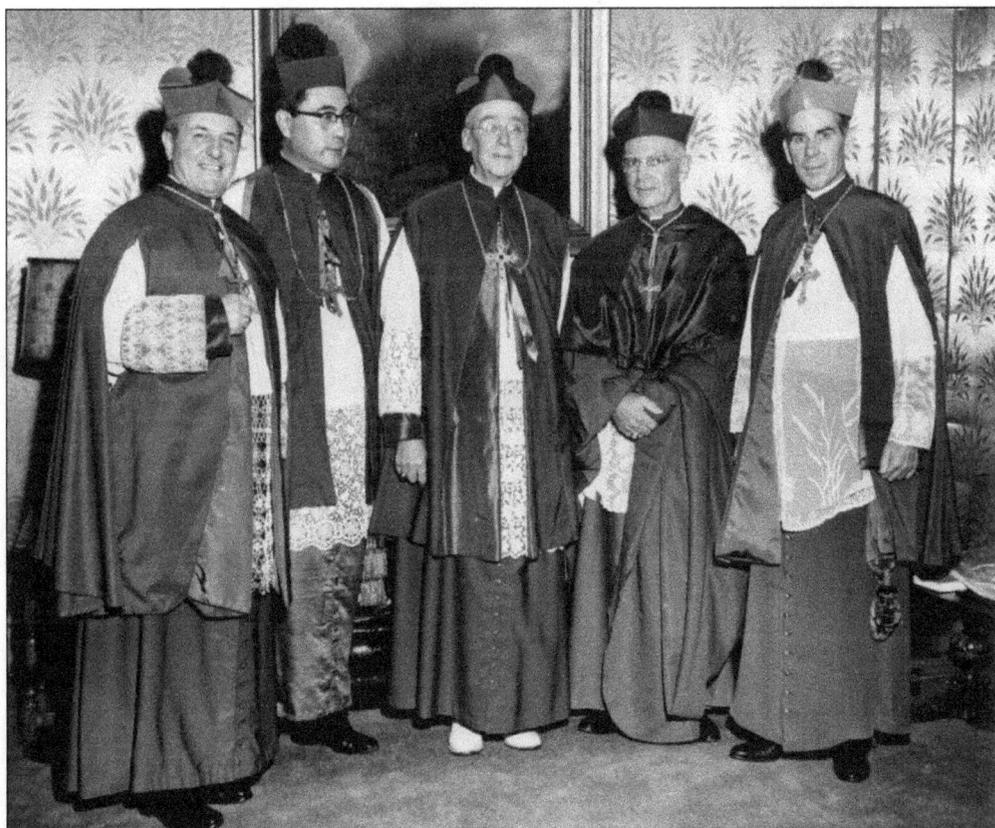

EPISCOPUS. The term "bishop" derives its meaning from the Greek and literally means "one who oversees." All local diocesan leaders, regardless of rank, fall under the guidance of a reigning Pope, a tradition carried on from the time of St. Peter, around 30 AD forward. This 1950s gathering of prelates includes Cardinal Paul Yu Pin, Archbishop Thomas Boland, and Bishops Cuthbert O'Gara, OP, James McNulty, and Fulton Sheen, who each either led, resided, visited, or had some connection to the Archdiocese of Newark during the course of their respective lifetimes.

PAPACY AND NEWARK. As the spiritual and administrative head of the Catholic Church, the Bishop of Rome, or Vicar of Christ, is alternately and often referred to simply as the Pope. Pius IX (served 1846–1878) was the first Pontiff to recognize the need for a diocese separate from New York and Philadelphia within the third-oldest state in the Union. This letter shows the characteristic support between the longest-serving Pope and the second Bishop of Newark, Michael Augustine Corrigan, who endorsed this Vatican-bound wire from the faithful of New Jersey. Pius IX was succeeded by Leo XIII (served 1878–1903), Pius X (served 1903–1914), and Benedict XV (served 1914–1922).

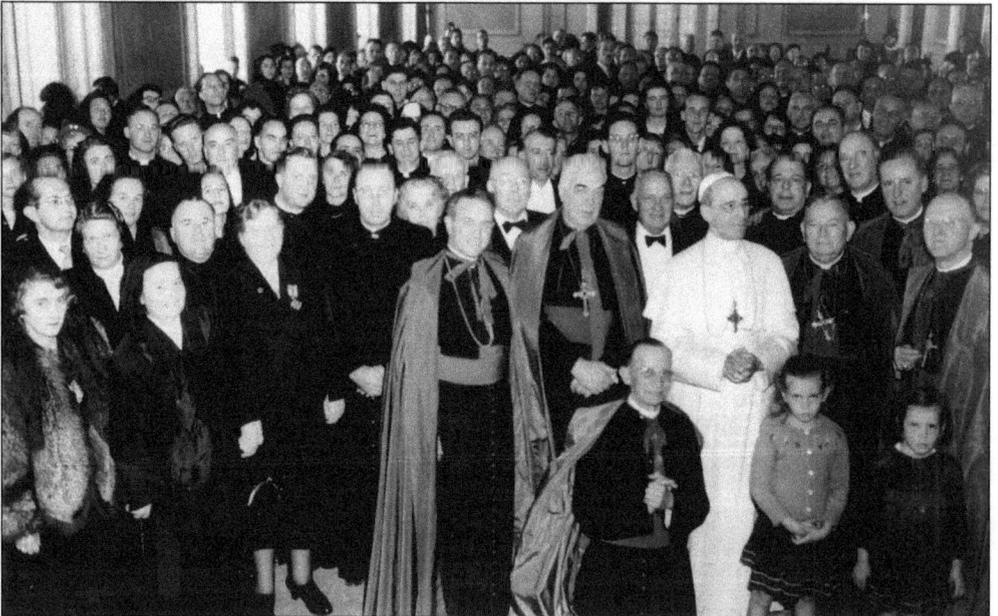

ROMAN HOLIDAY. Visitation via Vatican City to observe and possibly meet the Holy Father has long been a traditional and internationally popular destination for scores of church groups over the years. Here, Bishop McNulty and Jersey City native Monsignor John Dauenhauer are in the company of Pope Pius XII (served 1939–1958). Other Popes who reigned during the first 150 years of archdiocesan history include Pius XI (served 1922–1939), John XXIII (served 1958–1963), Paul VI (served 1963–1978), and John Paul I (served 1978).

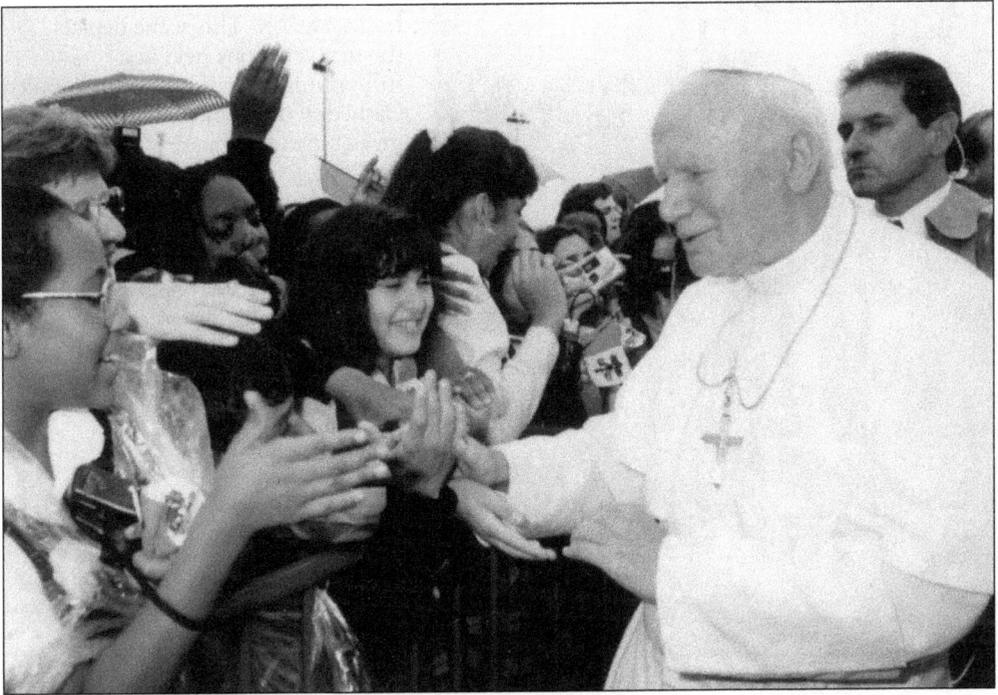

PAPAL PILGRIMAGE. John Paul II became the first and only leader of the Holy See to visit New Jersey to date when he arrived in Newark on October 4, 1995. Here, he shakes hands with a few of the thousands of individuals who gathered at Newark International Airport to mark this historical occasion. Then Archbishop of Newark Theodore McCarrick served as host to such dignitaries as former president Bill Clinton and former first lady Hillary Clinton along with US senators Bill Bradley and Frank Lautenberg, among many other state and local leaders. During this, his 68th trip across the globe, John Paul II celebrated Evening Prayer at the Cathedral of the Sacred Heart, which he proclaimed a basilica upon first sight, and "prayed" Giants Stadium in East Rutherford for an outdoor Mass before over 82,000 attendees the following rain-soaked day. His statement, "There is much need for love and the works of love," became a theme of hope echoed throughout this visit. (Above courtesy of the Archdiocese of Newark.)

PAPAL MASS
Giants Stadium
Thursday, October 5, 1995 – 5:30 P.M.

POPE JOHN PAUL II
PASTORAL VISIT · ARCHDIOCESE OF NEWARK · OCTOBER 4 - 5 1995

Papal Mass
Thursday, October 5, 1995 – 5:30 P.M.
Giants Stadium, New Jersey

PAPAL MASS

INSTALLATION. This scene depicts the first ceremony held in a still-unfinished, pre-basilica designated Cathedral of the Sacred Heart. The investiture of Thomas Walsh as the last "Bishop of Newark" was held here on May 1, 1928. When authority of leading a diocese is bestowed on a member of the hierarchy, it allows an opportunity for that individual to exercise guidance in combination with assurance that the faithful receive the sacraments as part of their spiritual privilege as Catholics.

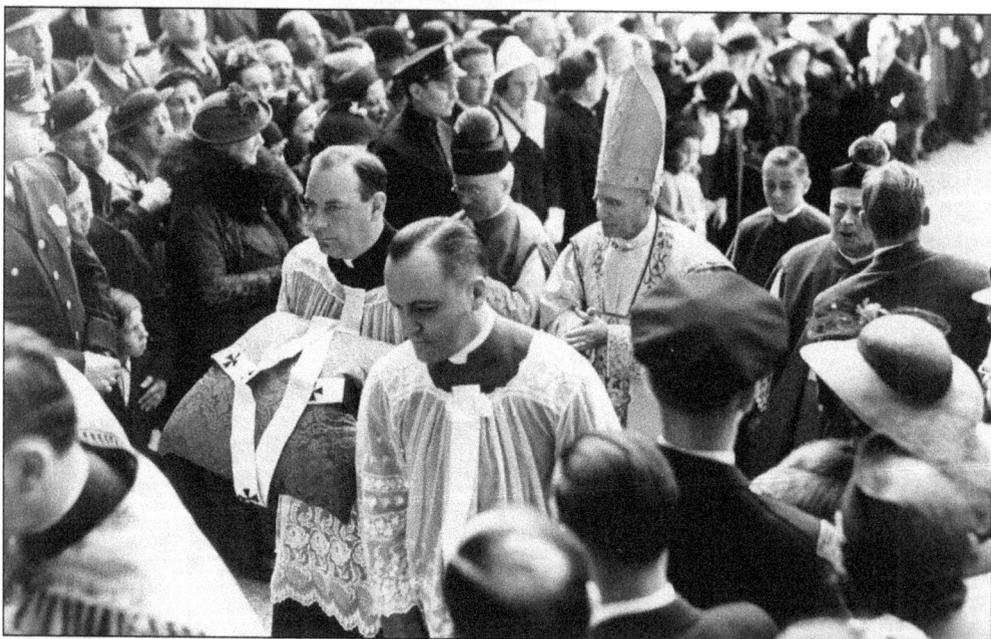

ELEVATION. Upon the elevation of Newark as the Metropolitan See of New Jersey, Archbishop Walsh received the pallium (a round cloth collar featuring two pendants), indicative of his leadership rank within the Church. This milestone occurred on April 27, 1938. Any ceremony of this kind with its spiritual overtones also includes a post-event reception to honor the celebrant. This particular fête was no exception, as an interesting array of musical interludes that included "Ave Maria," Irish Airs medleys, and selections from the movie Snow White and the Seven Dwarfs were played in his honor.

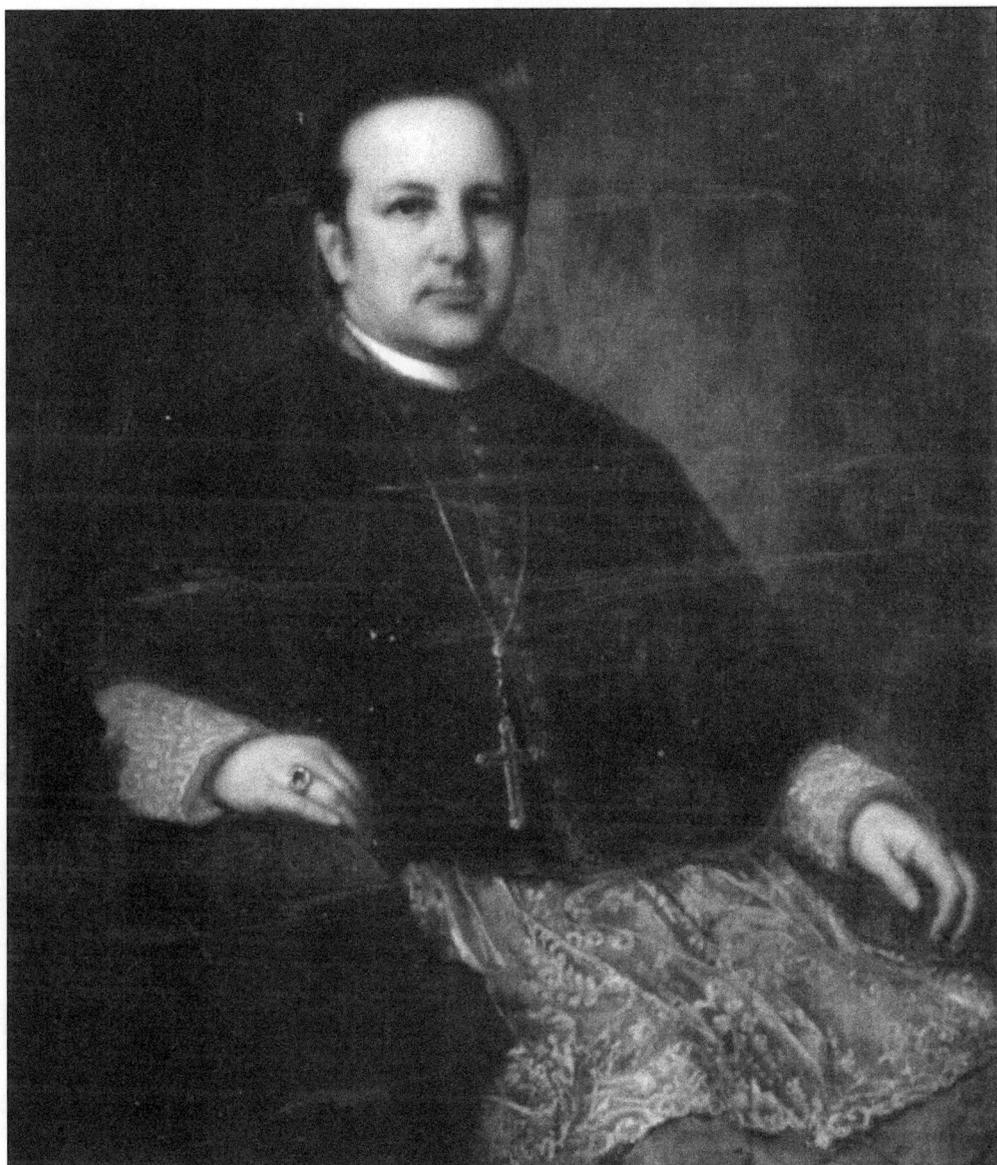

JAMES ROOSEVELT BAYLEY. Appointed the first Bishop of Newark on July 29, 1853, Bishop Bayley was consecrated on October 30 of that year. Bayley (served 1853–1872) began his sacerdotal life as a priest of the Protestant Episcopal Church prior to conversion in Rome during the spring of 1842. His aunt happened to be the first American-born saint, Mother Elizabeth Ann Seton, founder of the Sisters of Charity, whose spiritual daughters ultimately staffed various hospitals, schools, and institutions throughout the See during its earliest days of operation *zet forward* (from the Bayley and Seton Hall motto meaning "yet forward"). Born into a prominent New York family in 1814, Bayley was a true "knickerbocker" prior to his tenure in New Jersey. Upon entering a then largely bucolic Garden State, he faced a new diocese with around 40,000 Catholics over an 8,700-square mile area, with only 25 priests to serve them. Ties to Europe were also evident, as Bayley appealed to the Propagation of the Faith in France and the Leopoldine Association of Vienna for capital aid while simultaneously lending support to the building of the North American College in Rome. Bayley also served as the Archbishop of Baltimore from 1872 until his death five years later.

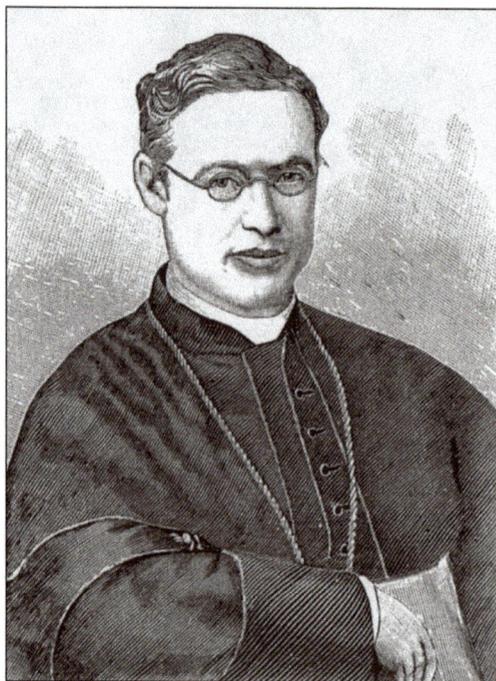

MICHAEL AUGUSTINE CORRIGAN. Born in 1839, Corrigan, the second Bishop of Newark (served 1873–1880), was also the first native son of the city to attain this exalted rank. A graduate of Mount St. Mary's (MD), he later went on to advanced study and trail-blaze as a member of the first class to enroll at the Pontifical North American College, Rome, in 1859. Upon returning to New Jersey after ordination and studies five years later, Corrigan served in various capacities, including vicar-general of Newark, director of the Immaculate Conception Seminary, and president of Seton Hall College prior to being consecrated and installed as head of the See on May 4, 1873. He later became coadjutor to John Cardinal McCloskey, Archbishop of New York, whose death occurred five years later. Archbishop Corrigan then assumed full leadership of the New York Church until his own passing in 1902.

PASTORALS AND CIRCULARS. These pronouncements typically originated through discussions recorded via a diocesan synod, or from the desk of the bishop proper. Documents of this manner traditionally offer instruction on correct spiritual practice, or to transmit informational updates germane to the faithful. This particular 19th-century graphic authored by Bishop Corrigan shows the creation of the Catholic Union, a lay organization that helped to foster bonding among individuals, but also to consolidate ties with their respective parishes and the Catholic Church at large.

BISHOP'S HOUSE, NEWARK, N. J.

February 1st, 1875.

REV DEAR SIR :

The "CATHOLIC UNION OF NEW JERSEY" has now been in existence for about two years and during that time—to say nothing of the beneficial results accruing to the members themselves, from their engaging in works of devotion and charity—the UNION has obtained a reputation and influence, that have already begun to tell on Catholic interests at large in this State. There is no reason why this influence should not go on increasing, and become of still greater service to Religion.

Hitherto, the CATHOLIC UNION has practically been confined to Hudson and Essex Counties, and that, mainly, for the reason that the requirements of the Constitution, calling for a large number of Councilors, made it difficult to introduce the UNION anywhere, save in large towns or cities. To obviate this difficulty, and yet to attain the same end, the rules have been considerably modified and simplified, so as to enable every Parish in the Diocese to take part in this good work; to give all the laity an opportunity of belonging to the organization, and to give the Pastors a direct voice in the controlling Council, by sending their best men as representatives.

Under these circumstances, I trust that your zeal for Religion will induce you to favor the introduction of the "UNION" in your Parish. It need neither displace nor interfere with any other society. It contemplates nothing disloyal, or illegal; but in these times, surely, the lessons of passing events teach us that, if we, the children of the Church, would hold our own ; if we would ultimately do away with certain great grievances that are imposed upon us, as, for instance, in the matter of the education of youth, and would ward off further violation of rights guaranteed to us not merely by the sanction of the natural law, but also by the very Constitution of the government under which we live, we too, like our opponents, must be up and doing and, above all, be *organized*, as they are, in order to stand firm in all things, as loyal citizens and good Catholics.

Referring you for further explanations to the Rules and Circular and hoping that your Parish will soon be represented in the UNION,

I remain, Rev. Dear Sir, with great regard,

Very truly yours,

+ MICHAEL, BISHOP OF NEWARK.

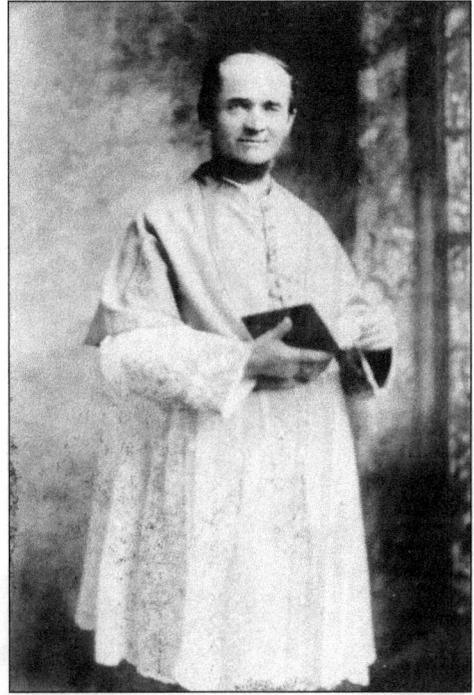

WINAND MICHAEL WIGGER. Bishop Wigger (served 1881–1901) holds the distinction of being both the earliest alumnus of Seton Hall College and the first of German American extraction to rise through the hierarchical ranks in New Jersey. Born in 1841, Wigger distinguished himself as a cleric at various parishes statewide between 1869 and 1881, including his earliest assignment at St. Vincent's, Madison, followed by St. John's of Orange, and as founding pastor of St. Teresa's in Summit. He became the third Bishop of Newark on October 18, 1881, and served in this capacity until his death in 1901. His immortal words, "In the Church of God there is no distinction of race, color or tongue," still resonate for the ages.

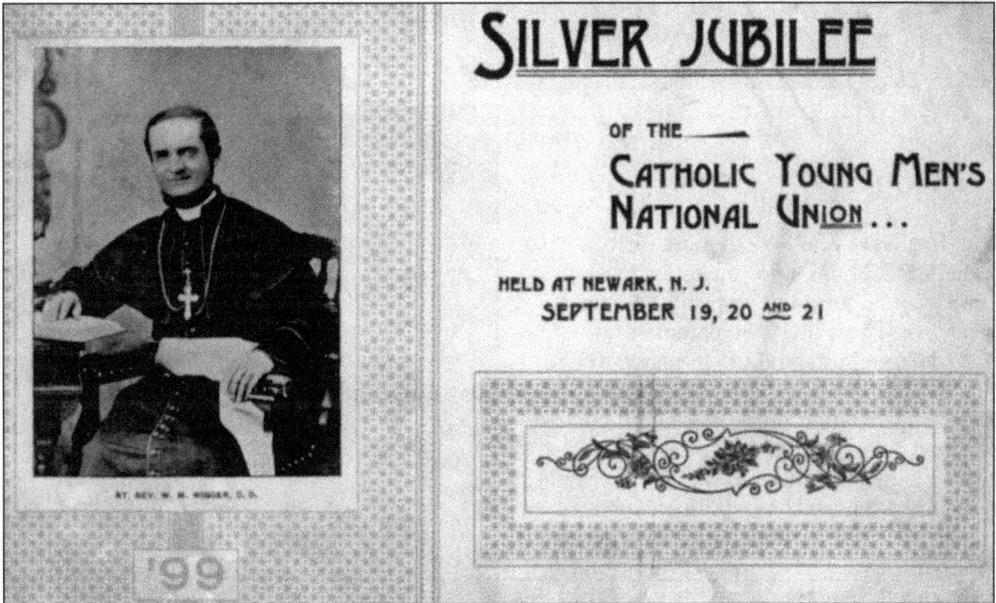

SILVER JUBILEE

OF THE ____

CATHOLIC YOUNG MEN'S NATIONAL UNION . . .

HELD AT NEWARK, N. J.
SEPTEMBER 19, 20 AND 21

RT. REV. W. M. WIGGER, D.D.

'99

COMMEMORATIONS. Like fellow brethren in the hierarchy, Bishop Wigger was very active in commemorating different landmarks and events around his own diocese on a perpetual basis. Within northern New Jersey in particular, anniversary milestones started reaching double digits by the time of his reign. Photographs of presiding leaders, including the Pope, bishop, and pastor, were commonplace on covers or frontispieces of church histories and event programs such as this publication from the late 19th century. Emblematic of this honored place, Bishop Wigger can be seen on the left side of this 1899 booklet. His most unique telling physical feature was a beard that provided necessary relief in response to a chronic throat ailment.

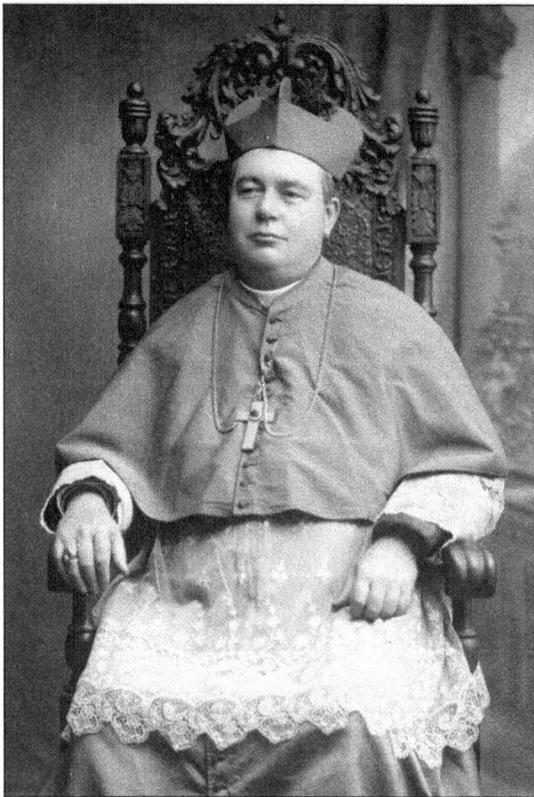

JOHN JOSEPH O'CONNOR. The longest tenure of any spiritual leader in the history of this See was held by Bishop O'Connor (served 1901–1927), who led Newark for over a quarter century. O'Connor began his priestly duties in 1877 after ordination when he became the chaplain for St. Mary's Orphanage, of Newark and a visiting minister at St. Leo's, Irvington, and St. Rose of Lima in Short Hills, among others. When he had his Episcopal ordination on July 25, 1901, O'Connor also attained distinction as the first to be born (1855) within, and later lead the formally established Diocese of Newark. He was the last prelate ever to be installed at St. Patrick's Pro-Cathedral, located in that city.

PRE-PRELATE. The lives of most early American bishops followed a somewhat similar and traditional pattern of divine sequence. These men had parents who emigrated from Ireland or Germany, rose to ambition as first-generation Americans, and later achieved high status in Church circles. Bishop O'Connor, for example, graduated from a four-year college in the United States and later attended the Pontifical North American College Rome and the American College Louvain in line with ordination. Early members of the hierarchy, once they arrived back in the states, often had to occupy multiple offices simultaneously, or in succession as O'Connor had when he pastored St. Joseph's, Newark, rector of the Immaculate Conception Seminary, and vicar-general for the See prior to later recognition as a national church leader during the 20th century.

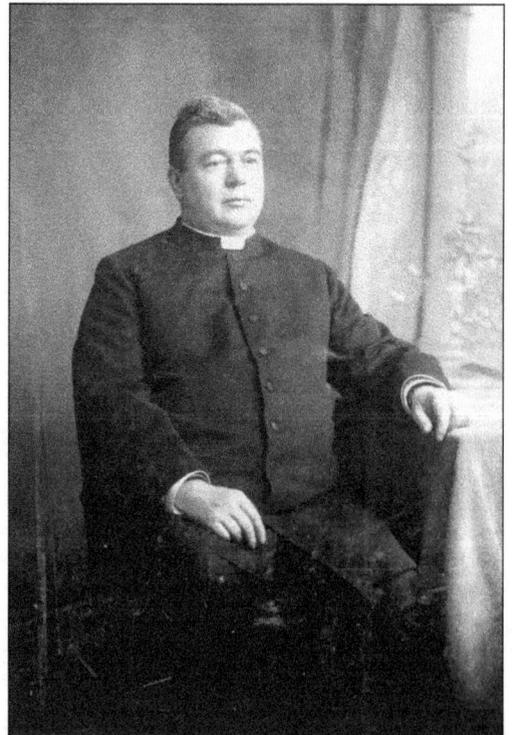

GOSPEL OF THE AIR. Shown here is Archbishop Thomas Walsh (served 1928–1952), who presented a Jubilee Year blessing to those gathered at the Cathedral of the Sacred Heart, Newark. Those who could not attend in person listened via radio station WAAT, which aired a number of other religious-oriented programs over the years. The voice of Walsh could also be tuned in at various times throughout the metropolitan listening area on different stations, including WOR and WNJ, Newark; WSOU-FM, South Orange, and neighboring outlets between the 1920s and 1950s.

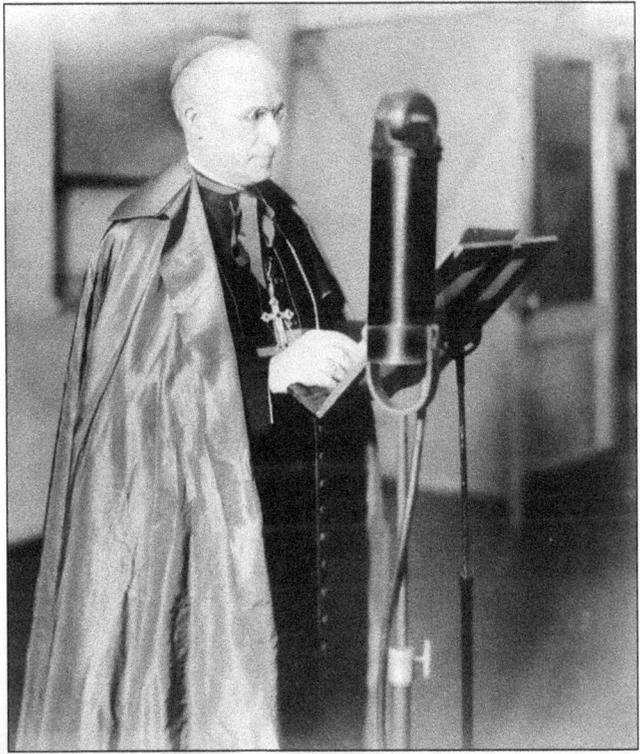

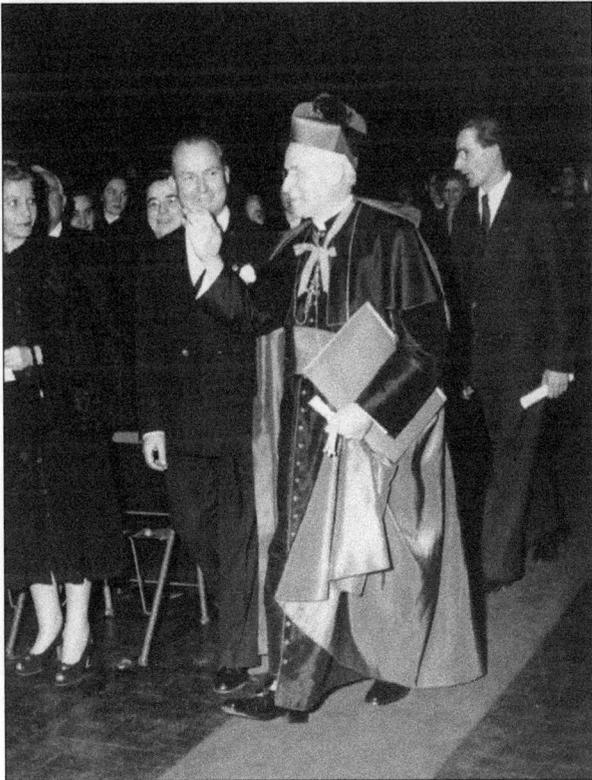

THOMAS JOSEPH WALSH. Prior to becoming the first Archbishop of Newark, Walsh, who was born in 1873 (died in 1952), began his ecclesiastical apprenticeship in Buffalo, New York, and later as Bishop of Trenton from 1918 to 1928. He mainly devoted himself to spiritual societies and education during his tenure in both cities. This adherence to parochial schooling stemmed from his days as a student at St. Bonaventure College in New York, and later at the Pontifical Roman Seminary in Rome, where he obtained both a doctorate of sacred theology and canon law in one academic year, 1907–1908. He is also counted among the most prolific and photographed of Newark prelates, as shown here at a c. 1940s observance.

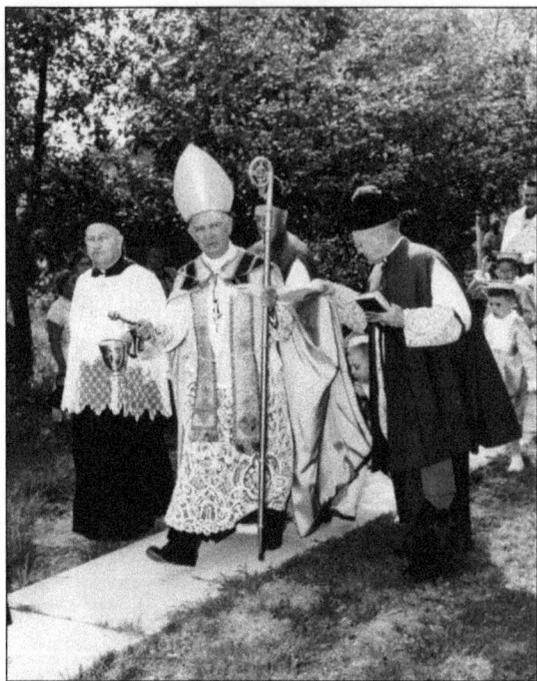

THOMAS ALOYSIUS BOLAND. Archbishop Boland became the first native of Orange and the last ever born in the 19th century (1896), to ascend through the ranks of church leadership within the See of Newark. Boland studied for, but did not earn his doctorate in sacred theology from the University of Propaganda (Pontifical Urbaniana) prior to his return to New Jersey in the early 1920s. His Episcopal ordination was celebrated in 1940, and he subsequently became the second Bishop of Paterson, a post held from 1947 to 1952. Boland was appointed the second Archbishop of Newark on November 15, 1952, and served until 1974 prior to achieving emeritus status before his death five years later. Pictured here in the 1950s, the archbishop dons ceremonial vestments in preparation for a glee-filled grammar school graduation.

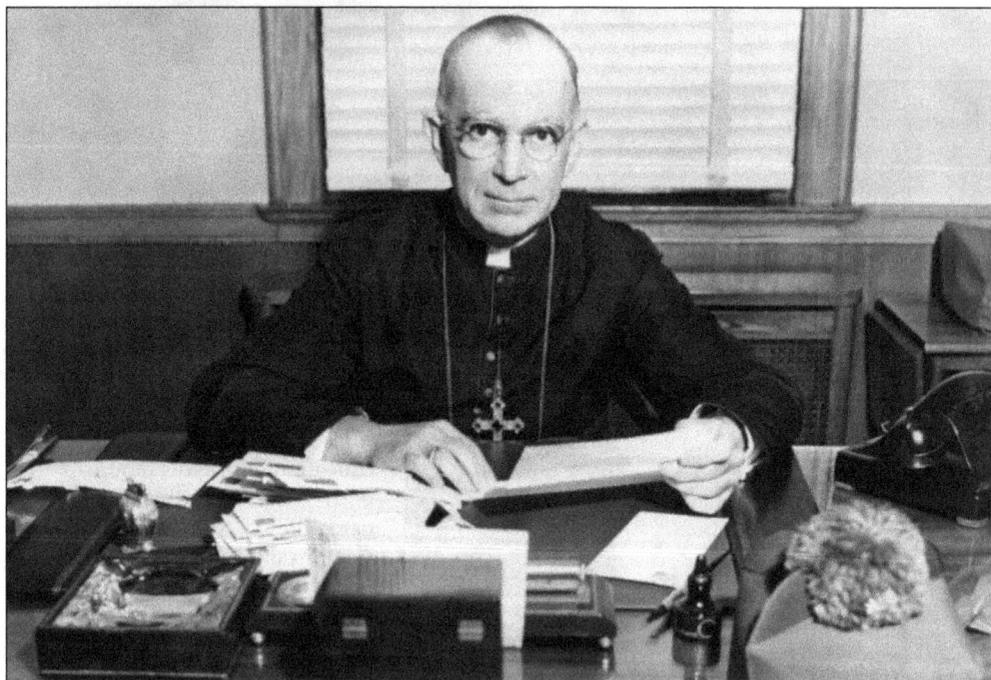

ADMINISTRATOR. The work of any bishop who heads a diocese is one that involves making decisions based on canon law with the welfare of those under his charge in mind. Here, Archbishop Boland, the chief cleric, pauses from his clerical duties of drafting memoranda, answering letters, and other tasks during the mid-1950s. Outside of the office, Boland was the last to live either on the campus of Seton Hall College or in Llewelyn Park, West Orange, the first planned residential community in the United States.

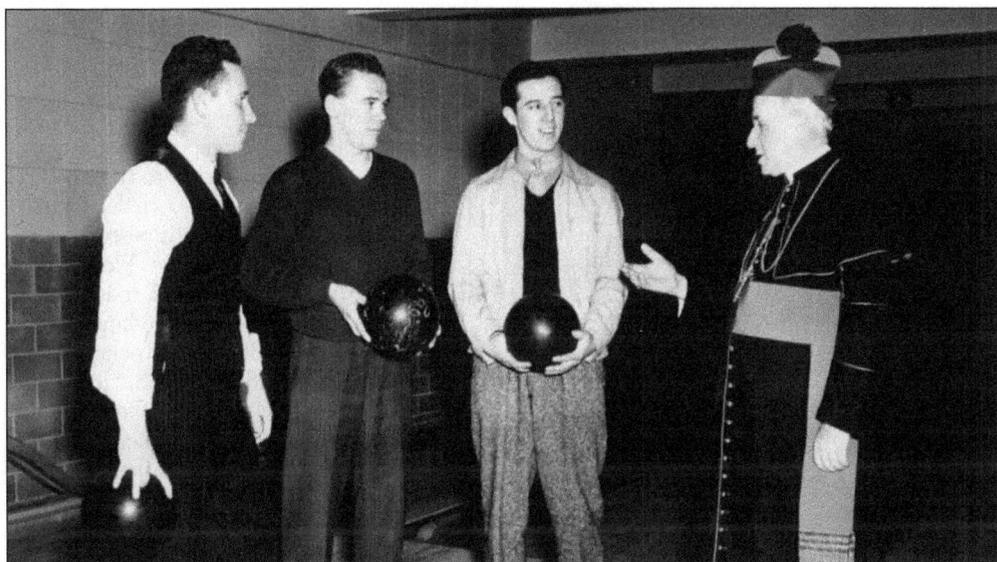

"Spare" Time. Social outings among the faithful and clergy alike included wholesome pastimes, such as tenpin—which Archbishop Walsh points out to a group of "keglers" in this 1941 "frame." This bowling alley located on the campus of then Seton Hall College was found in the gymnasium that still bears his name, Walsh Auditorium. Other popular endeavors that were endorsed in some manner by the hierarchy included basketball games, church socials, and the cinema, but only films approved by the Archdiocesan Legion of Decency.

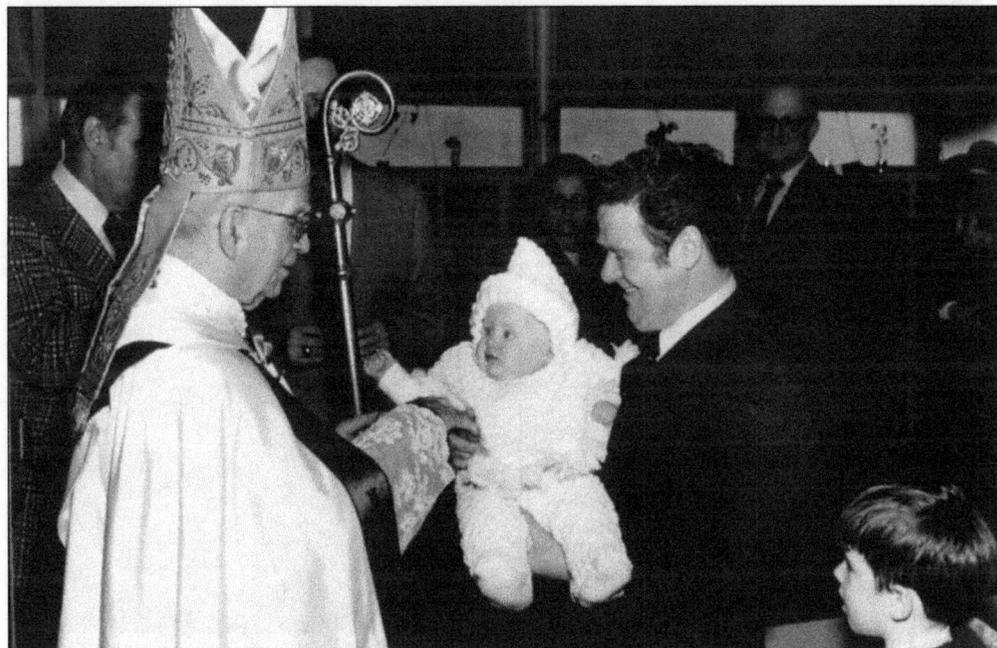

For the Ages. Archbishop Boland, who sports a miter, crozier, and ring signifying his role as shepherd of a flock, happily shakes hands with an equally well-bundled young child who waves their gracious greetings in turn. This is a typical scene within the Archdiocese of Newark, where different generations share pleasantries and dialogue after Mass and during other special functions. Here, a proud father and his older son also offer salutations during this mid-1970s parish visit.

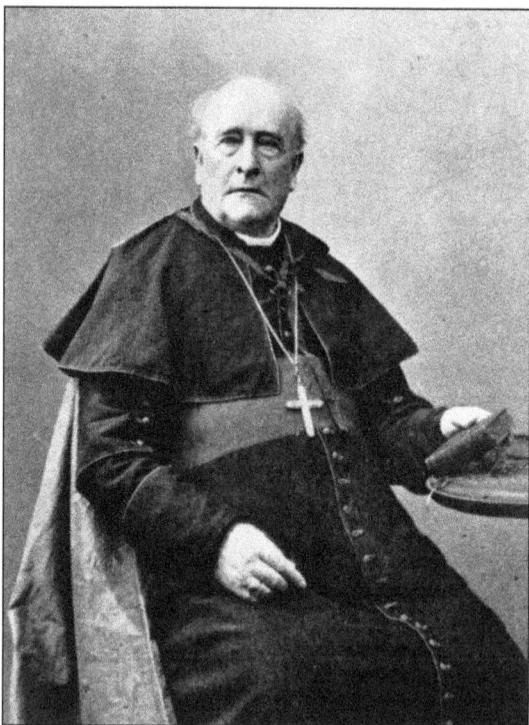

CRADLE OF HIERARCHY. The Archdiocese of Newark has long been a place where priests anointed for leadership posts have either come out of the Immaculate Conception Seminary or possessed a connection to the See in some other manner before departure to other spiritually verdant pastures across the country or planet. Pictured is Bernard Joseph McQuaid, inaugural president of Seton Hall, who later became the first Bishop of Rochester, New York, from 1868 to 1908. He led the way for Francis Monaghan (Ogdensburg, New York), Sebastian Messmer (Milwaukee, Wisconsin), Robert Seton (titular bishop of Heliopolis, Asia Minor), John Reiss, and James McFaul—who both served as Bishops of Trenton. Like Seton, bishops who did not lead a See hold symbolic, or "titular," leadership of a defunct diocese along with present affiliation in their own as an auxiliary.

THOMAS HENRY McLAUGHLIN. Born in 1881, Bishop McLaughlin, who served as the first auxiliary for Newark from 1935 to 1938, led both the seminary and diocesan college prior to his Episcopal consecration, on July 25, 1935. However, McLaughlin later achieved lasting distinction upon being named the first Bishop of Paterson in 1937. His void in Newark was later sealed by subsequent auxiliary bishops, including William Griffin (served 1938–1940), Thomas Boland (served 1940–1947), James McNulty (served 1947–1953), and Justin McCarthy (served 1954–1957).

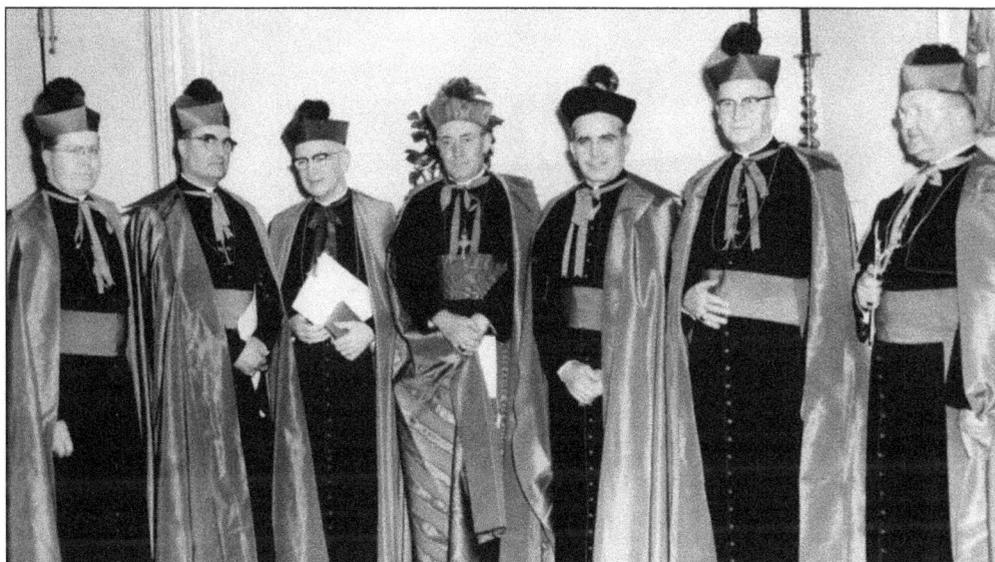

AUXILIARY BISHOPS. Within the Archdiocese of Newark, the auxiliaries who support the metropolitan are broken down into regions and deaneries that encompass Bergen, Hudson, Essex, and Union—mirrors of the four civil counties of northeastern New Jersey. Included among those who joined the ranks of this fraternity were Bishops Walter Curtis (served 1957–1961), John Dougherty (served 1963–1982), and Martin Stanton (served 1957–1972), shown above in a c. 1960s print. Below are some of the most recent auxiliary bishops, including Joseph Francis, SVD (served 1976–1995); John Dougherty; Dominic Marconi (served 1976–2002); David Arias, OAR; Robert Garner (served 1976–1995); and Jerome Pechillo, TOR (served 1976–1991). In addition, others who functioned in this capacity include Bishops Joseph Costello (served 1963–1978); John Smith (served 1988–1991); James McHugh (served 1988–1989); Michael Saltarelli (served 1990–1996); Nicholas DiMarzio (served 1996–1999); Paul Bootkoski (served 1997–2002); Charles McDonnell, Arthur Serratelli; Edgar Da Cunha, SDV; Thomas Donato; John Flesey; and Manuel Cruz.

PETER LEO GERETY. At the time of this writing, Archbishop Gerety (born in 1912) is the oldest living member of the Catholic hierarchy in America at the age of 99. A product of New England, educated in France, and Bishop of Portland, Maine, Archbishop Gerety also worked for the New Jersey State Department of Transportation prior to ordination. He went on to became the third Archbishop of Newark when he was installed on June 28, 1974, and served in this capacity until his retirement in 1986. Archbishop Gerety started the Office of Pastoral Renewal and is a strong adherent of the charismatic movement promulgated during his time in office.

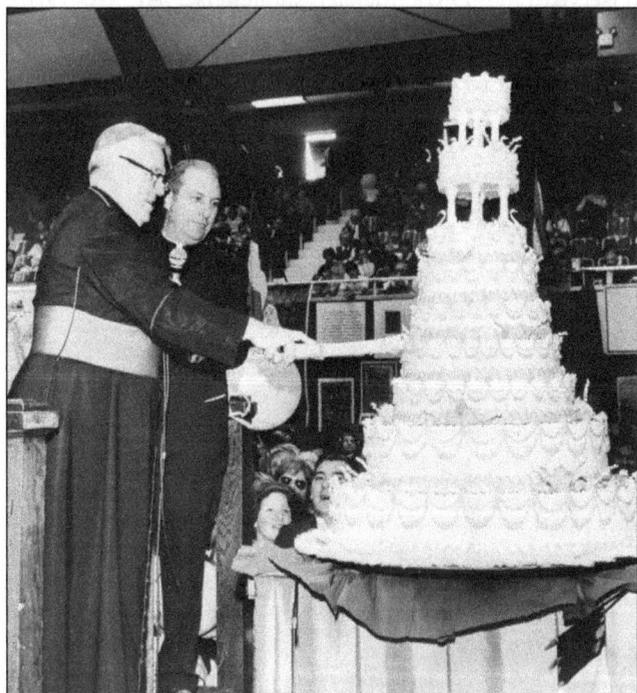

ANNIVERSARY. Aside from Holy Days and Years, part of the appeal found in celebrating the Catholic Church on a local level is evident through special commemorations, including parish and diocesan anniversaries. This ceremonial observance of the Archdiocese of Newark on its 125th anniversary occurred in 1978 with Archbishop Gerety heading these festivities from the chancery to cake cutting duties alike. He later expressed what it means to be a part of this spiritual community: "I am grateful to the Lord for the grace of helping people to understand and bring into their lives the teachings of Our Lord and those of the Second Vatican Council."

THEODORE CARDINAL MCCARRICK. The only former Archbishop of Newark to attain the "red hat" indicative of high level leadership in the Catholic Church. A former president of the Catholic University of Puerto Rico, and auxiliary bishop in New York, Cardinal McCarrick was named the first Bishop of Metuchen in 1981 before achieving elevation as head of the most populace See in New Jersey on July 25, 1986. Cardinal McCarrick continued in his capacity as the Archbishop of Newark over the next 14 years, during which time he most notably maintained a passion for social justice initiatives among other issues related to global peace and harmony.

CELEBRANT. Cardinal McCarrick was named to head the Archdiocese of Washington, DC, in 2000 and served in the nation's capital until 2006, but he retains strong ties with New Jersey to the present day. The fondness that Cardinal McCarrick has for the Archdiocese of Newark in particular remains evident: "With its great Basilica, its beautiful churches and effective agencies of help for the poor and the strangers, the Archdiocese of Newark is a blessing for the State, the Nation and the Universal Church." In this particular photograph, Cardinal McCarrick is shown in processional stride at St. Aedan's, Jersey City, during the 1990s.

JOHN JOSEPH MYERS. The current Archbishop of Newark (since 2001) came to New Jersey by way of Illinois, where he was raised in a family tracing its lineage back to Ireland, England, and France. Archbishop Myers was ordained in 1966 and later served as the Bishop of Peoria from 1990 to 2001 before coming east. His perpetual interest in canon law and educational issues led him to a place on the board of trustees at the Catholic University of America, located in Washington, DC. Closer to home, Archbishop Myers also led the See of Newark during its sesquicentennial year and proclaimed, "Our story provides a mirror of our life from many perspectives: the bishops and priests who have led the Church of Newark through the years; the growth of the diocese from our early days as mission parishes to a Church of at least 1.3 million men, women and children of varied ethnic and cultural backgrounds; the countless contributions of Religious sisters, brothers and priests, as well as lay women and men; the changing attitude toward Catholics from a past marked by prejudice to our present-day."

Four

CLERGY

PRIESTHOOD. Along with religious sisters and brothers, those who are called to the priesthood function most visibly as preachers, teachers, and leaders of their parish on a daily basis. Moreover, the role of any cleric is to join the faithful together into one unified spiritual community. Within the annals of local Church history, the first priest ordained for the See of Newark was Father Patrick Moran, in 1852, who also served as inaugural vicar-general. A vicar-general is the top administrative assistant to the bishop of a diocese or archdiocese, and as such is usually the highest-ranking priest who does not hold episcopal dignitary rank.

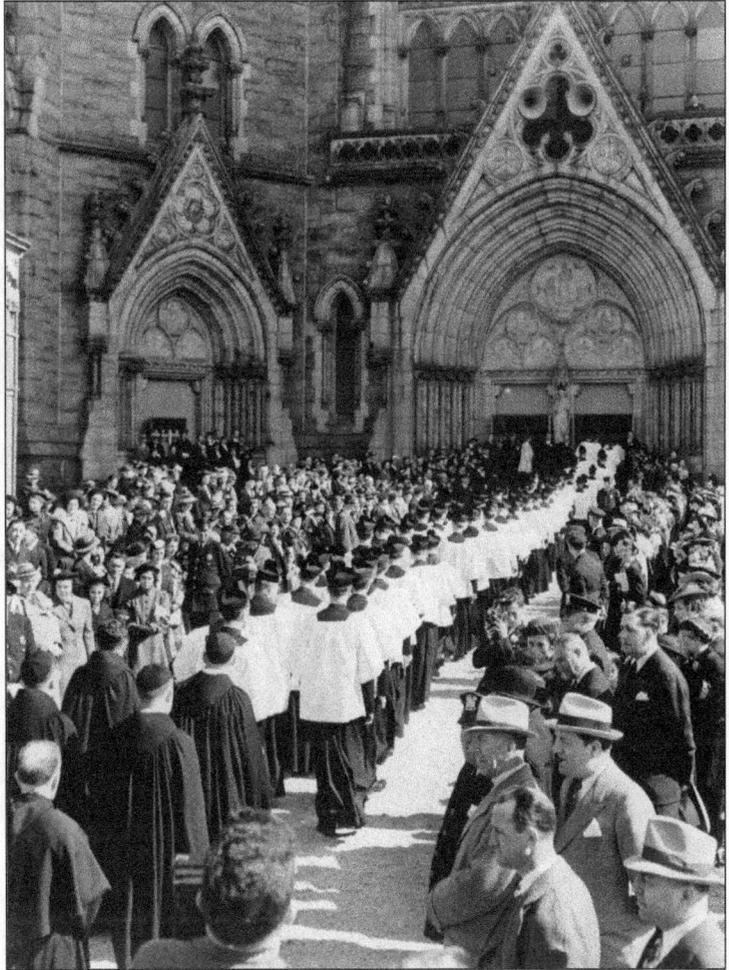

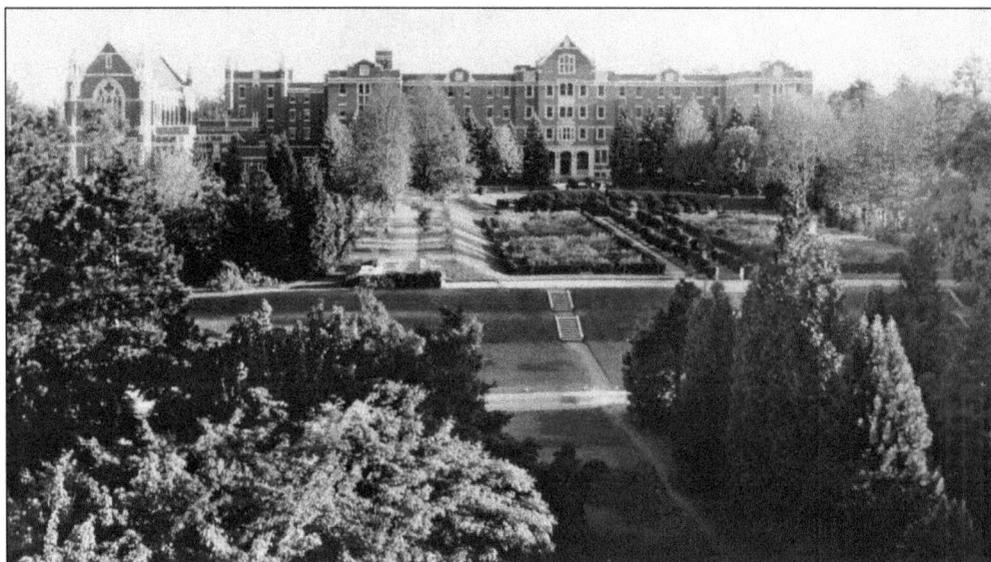

SEMINARY. A seminary is an ecclesiastical college of higher learning for the training of priests to serve the Catholic Church. The first such institution devoted to this purpose in New Jersey was founded in 1860 and named in honor of Our Lady of the Immaculate Conception. This academy was initially situated in South Orange, but operations moved to Mahwah (Darlington) in 1926 before reverting to its original home in 1985. Church historian Monsignor Robert Wister further noted that the seminary has ultimately become "a center of academic and spiritual formation."

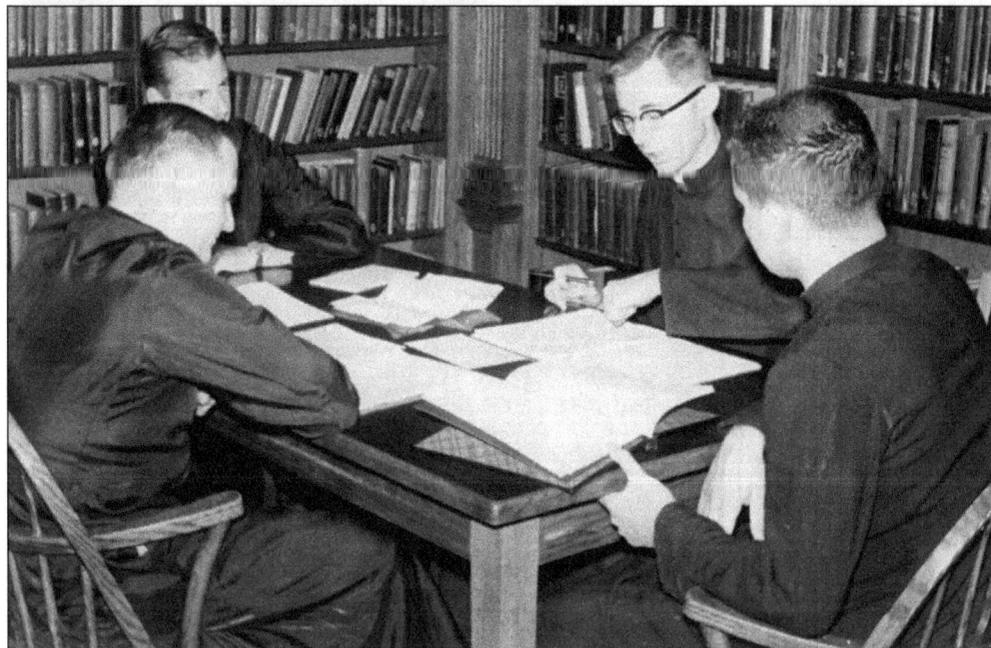

SEMINARIANS AT STUDY. According to the 1930–1931 *Immaculate Conception Seminary Catalogue*, young men of high moral character with an "integrity of life" and solid health with proof of parental marriage, certificates of baptism, and confirmation typically received admittance to the program. For those in attendance, a highly structured life of study, devotion, and sacrifice ensued. Weekdays routinely began with the Daily Order at 5:15 a.m., and lights were extinguished by 9:15 p.m.

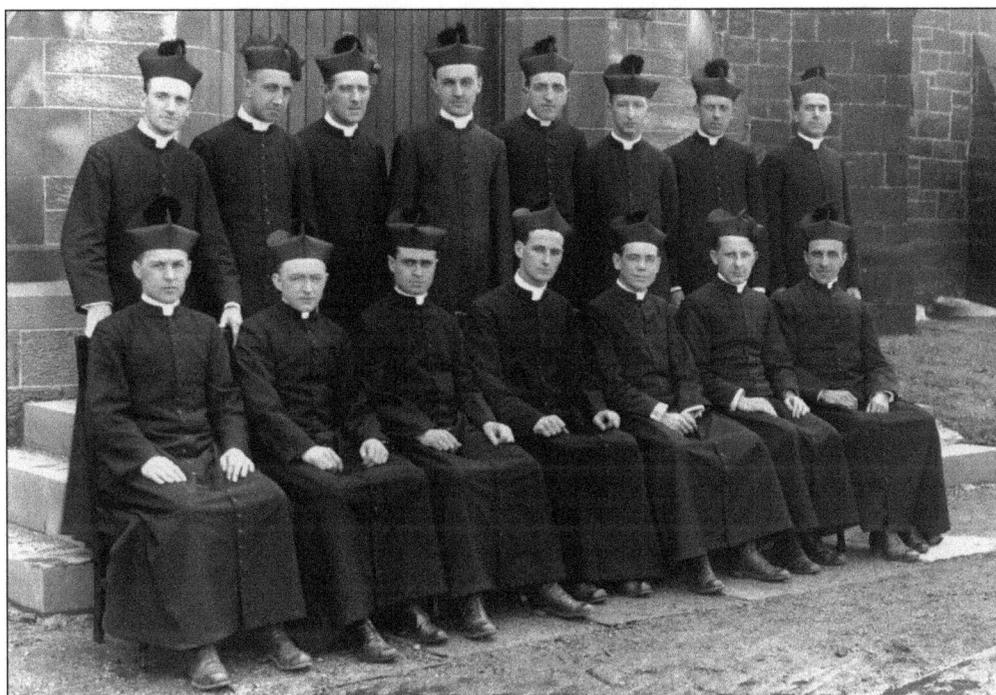

SEMINARIANS AT REPOSE. The telling faces of these young priests in training from Immaculate Conception show a seriousness of purpose in this c. 1920 image. This group is donned in the traditional seminarian dress of that day. A full-length black cassock and biretta (a three-pronged hat) was usually offset with a breviary to recite the daily office. Graduation and ordination summarily took place after a mastery of theological principles and Latin had been achieved.

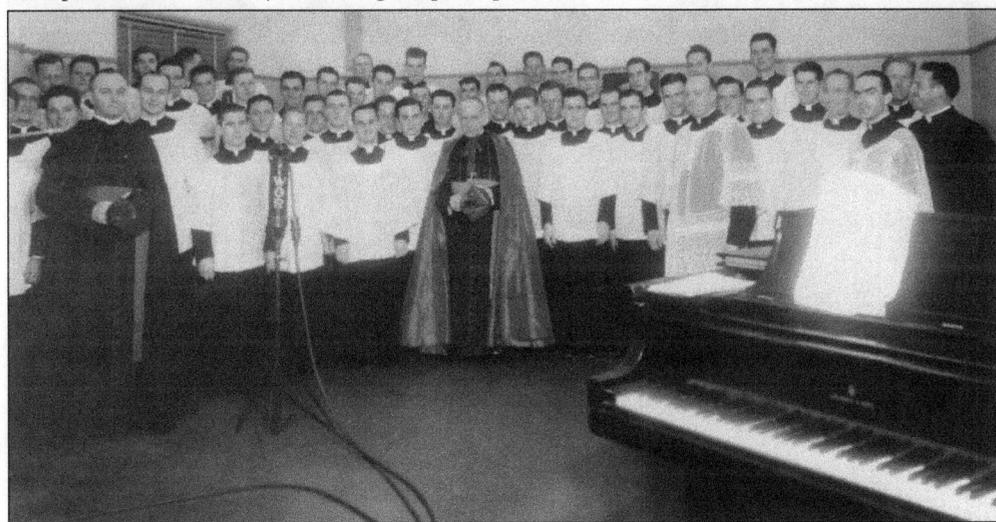

ANNUAL DRIVE. A yearly radio program featured the Immaculate Conception Seminary choir, who promoted awareness and fund-raising potential for their school through song and chant. This particular image from November 8, 1936, features Monsignors John Delaney, Charles Murphy, and Thomas Gilhooly. Additionally, there are two other training grounds for priests within the borders of the Archdiocese of Newark: St. Andrew Hall, South Orange; and Redemptorist Mater, Kearny.

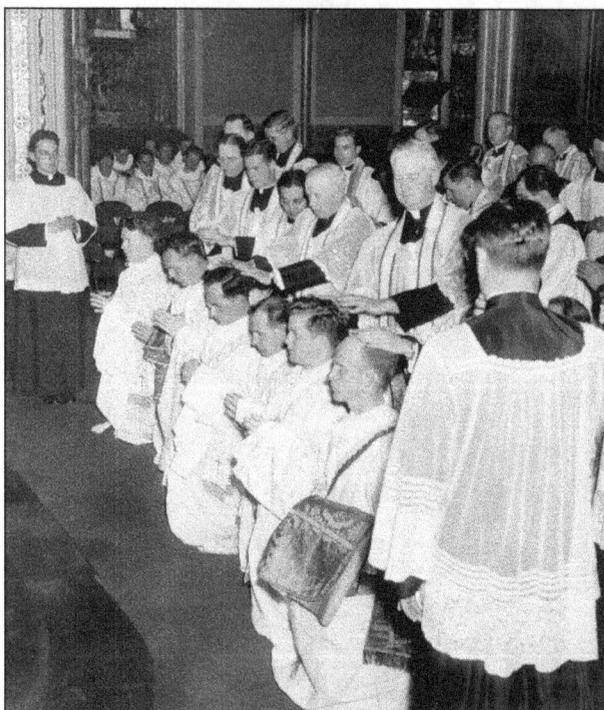

HOLY ORDERS. Ordination unifies the sacramental and vocational calling from God to males who finish their studies and enter the religious life. The alpha measure in the career of a priest comes when they professes Holy Orders, as shown in this 1942 image of the ritual being performed at St. Patrick's Pro-Cathedral, Newark.

CLERICAL RELATIVITY. Within the course of vocational discovery, young men and women joined the religious life in order to express their faith more publicly and profoundly as part of an extended family. Archdiocesan researcher Kate Dodds notes that priests such as Monsignor John Feeley, in this c. 1920s photograph with loved ones, face a wistful future: "When a man enters the clergy, we often think of him only in terms of his pastoral work, rather than in terms of his being a son, a brother."

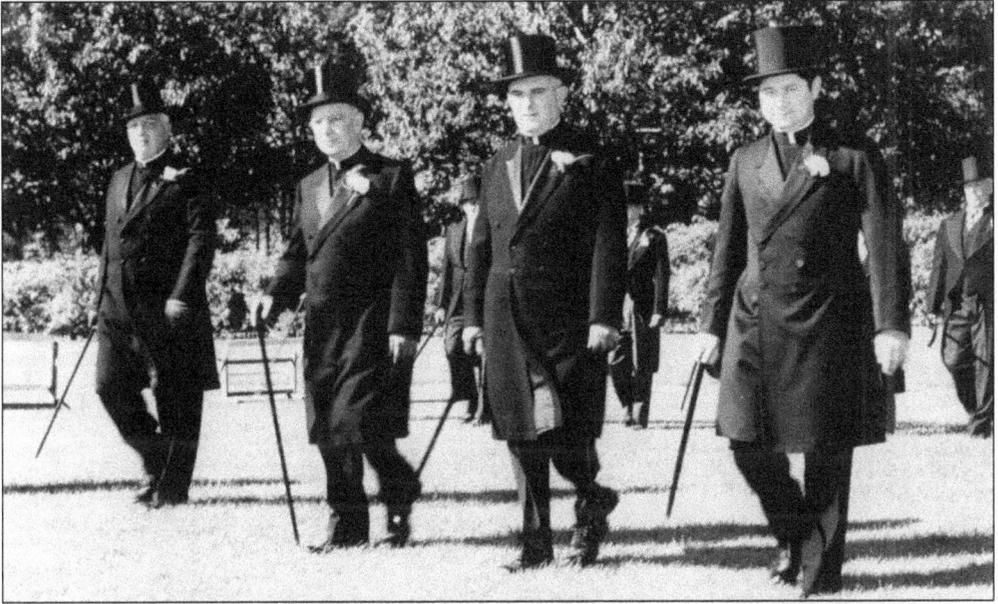

CHAPLAINCY. Catholic-affiliated associations, including clubs, institutions, sports teams, and schools, often call on the services of a priest. Shown above at an October 1955 Holy Name Society gathering in Elizabeth are proud clergy, including, from left to right, Monsignor Thomas Mulvaney, Archbishop Boland, Father Charles Bell, and Father Eugene Kowalski. Additionally, service group and military support has traditionally been counted among the most active and uniformly appreciated of all secular ministries. Fire and police departments along with those who served in the Air Force, Army, Marines, Navy, and other branches of service have counted on the comfort of priests especially during times of stress and conflict. Such memorable individuals as Father "Rush" Rankin, SJ, who served with the American Expeditionary Forces in World War I, is one of the many chaplains who came from New Jersey and served his country.

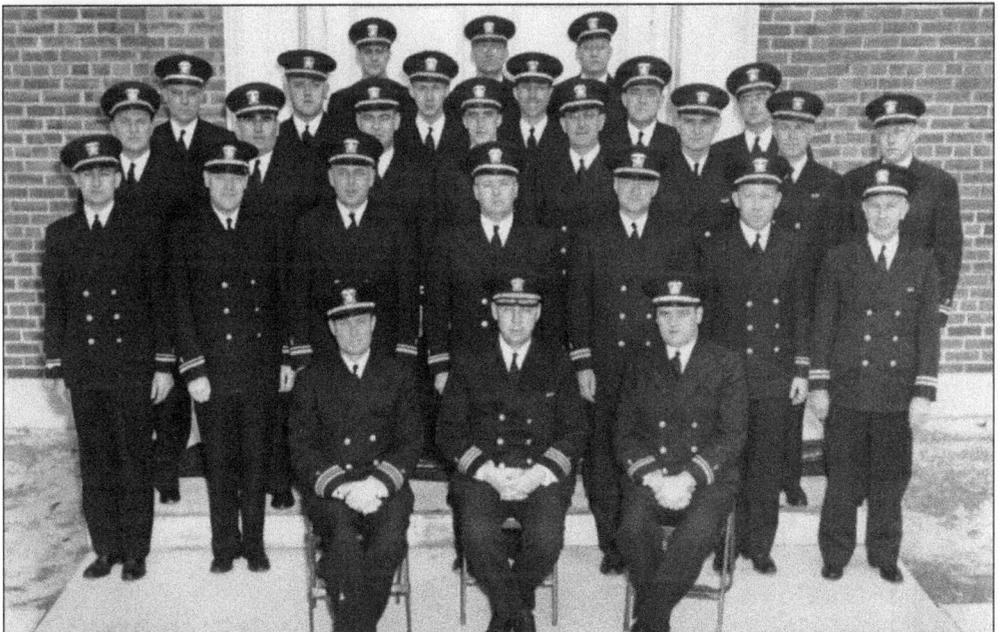

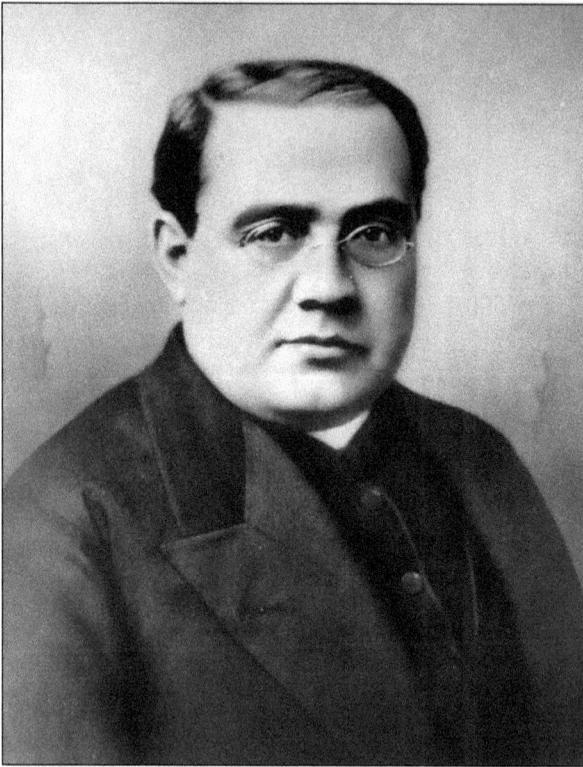

Januarius DeConcilio. Born in 1852, DeConcilio hailed from Naples, Italy, before coming to the United States, where he achieved fame as author of the popular *Baltimore Catechism, Catholicity and Pantheism,* and *Elements of Intellectual Philosophy,* among other standard religious-studies works. He became a professor of theology at Seton Hall in 1861 and rose to the rank of monsignor in 1887 while pastor of St. Michael's, Jersey City. DeConcilio passed away in 1898.

George Herbert Doane. The second vicar-general of Newark, Doane (1830–1905) succeeded Father Patrick Moran in the office of chief assistant to Bishop Corrigan and later served as acting bishop from 1880 to 1881. Monsignor Doane mirrored his mentor in various ways as a visionary administrator and convert from the Protestant Church. He became a Catholic in 1855 and attained ordination two years later. Monsignor Doane also served as pastor of St. Patrick's Pro-Cathedral during his years in Newark.

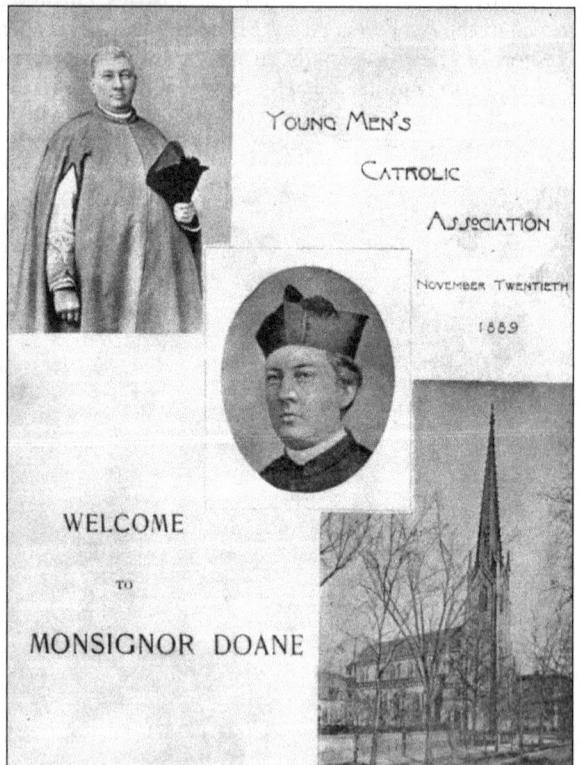

YOUNG MEN'S CATHOLIC ASSOCIATION

NOVEMBER TWENTIETH 1889

WELCOME TO MONSIGNOR DOANE

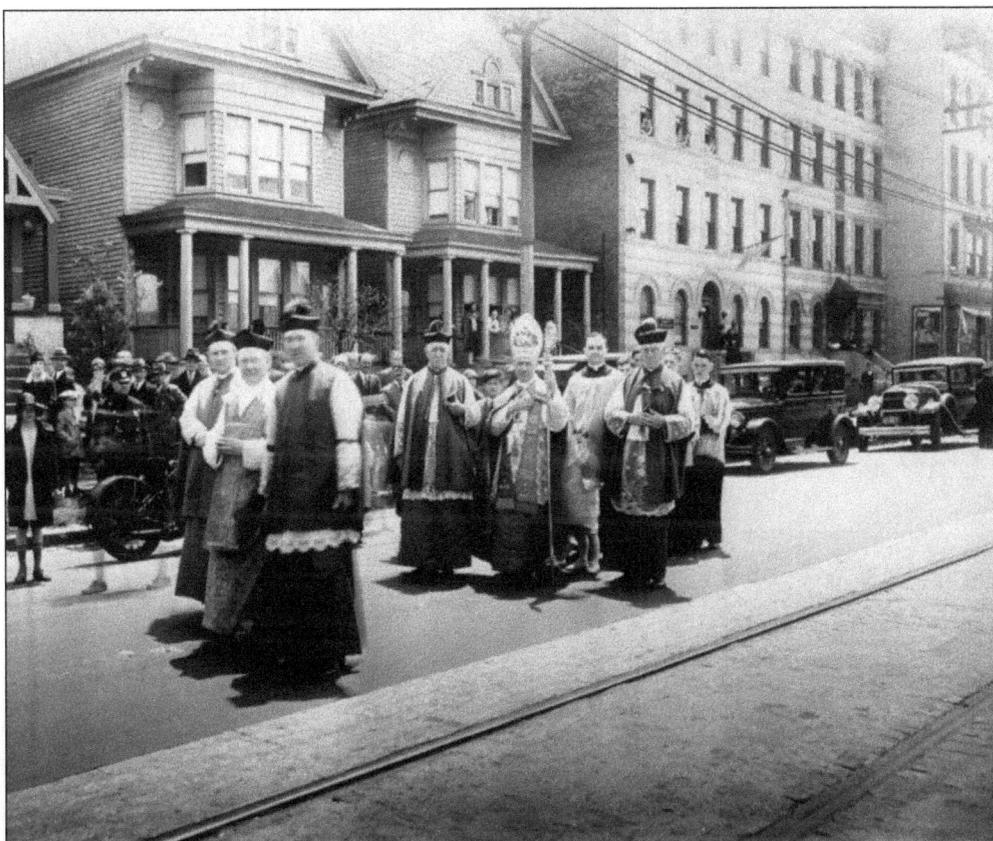

MICHAEL JOSEPH MULLIGAN. Mulligan was the muse in a biographical sketch entitled *The Making of a Priest*, written by famed author Jim Bishop of Jersey City and Tenafly, New Jersey. Monsignor Mulligan was born in 1878 and served at various parishes, including, most notably, St. Henry's of Bayonne, before his death in 1967. The Silver Jubilee celebration of his ordination came in 1929, and Monsignor Mulligan himself can be seen in the center of the first wave of priests walking down the streets of Hudson County toward his beloved parish.

JOHN PATRICK WASHINGTON. Known as one of the legendary "Four Chaplains," Washington (born in 1908) was serving aboard the USS *Dorchester* when the ship was destroyed in combat on February 3, 1943. He gave his life belt to a sailor and lent comfort on deck of the doomed ship that led to his being posthumously awarded the Congressional Medal of Honor. Washington, who last served at St. Stephen's Church in Arlington, remains the only archdiocesan priest to be featured on a United States postal stamp.

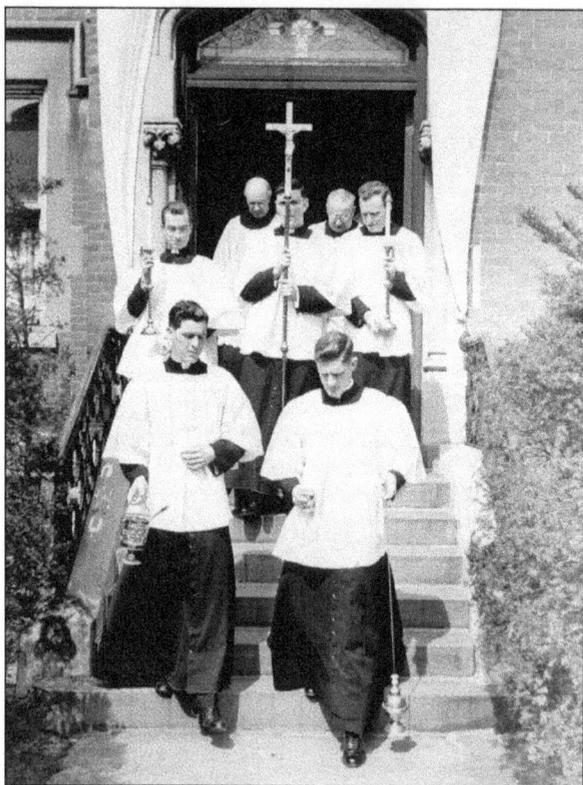

PARISH PRIESTS. Members of the clergy are typically assigned to serve in a parish setting as an associate (also known as a curate) before leading a church of their own one day. In literal terms, these men of the cloth are dressed in traditional clerical wear of their time, including roman collar, cassock, and surplice, with instruments of their trade including holy water, cross, incense boat, and burner with candles during this early 1950s ceremony held within the Archdiocese of Newark.

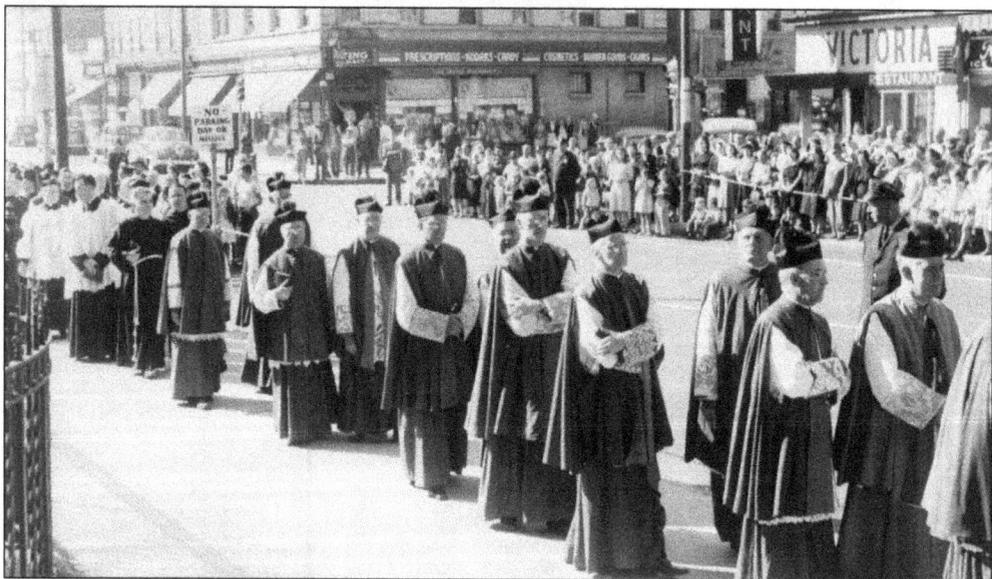

MONSIGNOR. The honorific rank that a priest achieves between that of father and bishop is taken from the French "mon seigneur," meaning "my lord." The title denotes an honorary prelate within the pontifical household, as this designation can be of different levels, including apostolic prothonotary, honorary prelate, or chaplain of His Holiness. Ironically, this particular group of monsignori strides in step to honor Thomas Boland, who achieved the rare distinction of elevation from the rank of father directly to bishop in 1940.

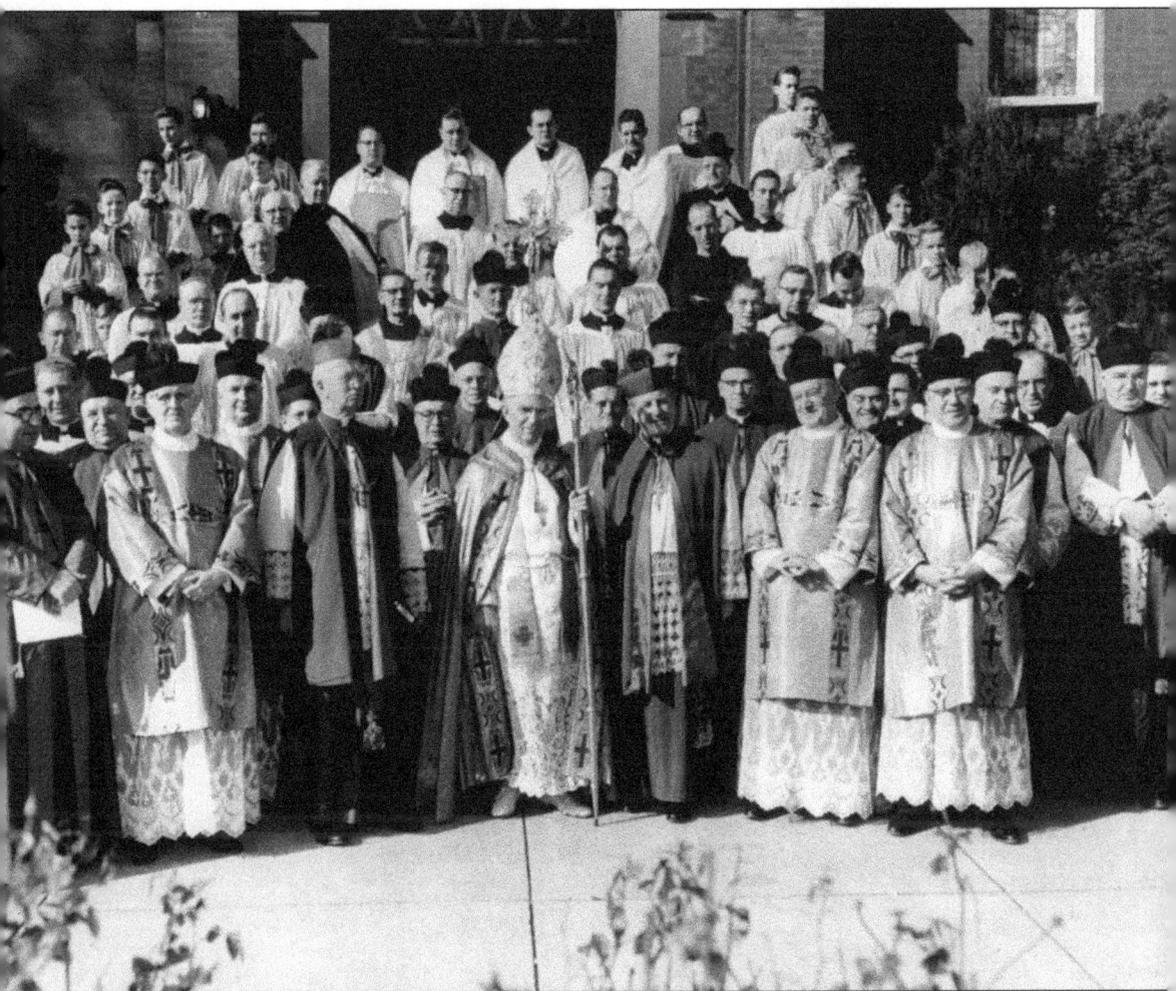

FATHER TIME. When it comes to members of the secular clergy, the duties of these men are varied and inspired. According to the *Catholic Encyclopedia* of 1911, the term "priest" comes from an ancient word, *presbyteros,* or *presbyter,* meaning "elder," which has been modified in address over succeeding generations to define one as "the minister of Divine worship, and especially of the highest act of worship, sacrifice." Their efforts constitute part of a professed duty and shared vocation regardless of place as depicted in this group photograph showing priests from both the Archdiocese of Newark and Diocese of Paterson taken during the 1930s or 1940s.

Brady BB ORANGE, N.J.

PRIESTLY PROFILE. Members of the diocesan clergy who lived in this See through the years have come from various places beginning with European-born clerics who were later joined by peers from Asia, Africa, Central America, South America, and other points abroad. When Bishop Bayley started the Diocese of Newark, he had a desperate need for priests and relied on Irish *sagart Caitliceach* ("Catholic priest" in Irish Gaelic) to fill the ranks, such as Father James Nolan, founder of St. Aloysius, Caldwell, for example.

FORMAL PORTRAIT. Another perspective of the earliest priests within this area is evident through the visage of Reverend (an alternate title and address for "Father" within the Catholic Church) James Reynolds, who served at St. Aloysius, Newark, in 1908 and four years later became the resident priest at Holy Rosary, Elizabeth. The high Roman collar, sometimes called a "collaret" when partially covered, is indicative of his religious station, which is typically worn by all Catholic priests, regardless of rank.

CEREMONIAL INFLUENCE. A strong Italian Catholic presence has been manifest within the Archdiocese of Newark ever since the 19th century. Priests who migrated from their respective regions of origin were particularly instrumental in enhancing their fledgling ministries through the value of linguistic translations while simultaneously *preservare la cultura Italiana*. For example, the first to speak in the vernacular was Father Joseph Borghese, who came to the See during the 1870s. Pictured here is Father G.A. Vassallo from Murialdo, a contemporary of Borghese, who served in Orange, New Brunswick, and Summit, among other nearby stations.

PLEASANT PADRE. Another group of priests that had an early influence on their respective flocks included those of German extraction. These men from the Old Country related in *Deutsch Sprache* with those who emigrated from varied states to their new country and culturally secure local parishes. This was especially apt under the shaping of German-blooded Bishop Wigger during the later part of the 19th century. Pictured is Father Aloysius Stecher, former rector of St. Peter's, Newark, from 1886 to 1916.

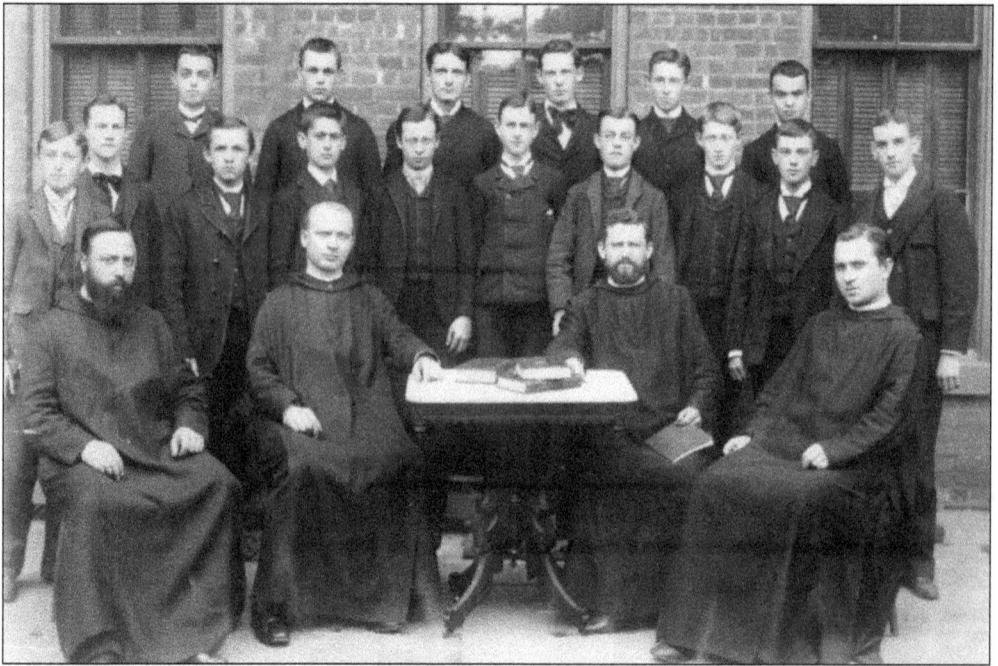

BENEDICTINES. These oblates are the first order of religious fathers invited to reside and administer to congregants within the burgeoning See. These pioneers from the Order of St. Benedict staffed St. Mary's, an early church in Newark before having an expanded divine influence beyond their 19th-century origins alone. Posing in 1886 are monks representing their ancestral and still-active parish. (Courtesy of St. Benedict's Preparatory School.)

PASSIONISTS. Representatives of the Congregation of the Passion of Our Lord Jesus Christ arrived in Hudson County during the 1860s and are among the earliest religious orders to make a difference in the spiritual life of New Jersey and beyond. According to Father Rob Carbonneau, CP, "The missionaries originated in Union City and their mission spread throughout the world." Early members found within this assemblage include Fathers Ventura, Galvin, and Croker, pictured here. (Courtesy of the Passionists of America.)

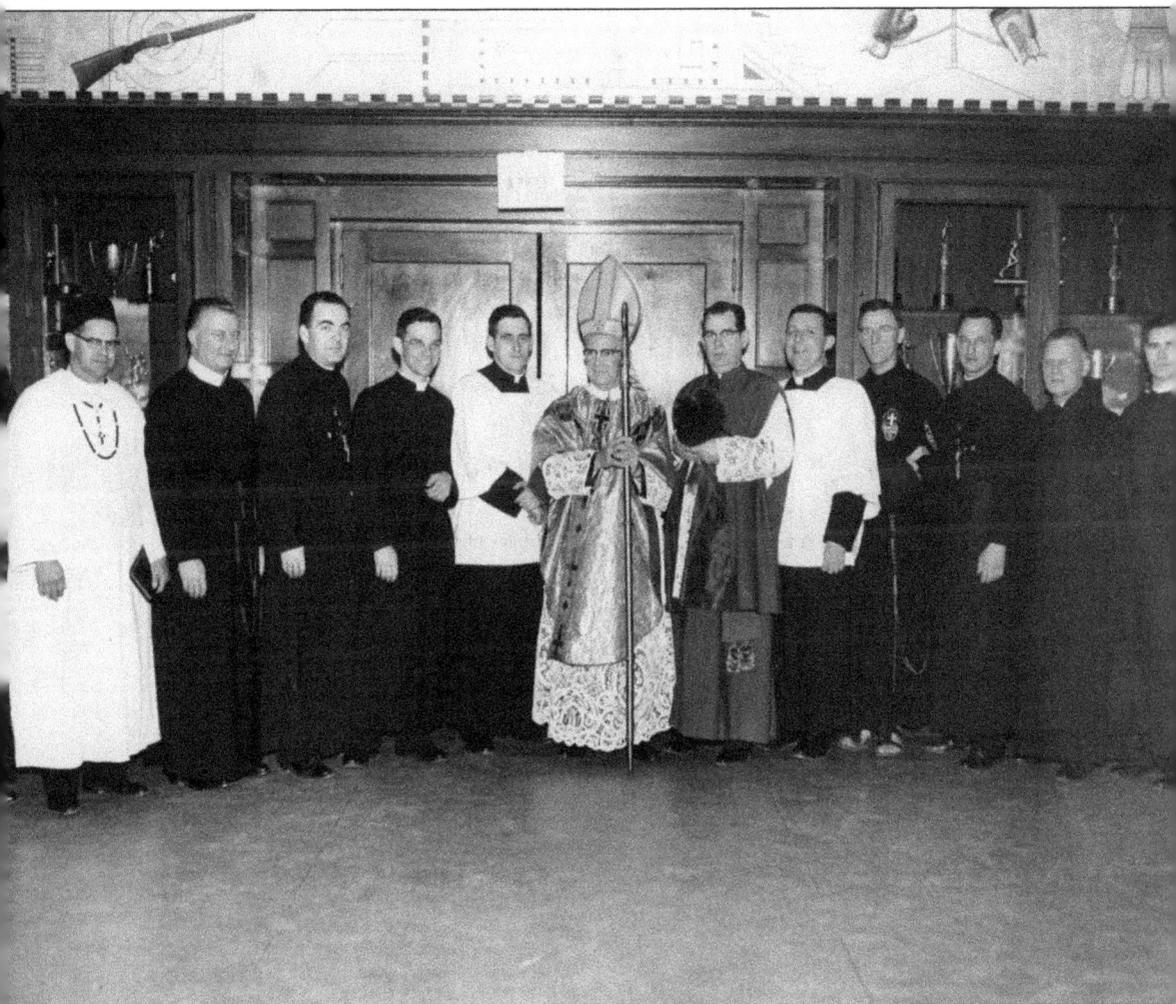

RELIGIOUS ORDERS. Known as "regular clergy," those who report to an abbot or provincial are not considered diocesan priests. Other ordered representation during the 1860s came from the Brothers of Our Lady of Mount Carmel (Carmelites), who were followed by Order of St. Francis (Franciscan) Conventuals and Society of Jesus missionaries. Several hundred members of the regular clergy including the Adorno Fathers, Augustinian Recollects, Capuchins, Pallotine Fathers, Paulists, Redemptorists, Salesians, Salvatorians, and Vocationist Fathers have also been a devout presence over the years.

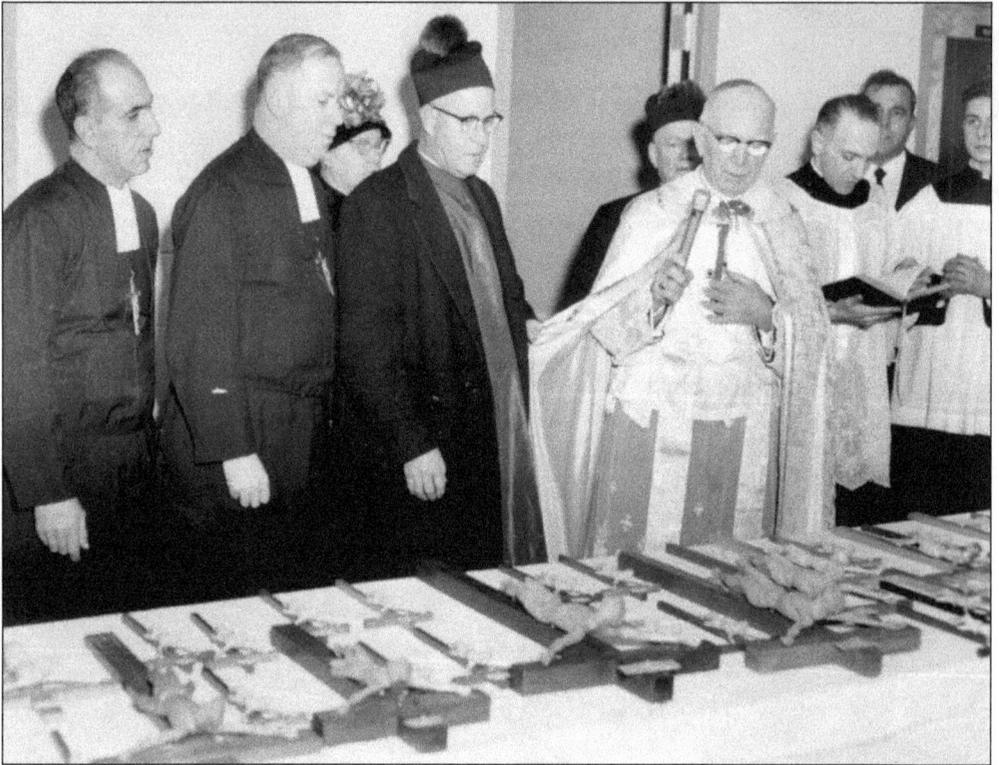

BAND OF BROTHERS. Those who belong to religious orders are primarily engaged in the service-oriented vocations of teaching, nursing and other important works of charity. Among the collectives that have been present within this See include the Communities of Irish Christian Brothers in Oradell, De La Salle Christian Brothers of Jersey City and the Marist Brothers or Bayonne. Shown here are Brother Leo Syvlius, FMS, and fellow clerics watching Archbishop Boland bless a row of crucifixes for devotional use.

MISSIONARY SPIRIT. For most of its early and middle history to date, especially during the 1700s, the United States was considered mission territory in the eyes of the Holy See, and New Jersey by extension fell into this category. At this juncture, the Augustinians, Jesuits, and Sulpicians were active in traveling on horseback to far-flung Catholic homes located across the state prior to the presence of permanent church structures. Presently, outreach to other lands is made by the Tenafly-based Society of African Missions and other orders who actively travel and administer abroad.

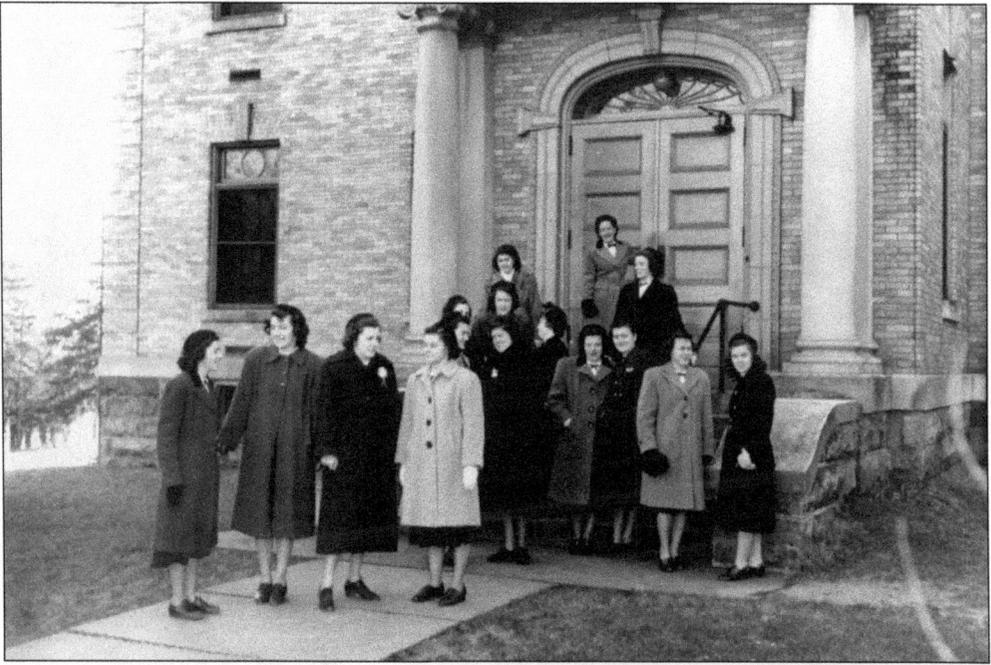

CONVENT. The term convent, also referenced as a "gathering," is commonly known as the place where members of a female-based religious order reside. Women who have a vocation typically join one of these societies in order to further their calling to the Church, at which time they take vows to help the poor, sick, and those in need of educational training as part of their standard modus operandi. Shown here are hopeful Sisters of Charity, who arrive to begin their period of training during the early 1950s. An education for any prospective nun usually lasts a few years and entails training in theology, philosophy, pedagogy, and a chosen subject specialization. Each of these components helps prepare sisters to effectively serve the people in their care, however, they may also choose to follow the solitary and contemplative life as part of a cloistered community.

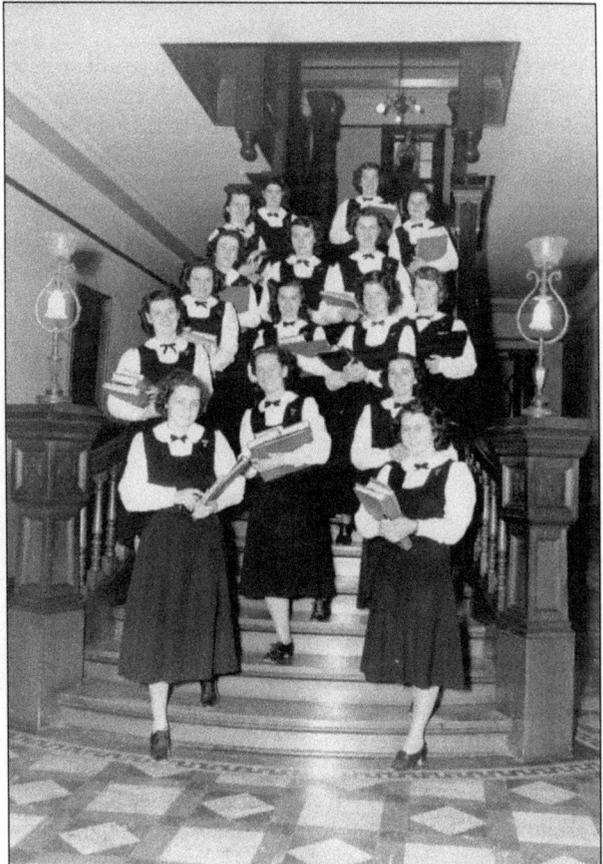

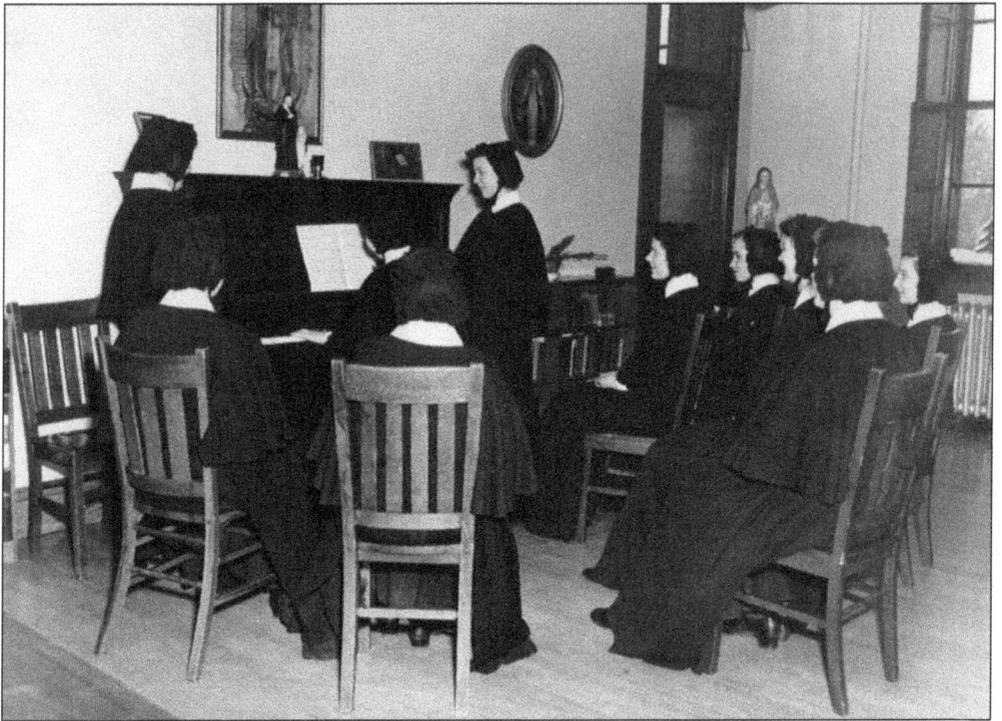

POSTULANTS. These are the steps made before full profession for a prospective religious nun. The term "sister" is more specific, referring to a woman who has made simple vows for the benefit of her order. Contemporary sisters do not wear the traditional clothing that distinguished their choice of service as a rule anymore, but as Sister of Mercy Anita Talar, noted, "The more traditional habits brought back memories of earlier days and many 'remember when' thoughts."

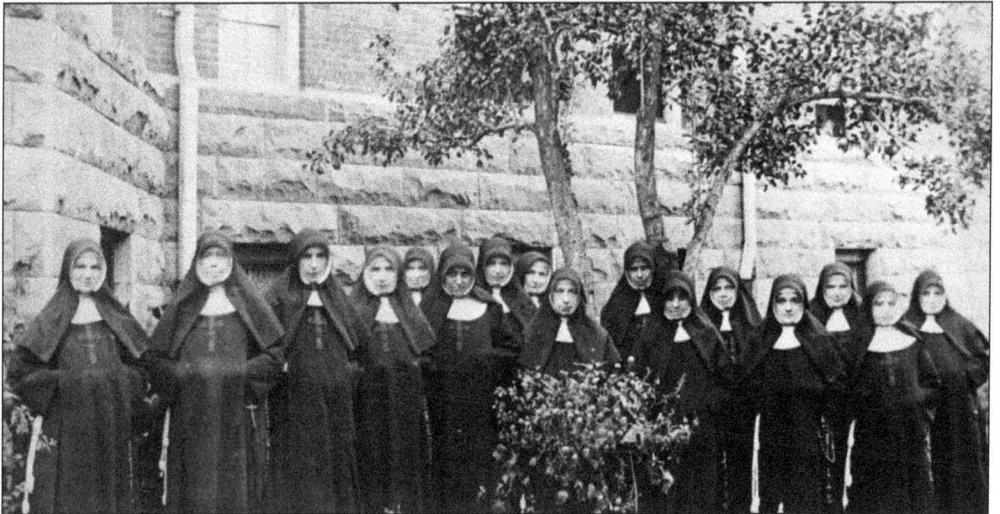

SISTERHOOD. Shown here is the nursing staff at St. Michael's Hospital of Newark in 1888. The first presence of sisterly influence in the region included the Sisters of St. Benedict, who arrived during the mid-to-late 19th century and settled around Elizabeth and other nearby municipalities. Teaching orders were vital, as further classroom assistance came from the Sisters of St. Charity of St. Elizabeth Ann Seton by 1859 followed by other orders in turn.

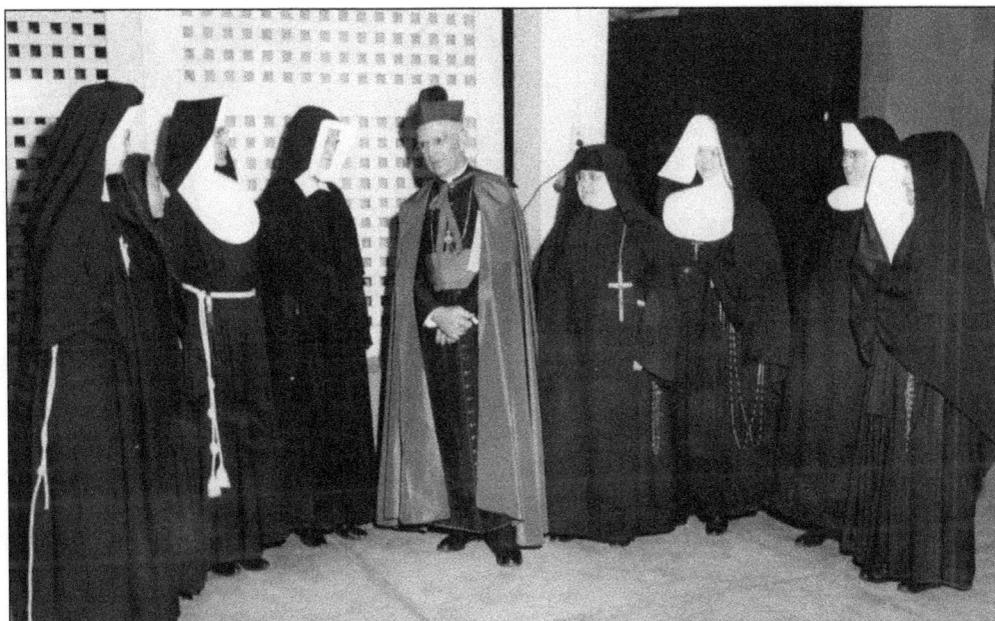

PURPOSEFUL COMMUNITIES. Representation from the Sisters of the Poor of St. Francis, School Sisters of Notre Dame, Missionary Sisters of the Third Order of St. Francis, Sisters of St. Joseph of Chestnut Hill, the Sisters of St. Dominic, and other entities have been active throughout northern New Jersey since the mid-19th century. Their respective and collective attention to service has led to an esteemed place in the annals of Archdiocese of Newark lore.

HOLY WOMEN. Some friendly nuns from the Sisters of Charity constituted part of the faculty representing the Immaculate Conception School in Elizabeth. This gathering includes the principal, Sister Rose Eileen, Sister Marita Joseph, Sister Rose Carmel, and Sister M. Inez, shown above. This early-1950s image denotes a time when the presence of nuns was at a zenith, with an average of nearly 3,000 sisters in active ministry archdiocese-wide by the mid-20th century.

SISTERLY CARE. Nuns have served as a vital force in pastoral, educational, and spiritual care circles for several decades. Those who profess solemn vows, or "moniales" of poverty, chastity, and obedience are exemplars of this life choice. Religious communities often share duties and goodwill either individually or together, as members of a group from St. Joseph's, Maplewood, demonstrate in this 1964 image.

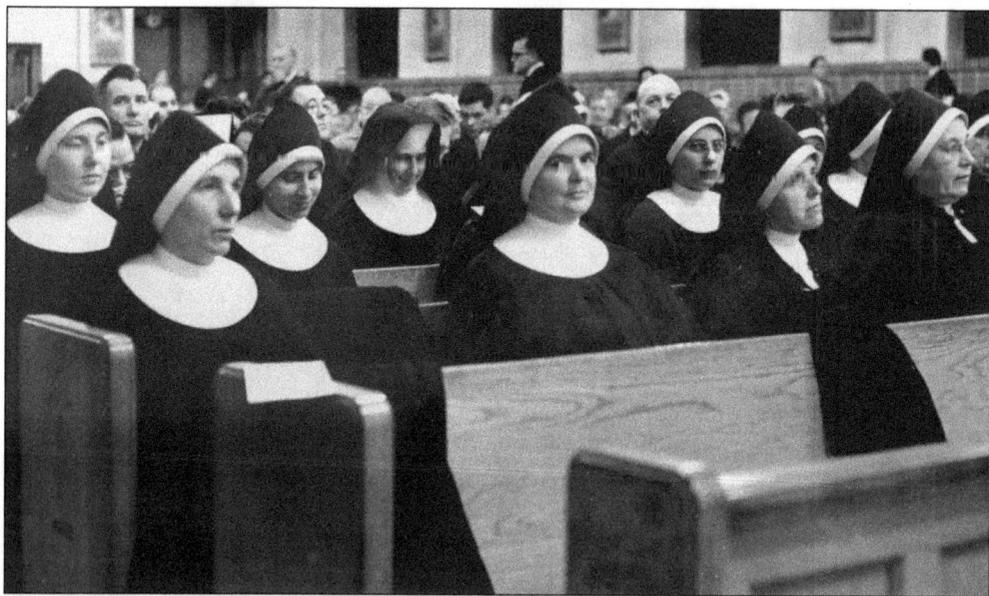

MOTHERS OF NECESSITY. The value of these unsung nuns as teachers, nurses, and nurturers is well appreciated in most quarters. Over 63 different religious orders have been part of the Archdiocese of Newark, from the Adorers of the Blood of Christ to members of the Vocationist Sisters. Other groups represented along with the aforementioned include the Dominicans, Felicians, Franciscans, Missionary Sisters, religious teachers Filippini, Salesians, Sisters of Mercy, Trinitarians, and Vocationist Sisters, to name but a few.

Five

LAITY

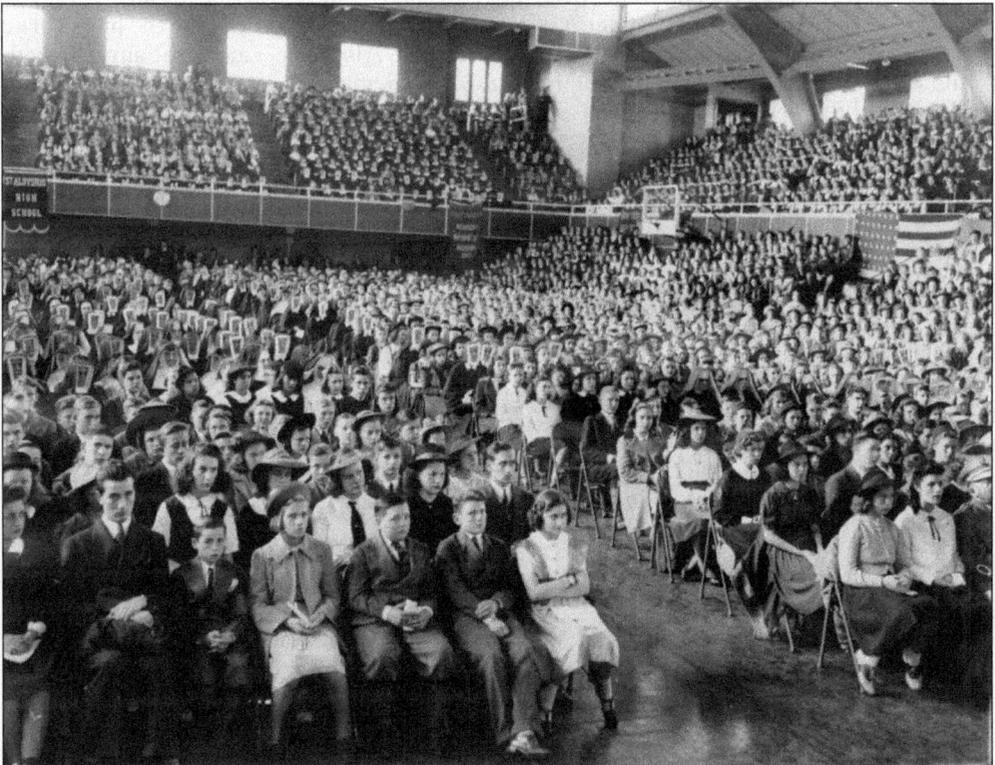

SODALITIES AND SOLIDARITY. Individuals who connect themselves to the Archdiocese of Newark are often distinguishable in public ways when attending Mass or joining various faith-based organizations. As archdiocesan historian Father Chris Ciccarino wrote in regard to these wonderful individuals. "One is humbled—and spurred to action—by the privilege of exploring the witness, fidelity, and trust in the Lord of so many ordinary Catholics over the decades."

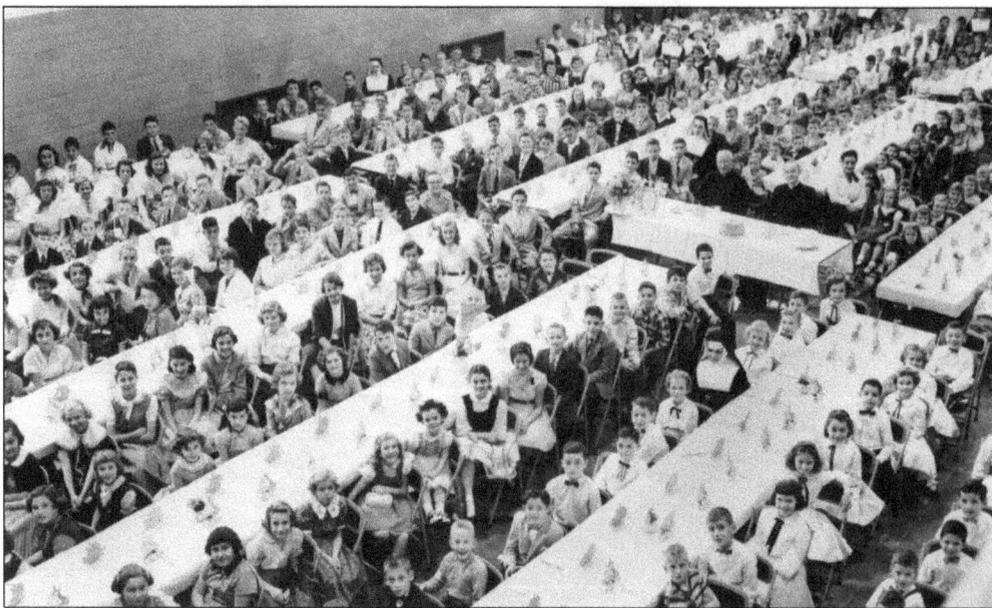

YOUTH PARTY. A group of children and friends attend a church function during the mid-1950s. The Archdiocese of Newark features a number of specialized day nurseries, including the Immaculate Heart of Mary and Perpetual Help Day Nursery of Newark. Also in operation are Saint Elizabeth Child Care of Jersey City, Holy Family in Nutley, Our Lady of Perpetual Help in Oakland, St. Joseph's of Ramsey, and Our Lady of Sorrows in South Orange.

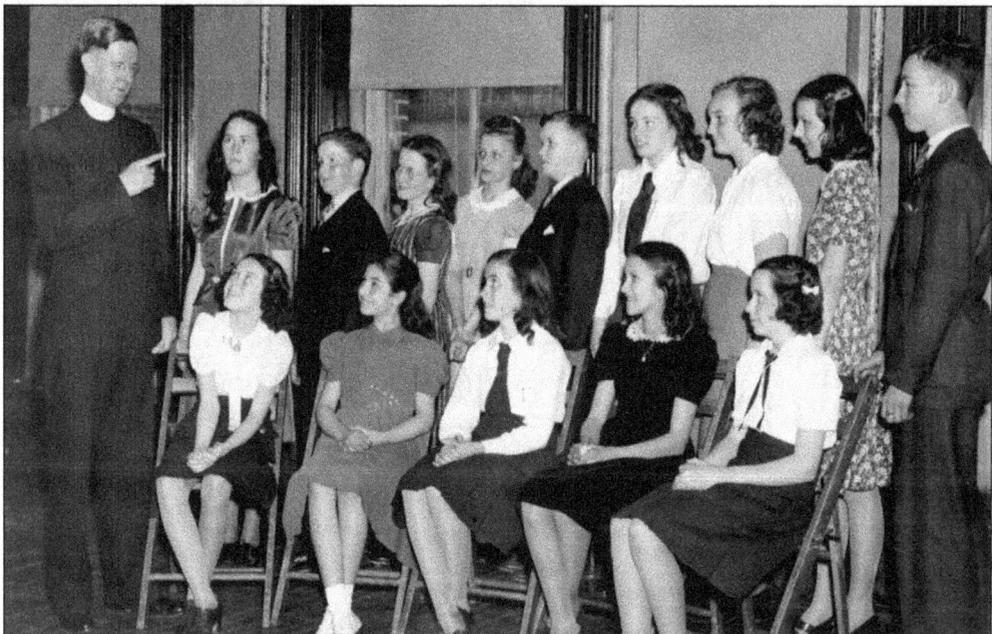

GUIDING PRINCIPALS. A young host of students is offered advice by a parish priest during the 1940s. Oftentimes, a group of this type has a moderator who is trained in the basics of religious principles and activity scheduling. Longtime congregant Eileen Poiani noted, "My Catholic journey at Holy Family Parish in Nutley continued with . . . a published newspaper called *The Leader* . . . an array of crafts and games, lake trips; weekly dances; and so much more."

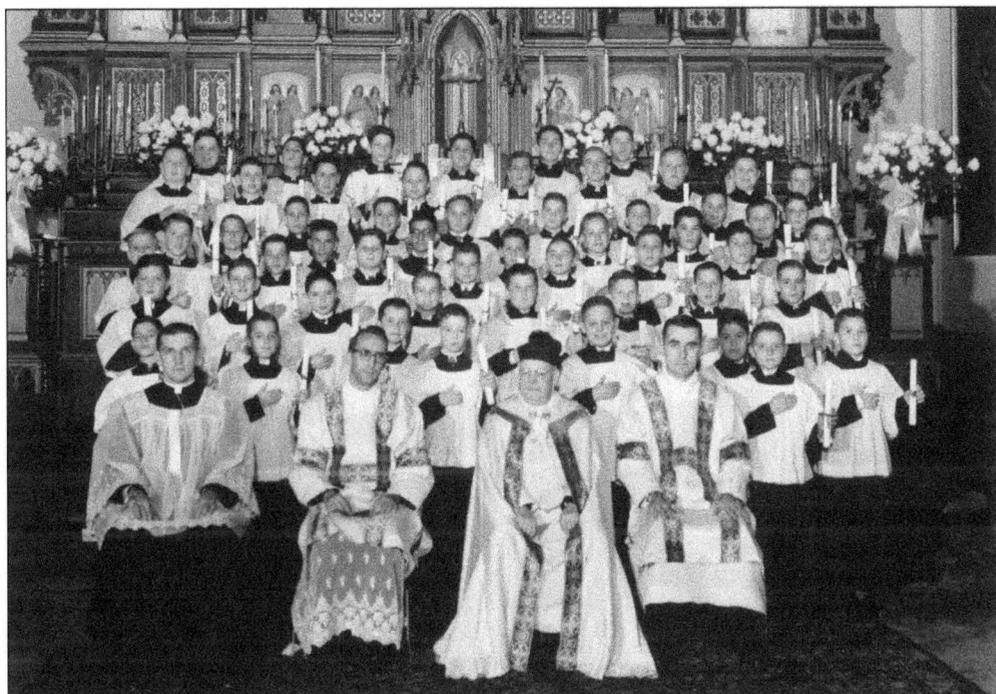

ALTAR SERVER. Within the course of celebrating Holy Mass, acolytes are called upon to accompany the celebrant and perform a number of specially proscribed tasks. Serving as candle and cross bearers, aiding the priest with preparation of the gifts, holding the patent during Communion, and other important functions are often identified with these selfless volunteers. This legacy is a symbol of pride, as author Anthony De Palma noted: "Altar boys at Our Lady of Grace wore sweatshirts that identified them as 'Knights of the Altar' on the tough streets of 1960s Hoboken."

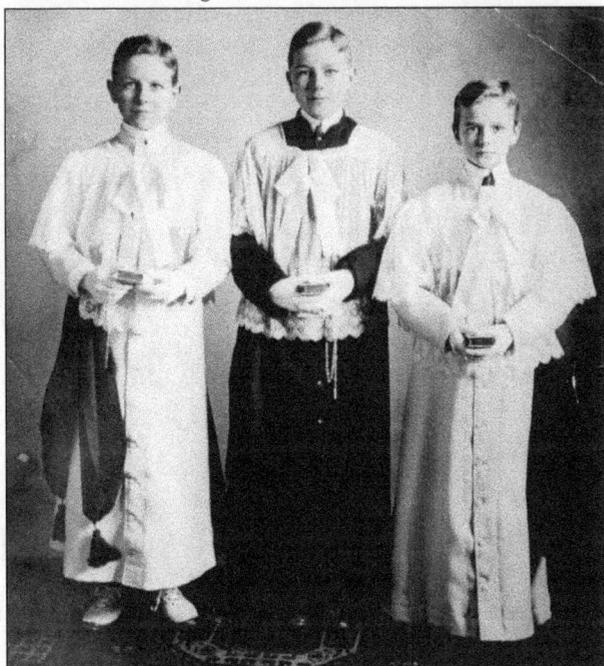

FAMILY TRADITION. Mothers and fathers typically raised their children with a fundamental appreciation of their faith. This pride often manifested itself in displays of religious allegiance, especially during the adolescent years. In this c. 1911 image are James McNulty (later bishop), John McNulty (later monsignor), and William McNulty, who became a pharmacist. This is one example among many close-knit Catholic families who call the Archdiocese of Newark home.

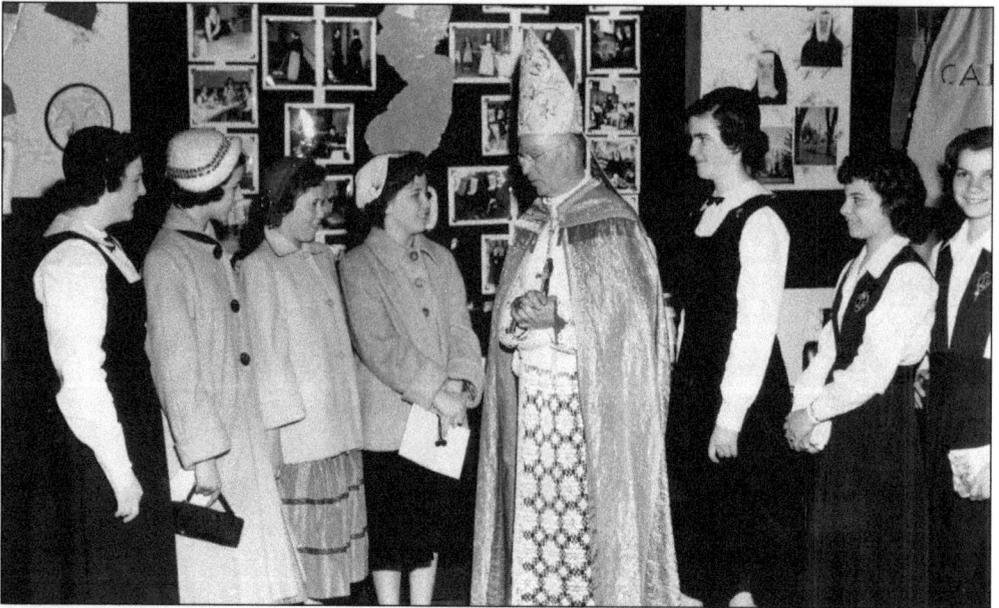

GIRL GUIDES AND BOY SCOUTS. Catholic scouting traditions are well established within the Archdiocese of Newark as an outlet for young women to conduct service projects, as in this 1970s gathering of leaders. By the mid-1950s, over 400,000 belonged to the Girl Scouts of America, which featured guidelines from a Catholic advisory committee for participation. Another group that existed for females at this time was the Junior Catholic Daughters of America, which offered participants a means-of-service option. The same measure of spiritual guidance was applied to this archdiocesan Boy Scout troop posing for an Ad Altare Dei Awards presentation in 1956. Over 520,000 young men of Catholic affiliation belonged to the Boy Scouts of America by the mid-20th century. The National Catholic Welfare Council authorized the Boy Scouts of America to form a Catholic Bureau as early as 1914.

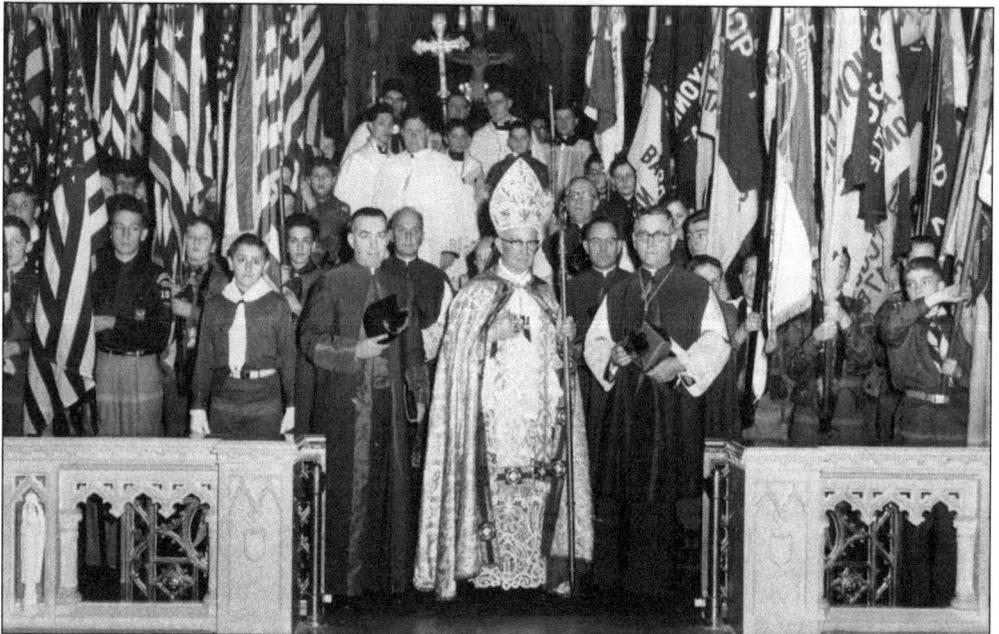

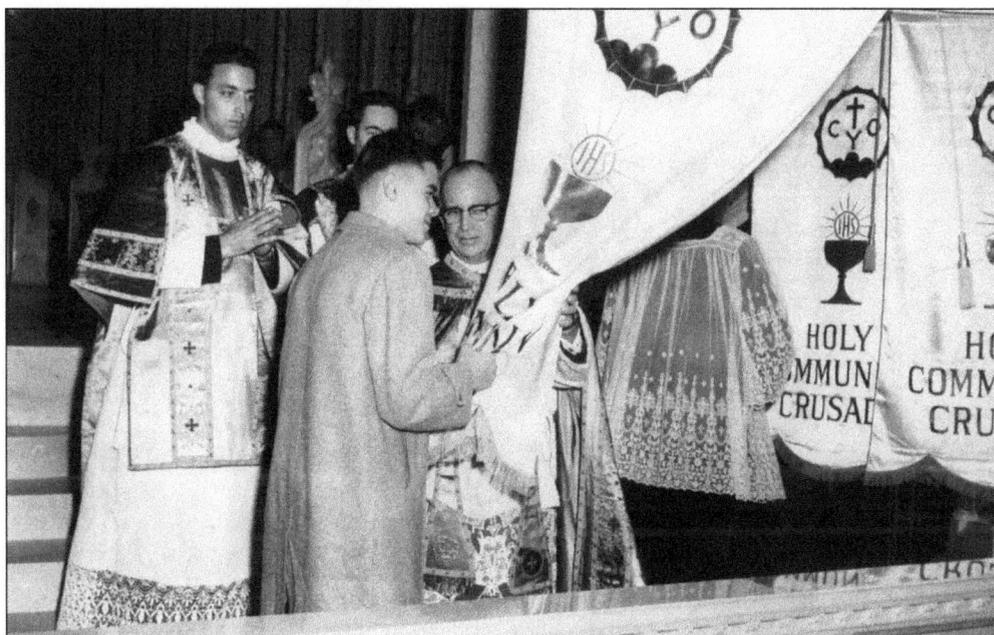

CATHOLIC YOUTH ORGANIZATION. Commonly known as the CYO, the Catholic Youth Organization, started in 1930, established a presence in every parish around the Archdiocese of Newark by 1946 to promote recreational, educational, cultural, and religious programs that would aid in the spiritual and physical development of young Catholics. Included among their activities was the publication of a regularly printed newsletter during the 1940s and 1950s. They also worked with the March of Dimes, Crusade of Prayer for Peace, Saturday devotionals, and the annual Catholic Youth Rally in Newark. More than 400 on average usually attended these rallies from major CYO offices in Newark, Elizabeth, Jersey City, and Fort Lee alone. Additional activities are attached to parish life, including athletic teams like the All Souls baseball squad of East Orange pictured below. Archdiocesan events contested between CYOs, parishes, along with intraparochial or interparochial academy or high school tournaments, offered prime opportunities for keen, but friendly, competition.

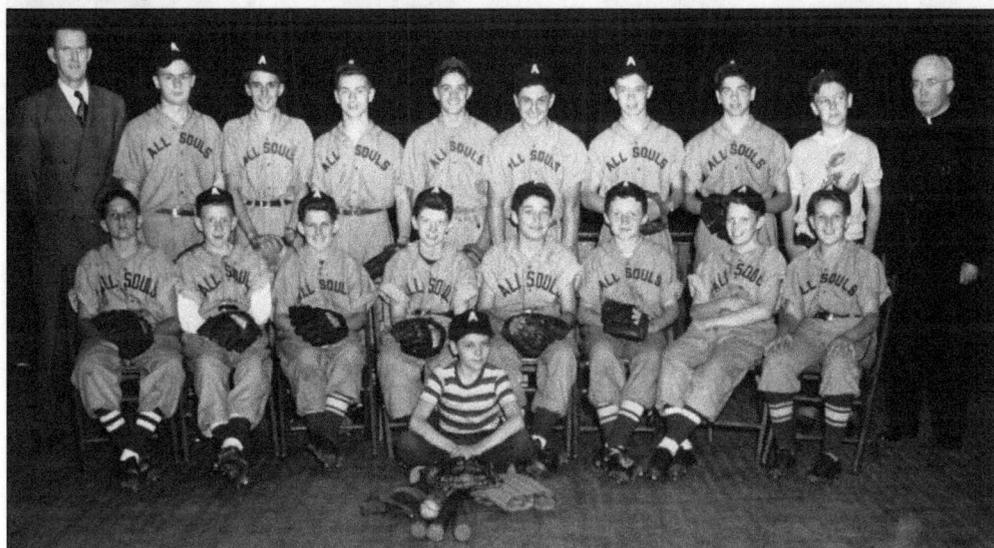

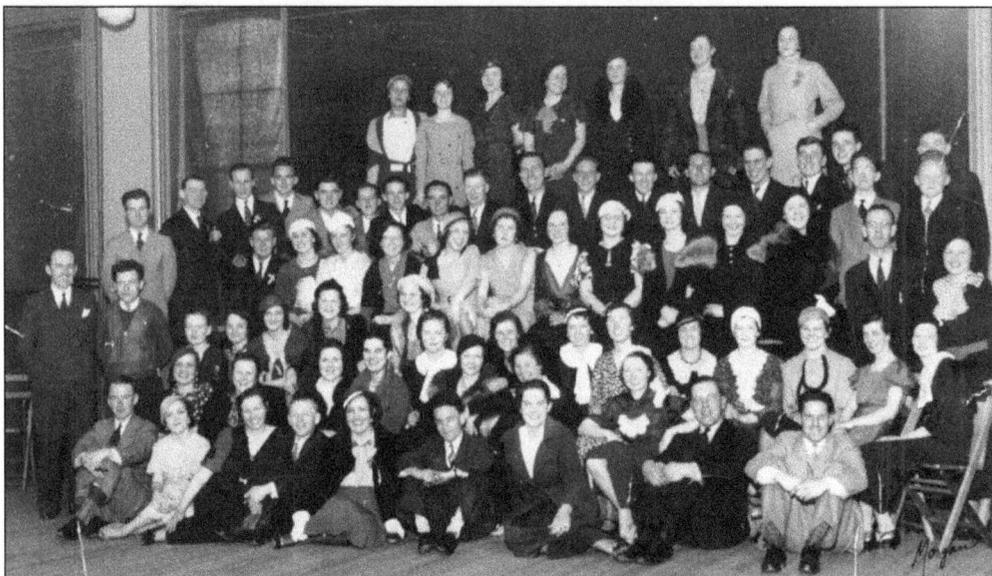

PLAYS AND PARTIES. Above, the 1933 cast and crew from St. Patrick's Pro-Cathedral pause from their work on a church-themed dramatic production. Theatrical presentations were also regular fixtures at local parochial high schools, colleges, and other venues that drew appreciative crowds from the community. Passion plays became a popular and dramatic show of faith. Various organizations across the country also had an influence on the spiritual arts. The Catholic Theatre Conference and Catholic Dramatic Movement both provided a service that promoted cultural exchanges between faith-based entities. Additional activities that were commonplace during the mid-20th century included dances and mixers. Shown here is a group from Our Lady of Fatima, sponsored by the Mount Carmel Guild, in November 1945.

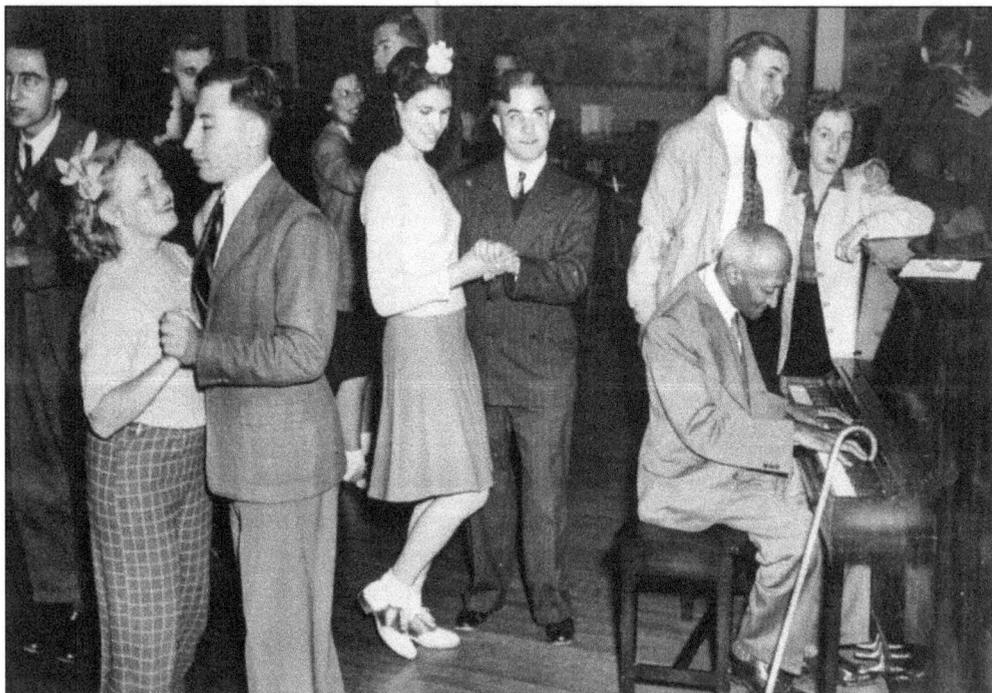

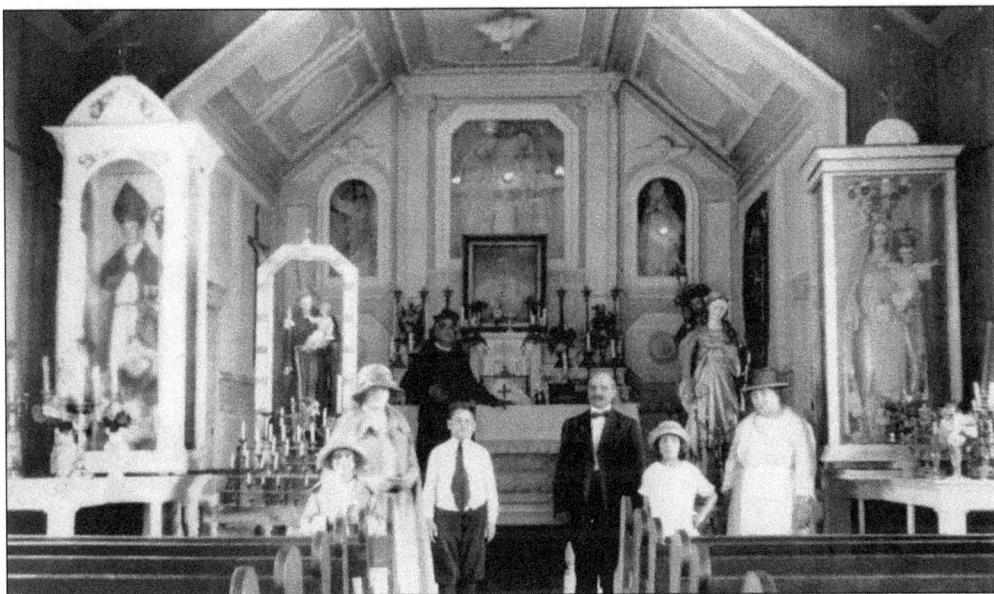

FAMILY AND TRUST. In this image from Holy Family, Nutley parishioner Frank Cullari poses with his son Carmen and relatives of Father Joseph Monastero during the 1920s. All were involved in the maintenance of this parish at some level, either indirectly through weekly church attendance or through regular service on a special board. Lay trustees are appointed to work with clergy to maintain the welfare of their respective parish, whether it be Holy Family or any other church found within the Archdiocese of Newark.

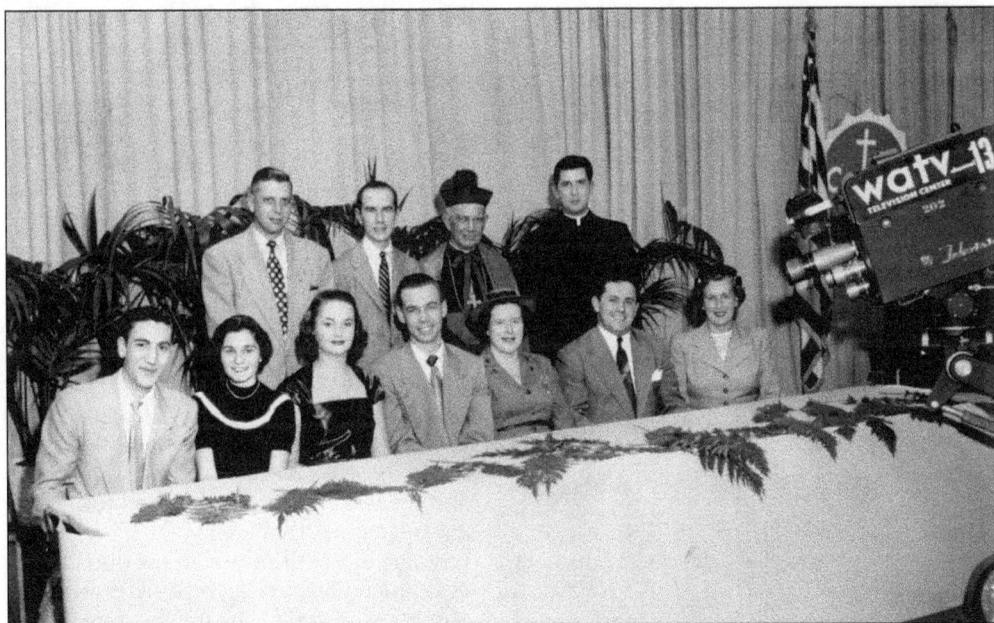

MEDIA DAY. A local and select panel of experts discusses various issues related to the Catholic Church during this 1950s television special. This episode featured Archbishop Boland and Father Dennis McKenna of St. Mary's, Elizabeth, along with a cast of invited commentators. Prior to televised programs aired by WATV Channel 13, shows such as Catholic Youth Presents on local radio station WAAT in Newark were commonplace for such groups as the CYO, among others.

71

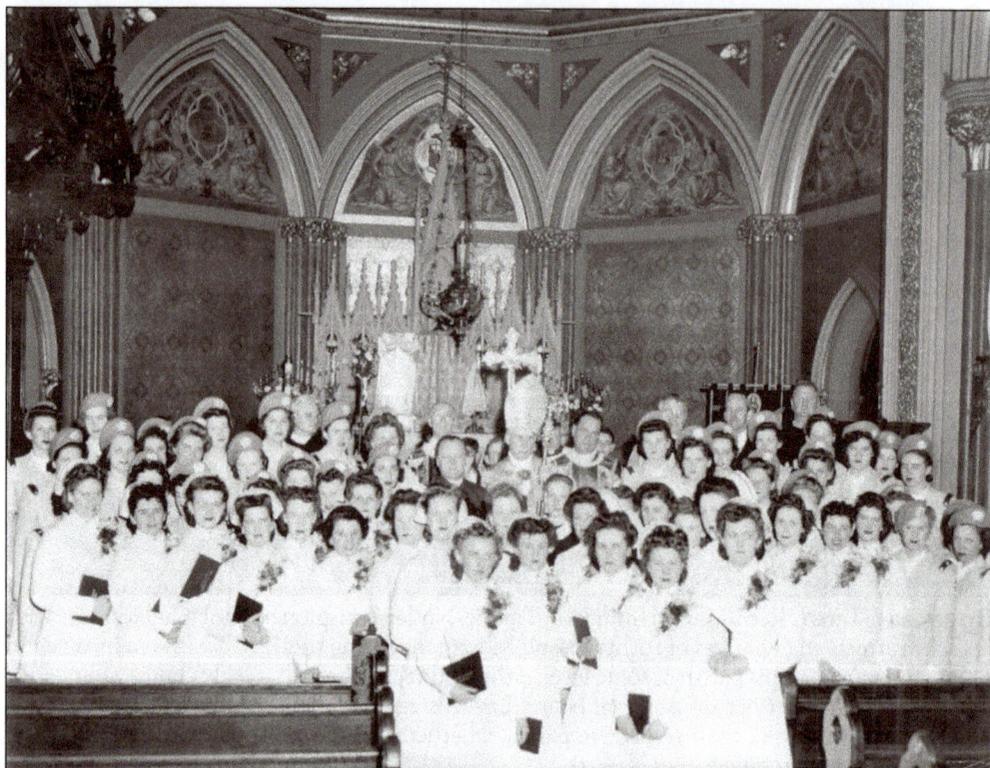

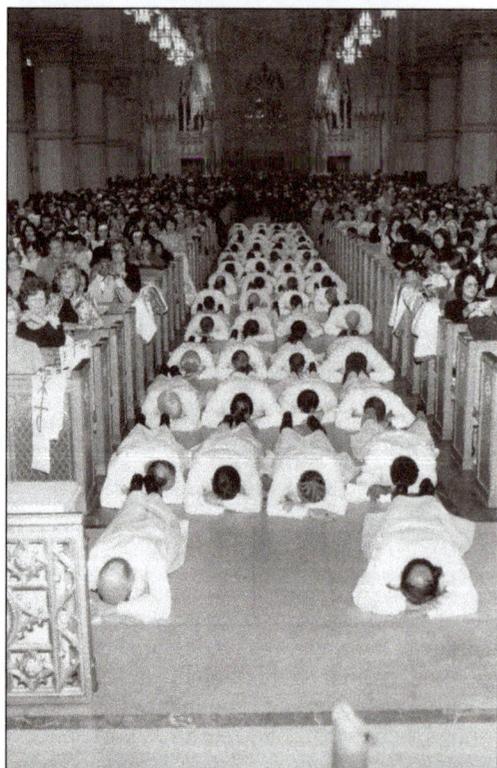

NURTURING CARE. The healing merits of the nursing vocation are often recognized by the archdiocese. Here, members of a class of nurses are honored at St. Patrick's Pro-Cathedral, Newark, around the late 1940s. The mission of helping others is emblematic in the nursing cap, cape and special pin bestowed on graduates in spirit with a blessing offered by a bishop prior to their first assignment which often entailed rounds at a Catholic sponsored hospital or health care facility.

DEACONATE. Originally, deacons were select and special assistants to the apostles, and the term literally means "servant." In a secular sense, they are invaluable to the function of a parish through the distribution of Communion, serving as acolytes and offering related aid. The link between priests and laity is often seen in their joint dedication to celebrating the faith through good will and works. The first permanent deacons appeared within the Archdiocese of Newark during the mid-1970s.

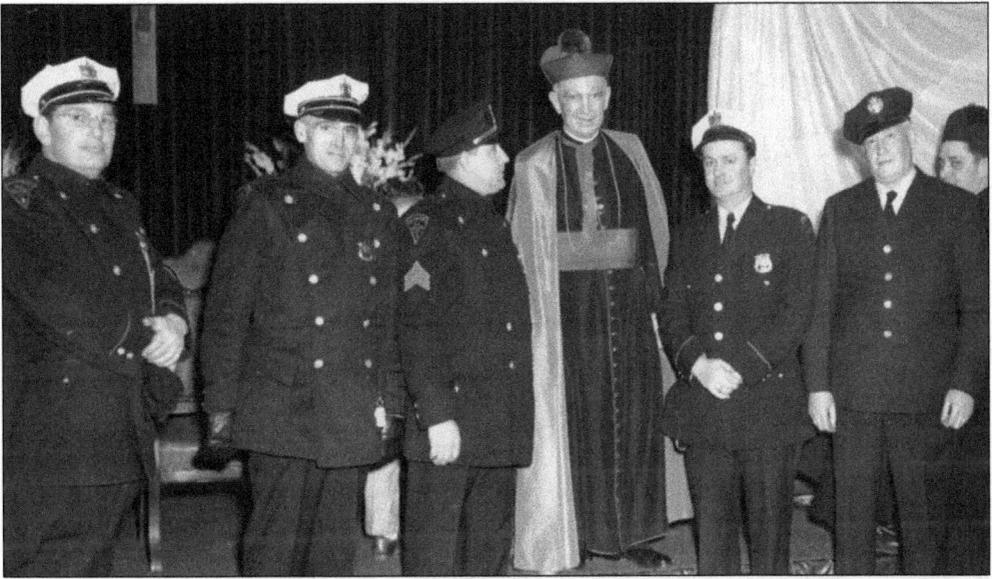

POLICE AND FIRE. A popular occupational choice among many Catholics in the Archdiocese of Newark is that of public safety. The respect of uniform worn and the strong bonds of community formed often lead to several generations following the vocational compass of the first. Shown here are just a few of the finest and bravest during the 1950s. Three decades later, all men and women of the badge began to be honored with an annual Red (fire) and Blue (police) Mass to recognize their efforts and sacrifice.

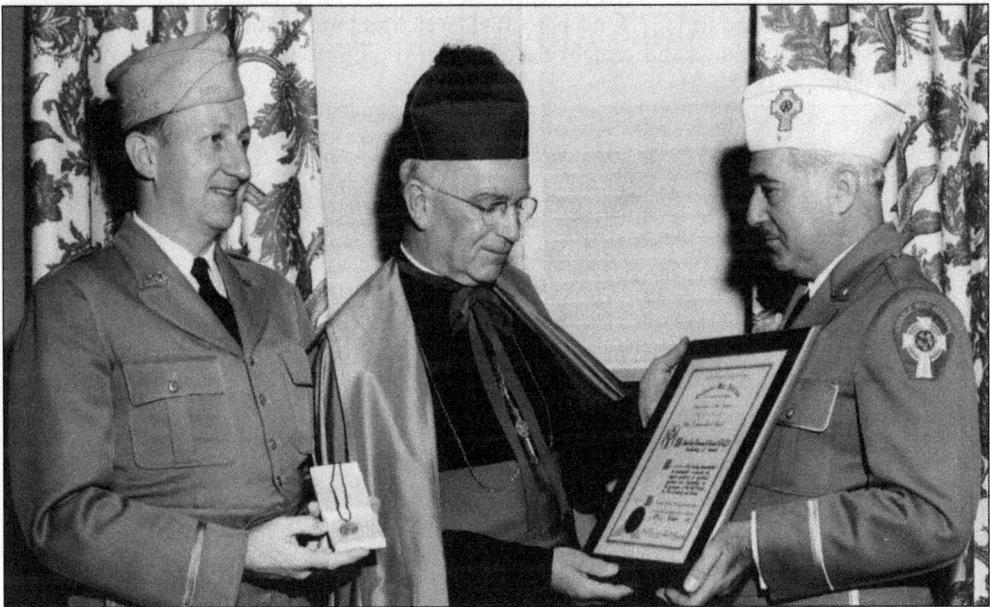

CATHOLIC WAR VETERANS. Career soldiers and sailors, along with those from the civilian ranks, are represented in all towns and cities across the Archdiocese of Newark. Those who belong to the organization of Catholic War Veterans have served in the armed forces and represent participatory sacrifice, in turn. Since the beginning march of the See, thousands of Catholics have served in battle zones, beginning with the Civil War and continuing forth through the Spanish-American War, World Wars I and II, Korea, Vietnam, and the Middle East.

NICOLA MONTANI. A past director of the Archdiocesan Institute of Sacred Music, Montani (born in 1880) became a widely regarded expert on sacred music. This proficiency came through a lifetime study of composition, as found in his oft-reprinted tome, the *St. Gregory Hymnal and Catholic Choir Book*, first published in 1922. On a parochial level, Montani was musical supervisor for the annual Demonstration Mass and professor of chant at the Immaculate Conception Seminary prior to his death in 1948.

MUSICAL MARCH. Shown here is a melodic ensemble from Christ the King, Jersey City, in repose during the 1930s. Orchestras of this type formed to play at for various church functions within their own parish and have been a fixture not only in their home sanctuaries, but also in demand for other events, especially if attached to a school or society sponsored event. Specific parade opportunities, including St. Patrick's Day, Holy Name, Thanksgiving, and Independence Day often feature Catholic-affiliated musicians in full step and sound.

PILGRIMS' PRIDE. A crowd of well-wishers waving adieu to a group of spiritual devotees en route to the 1954 Marian Pilgrimage in Rome aboard the M/N Vulcania. Other religious-based destination devotionals were often organized and chaperoned by priests who served as tour guides and spiritual advisors for individuals with pious leanings. Popular locales of veneration include Our Lady of Knock (Ireland), Fatima (Portugal), Lourdes (France), Guadeloupe (Mexico), and others.

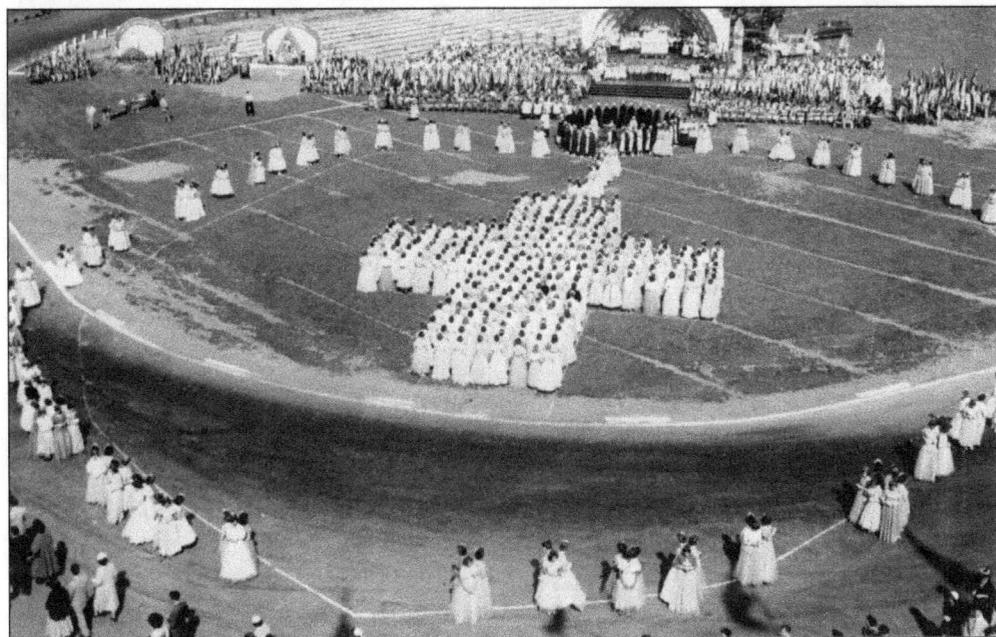

MARIAN YEAR. A centennial commemoration honoring the miracle of the Immaculate Conception occurred in 1954. This event led to a number of large scale celebrations worldwide where prayer, penance and veneration of Mary, the Mother of God were urged among those in attendance. Included in this spring 1954 pageant was a major show of devotion at the CYO youth rally held on the field of Roosevelt Stadium in Jersey City.

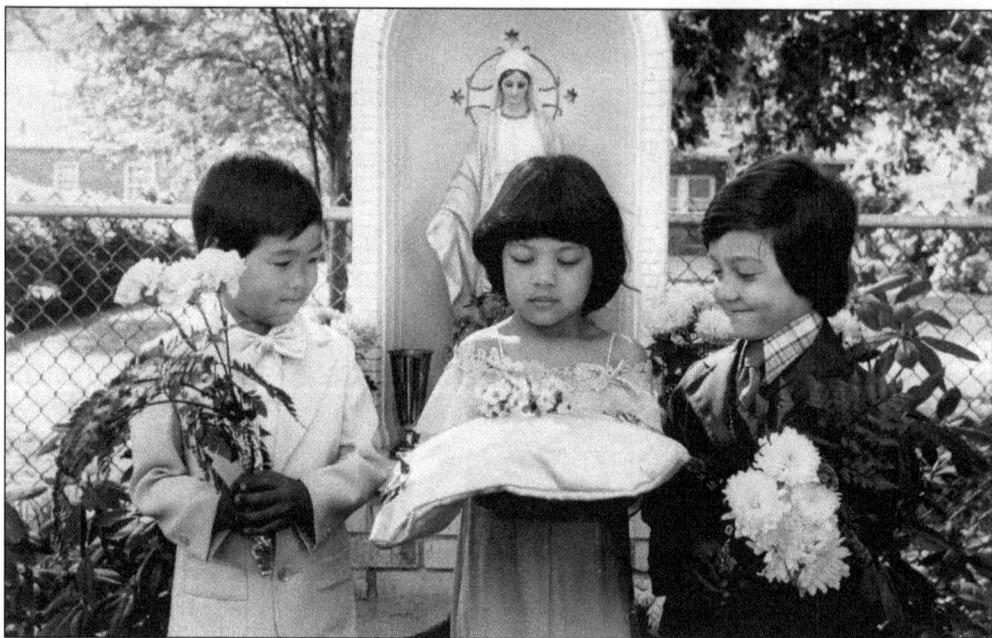

MAY CROWNING. These youngsters symbolize the joy of honoring the Immaculate Conception at a May Crowning celebration during the early 1980s. This tradition of veneration calls for having the youngest female in a parish place a circlet of flowers on the head of a statue of Mary. Our Lady of Fatima (Portuguese) is another Marian deity venerated throughout the archdiocese and has served as the patron saint of New Jersey since 1918.

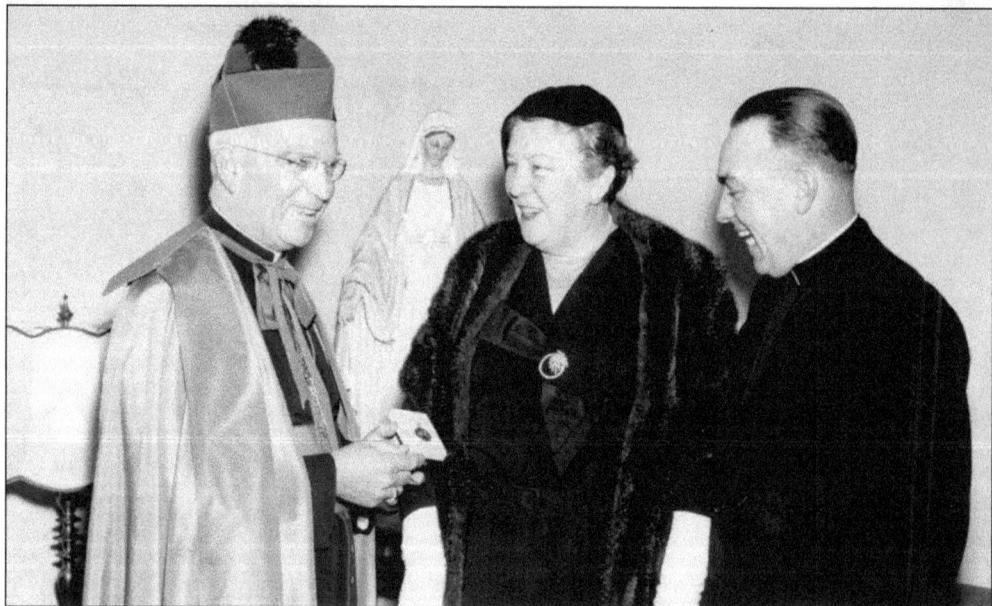

ADORNMENTS OF ADORATION. When it comes to articles of faith, objects such as statues, rosary beads, scapulars and religious medals depicting patron saints are often held close by the faithful. Aside from personal expression, group devotion often manifested itself outwardly through parish altar and rosary societies. Archbishop Boland and Monsignor John Kiley are shown here conferring with a woman holding one such holy ornament during the 1950s.

MOUNT CARMEL GUILD. One of the most active and prolific spiritual support organizations within the Archdiocese of Newark, this charitable entity was created to promote the spiritual, intellectual, and physical welfare of volunteer workers in the name of Christian charity. Founded by Bishop Walsh on September 25, 1929, the Guild had 26 administrative centers and coverage from 35,000 volunteer workers at its height between the 1930s and 1950s.

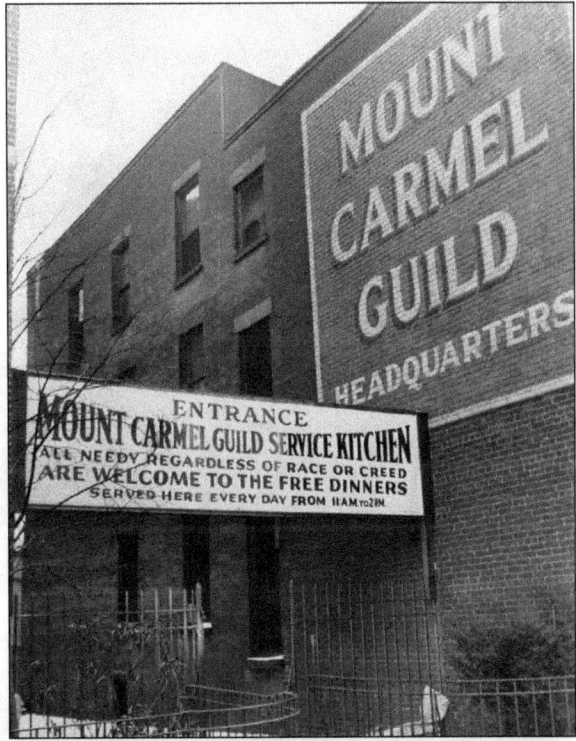

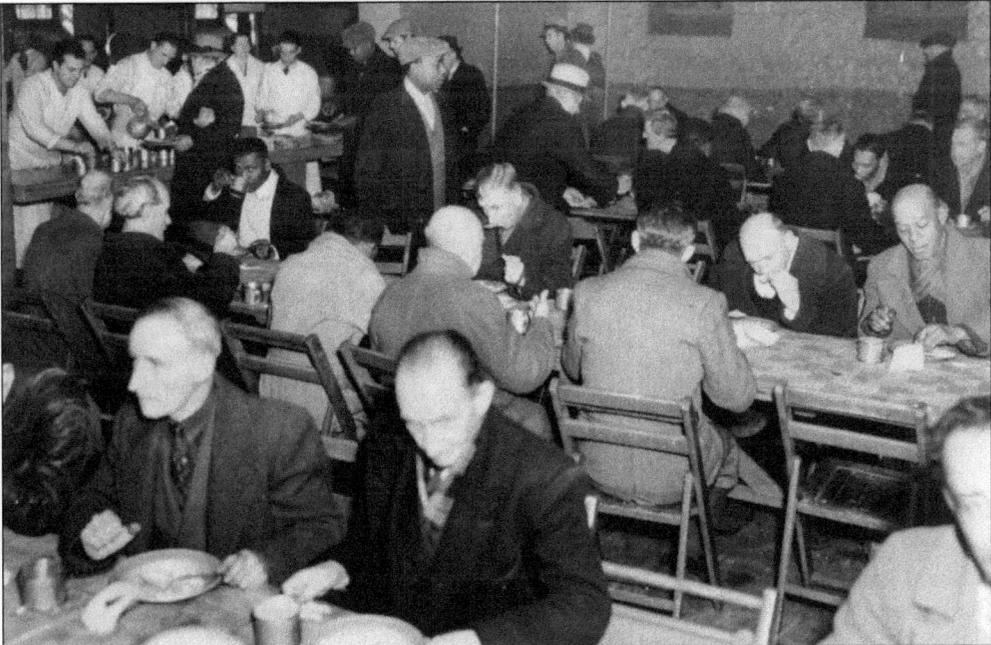

SOCIAL ACTION. Helping others is the focus of the Mount Carmel Guild, which was most evident during the Great Depression of the 1930s. The Guild also supported visiting priests and aided with mail pledges on behalf of the Church that resulted in mail routes as diverse as Alaska to Basutoland, for example. Partnering with Missions for the Society for Propagation of Faith founded by Bishop Bayley in 1858, Mount Carmel further expanded its reputation as a collaborative enterprise.

Toy Story. The charitable focus of service groups is daily, weekly, and seasonal alike. Providing new toys to children of the Archdiocese of Newark at Christmastime was one of the most rewarding and joy-filled events on the calendar. The spirit of giving is emblematic in this annual tradition and often became a prime motivational mantra among these and many other volunteers over the decades. This c. 1939 photograph shows that dolls were a particularly popular choice that year.

Benevolent Societies. The Bayley-Seton League of South Orange, headquartered at Seton Hall University, is named in honor of the founding inspirations for the archdiocese (Bishop Bayley and Mother Seton, respectively). They work to promote varied causes—especially those centered around academic scholarship initiatives throughout the area. Other groups that were also very active throughout the 1940s and 1950s included the Association of Catholic College Women and the St. Vincent de Paul Society, an aid-based alliance formerly known as the Conference of Charity founded in 1903.

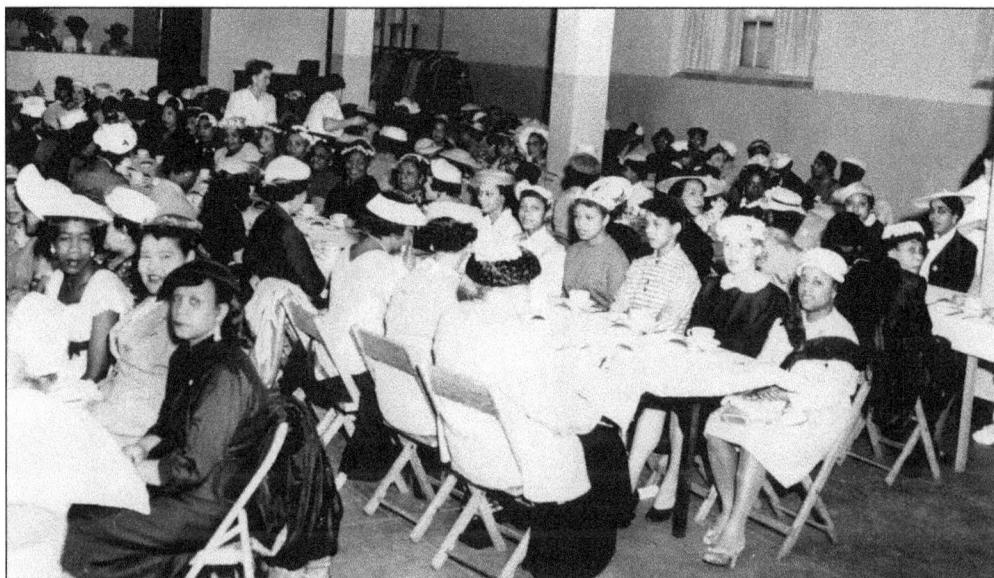

FELLOWSHIP IN ACTION. The gathering of volunteer partners at Communion breakfasts, afternoon teas, banquets, and other soirees helped bond people together for the purpose of planning events and financial aid initiatives to benefit their respective organizations. These women represent works of charity being performed around Hudson County and environs at Christ the King, Jersey City, during the early 1940s.

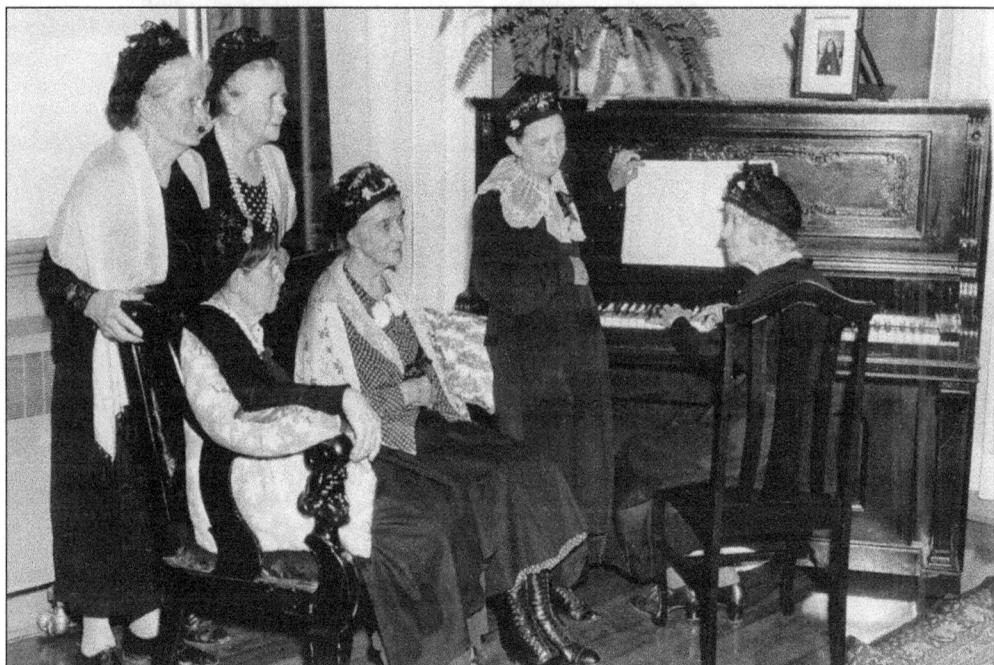

COMMUNITY. The Home of the Little Sisters of the Poor is one of various residential dwellings that serve the needs of the faithful, whether they represent the laity, religious sisters, or priests attached to the Archdiocese of Newark. Specific nursing homes and centers for the aged, including St. Vincent's of Cedar Grove, Margaret Anna Cusak, and Saint Ann's of Jersey City, also have a long-standing place in the historical life of the region.

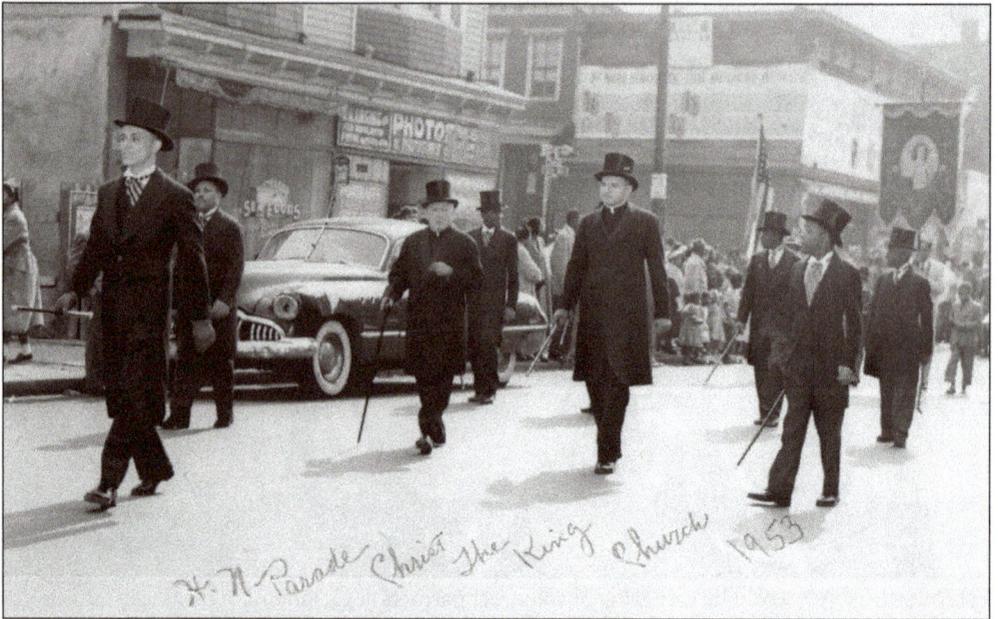

H.N. Parade Christ The King Church 1953

HOLY NAME SOCIETY. This organization, which began at the dawn of the 20th century, promotes reverence for and devotion to the Holy Name of Jesus. The group was first established in Jersey City and quickly expanded to other parishes throughout the archdiocese, including St. Lucy's, St. Mary's, St. Bridget's, and St. Joseph's of Newark, which founded their own nascent chapters between 1901 and 1903. County federations emerged during the 1910s in Bergen, Essex, Hudson, and Union to consolidate the efforts of individual parishes and plan the introduction of an annual Field Day pageant. The first such parade traversed the streets of Jersey City in 1905 and led to subsequent marches, including the top snapshot featuring society gentlemen from Christ the King, Jersey City, in 1953 and some of their brethren from Newark in the image below.

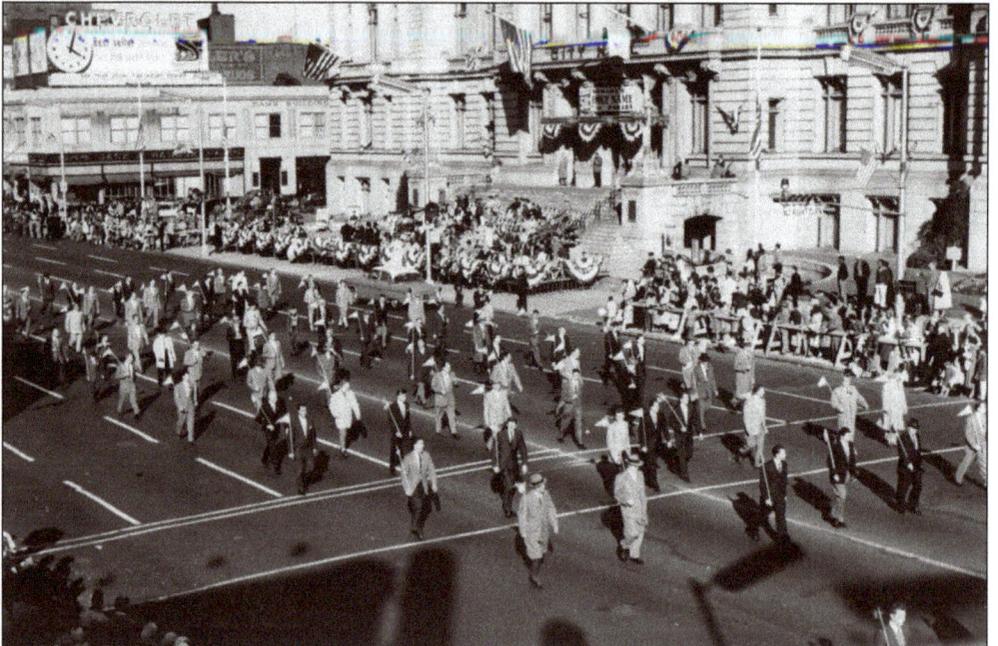

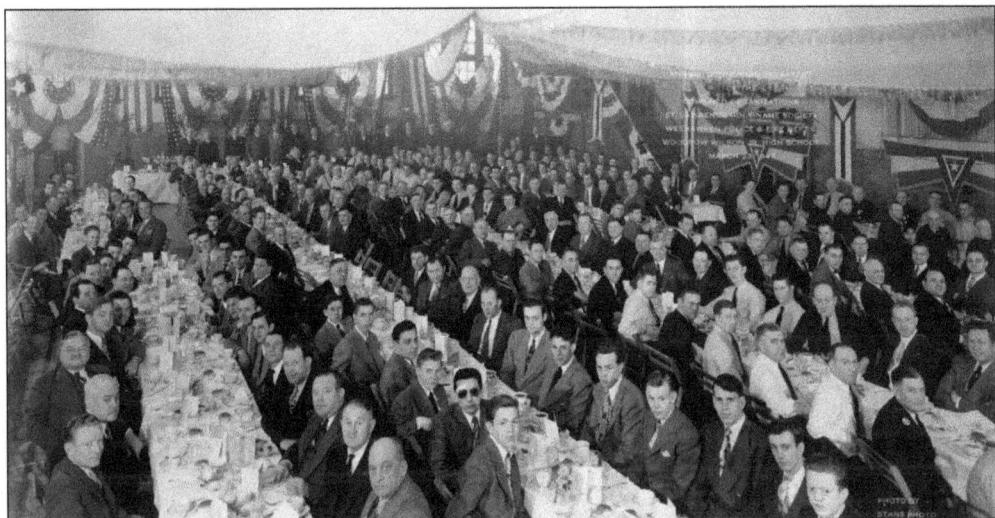

FAITH-BASED ORGANIZATIONS. Fraternal gatherings such as this Holy Name Society event at St. Lawrence, Weehawken (shown above), became commonplace during the 1950s. Corresponding groups around the Archdiocese of Newark also united at regular intervals to share spiritual discourse in similar settings, whether it be a parish hall or convenient neighborhood venue. Members of the Third Order of Saint Francis, Frank Wagner and Robert Sievers, note, "They dedicate their lives to Eucharistic Adoration, prayer, penance, and acts of good works. A rule emphasizing simplicity, continual conversion, and humility are parts of their charism [healing power]. They pledge themselves to true fraternal dialogue and as good lay stewards in practicing a universal purity of heart."

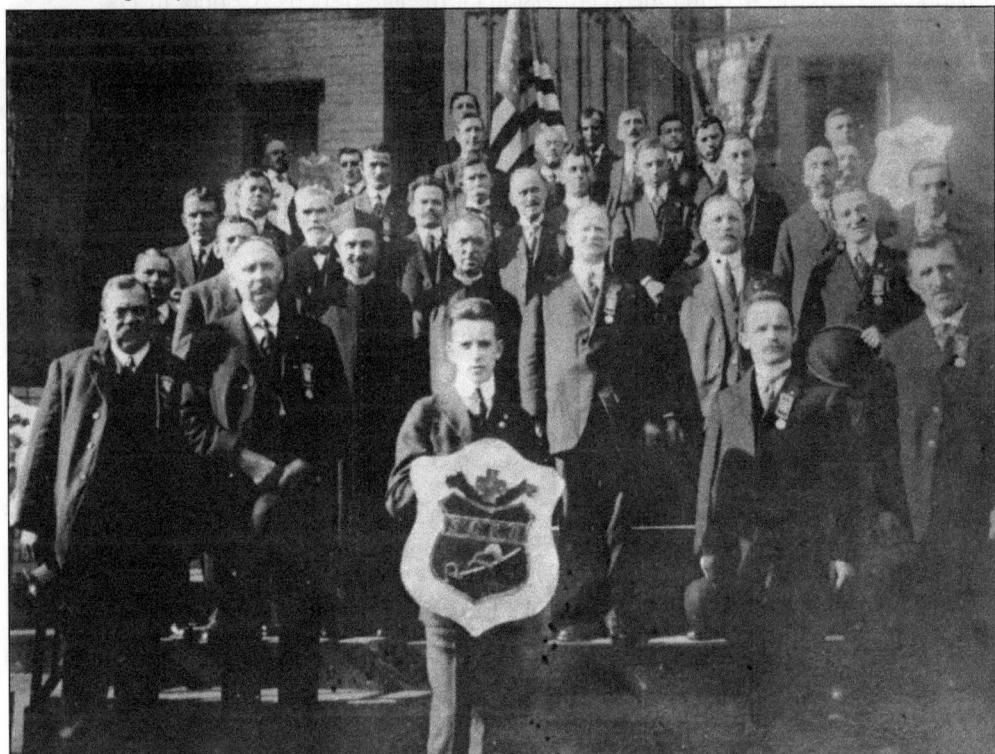

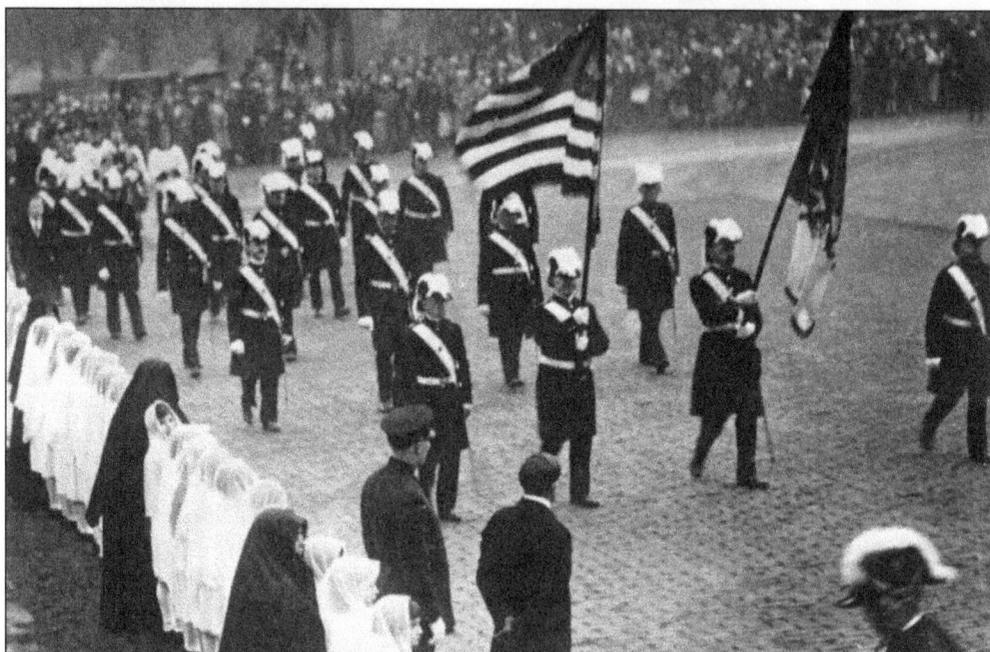

KNIGHTS OF COLUMBUS. The Knights of Columbus are a popular fraternal organization, historically active in promoting Legion of Decency retreats for the laity, working with the Catholic Evidence Guild, and promoting religious-oriented activities within the mainstream press among other endeavors. Their most prominent public role comes in forming honor guards at various church functions, such as this solemn funeral procession for the late Bishop O'Connor in 1927.

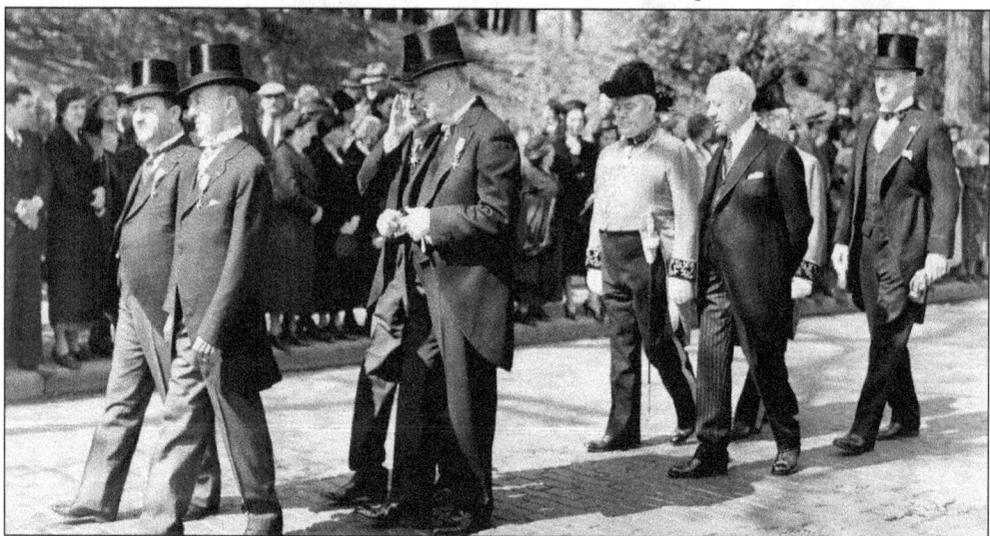

HONORED LAITY. Those who achieve renown and perform good works on behalf of the Church are sometimes bestowed with secular knighthood in the Order of Malta or Order of St. Gregory, for example. This image shows local awardees Judge Elmer Matthews and Professor Louis Raggi, famed for jurisprudence and art, respectively, in their day. Each is seen walking alongside 1928 presidential candidate Alfred E. Smith (third from the right in dress suit), a frequent visitor to the "Sidewalks of New Jersey." These gentlemen are part of a procession that honored Bishop William Griffin during the late 1930s.

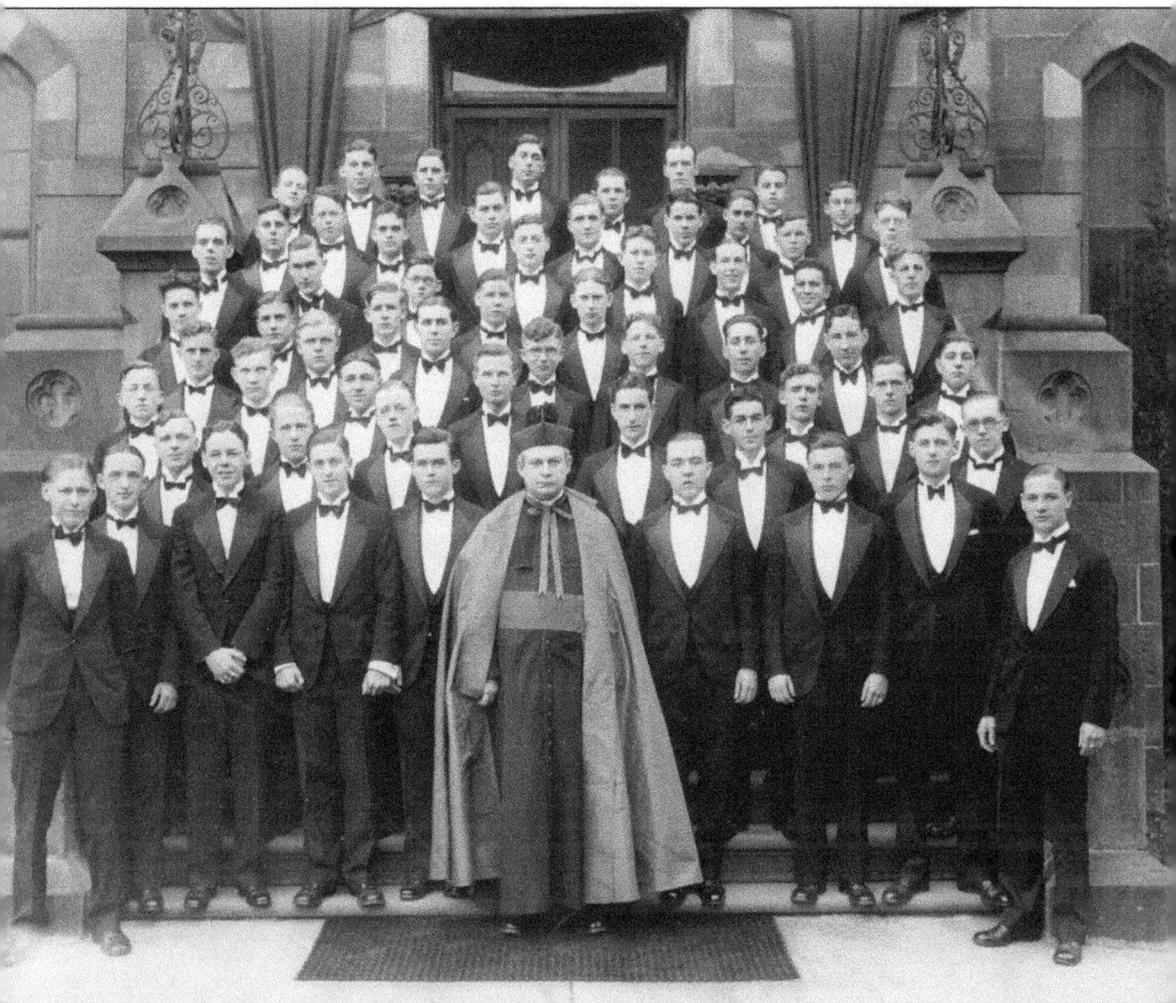

CHURCH AND CAREER. Individuals who do not choose the route of religious life within the Archdiocese of Newark often find varied career options that contribute to the commonweal of society, but at the same time shows of allegiance to the Catholic Church came in bow tie and clerical collar alike. This gathering of Seton Hall College students from 1935 found possible impetus to serve in such lay organizations of that era as the Young Christian Workers and Young Christian Students among other comparable choices. Hudson County native Ed Lucas found that such clerics as Fathers Michael and William Hornack of Assumption in Jersey City, like many other men of the cloth, had respect for their lay brothers and sisters as he related retrospectively and simply that "they were my spiritual advisors as a youngster and always there to guide me."

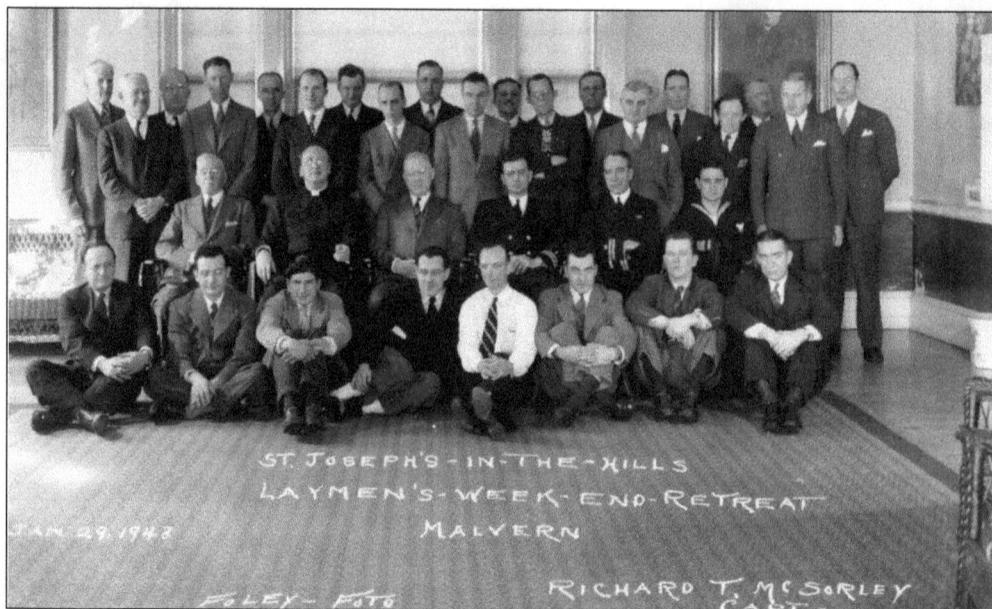

LAITY IN ACTION. Group retreats were often held from Friday evenings through Sunday afternoons during the mid-20th century at the height of the Catholic Retreat Movement. These encounters were conducted for individuals who wished to experience contemplative Catholicism in a peaceful setting. Host sites could be found in nearby Morristown, Newton, Paterson, or West End. Out-of-state journeys to such retreat destinations as Malvern, Pennsylvania, were not uncommon for those who wished to travel a distance.

CHURCH AND STATE. Adherents to the Catholic Church are found in a wide range of professions including law, medicine, and government, among many others. This image showcases civic pride during the 300th anniversary celebration for Newark held on May 18, 1966. Included in this spectacle were individuals from every walk of life and religious persuasion. Prominent lay Catholic participation included Richard J. Hughes, first Catholic governor of New Jersey, who is standing on the far right; Hugh Addonizio, former mayor of Newark, leaning forward from the reviewing stand; and police director John Caulfield, along with other noted citizens.

84

Six

PARISH

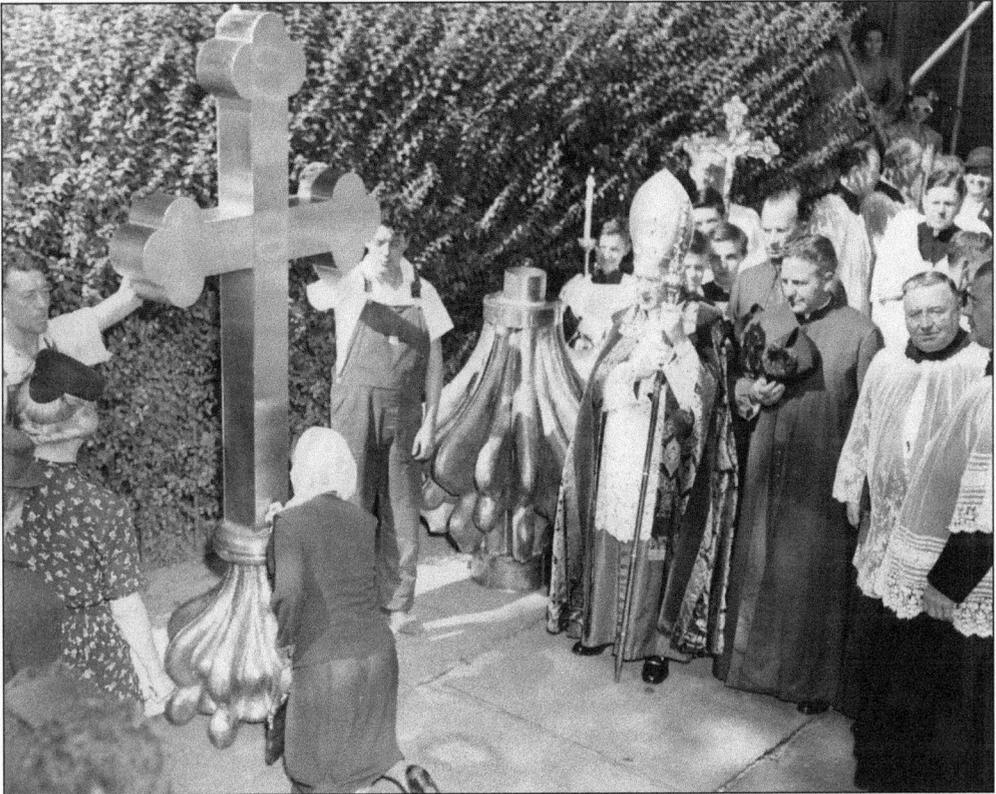

BRICK AND MORTAR. Over 300 different parishes and scores of institutions, schools, and related entities have been inspired by, and constructed for the faithful since the formation of the Newark See during the 19th century. Indicative of the golden years of church composition is this view of Archbishop Walsh after blessing the steeple cross for St. Patrick's Pro-Cathedral on September 16, 1946. Also included in this scene are Bishops Martin Stanton and James McNulty, along with Monsignors Paul Collins, James Hughes, and James Looney.

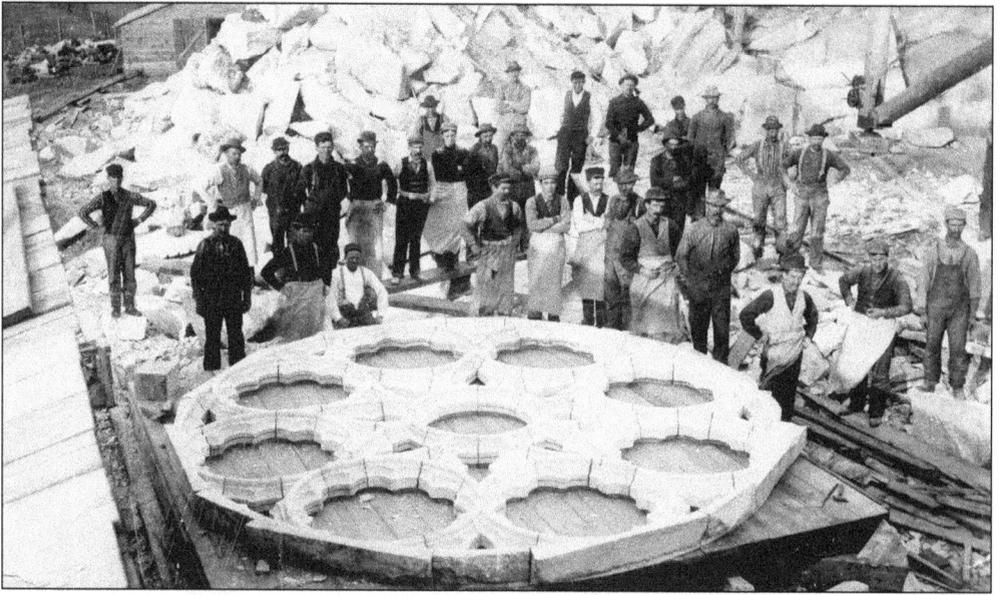

CONSTRUCTIVE GUIDANCE. A proud crew pauses during the construction of a window frame during the 1920s. This scene is indicative of the intensive labor and expert skill required in building all parts of a church edifice in styles that range from English Gothic to pattern block. According to Troy Simmons, architectural historian for the Archdiocese of Newark, Jeremiah O'Rourke, Patrick Keely, Paul Reilly, and Charles Maginnis are among the most prominent architects who lent their talents over the years.

STAINED GLASS. The crafting of leadlight, an art form often synonymous with the Catholic Church, is esteemed as an ecclesiastical expression of craftsmanship and praise. The individualism of a parish is often distinguished by depictions honoring namesake and popular saints. In this case, the vivid image of Our Lady of Mount Carmel adorns the parish entrance that bears her name in Ridgewood, founded in 1889.

ARCHDIOCESAN DIRECTORY.
The proliferation of churches
within the Archdiocese
of Newark necessitated a
more connected means of
communication between
parishioners and their parish
administrators. Telephone
exchanges as shown in this
1945 index helped in this
regard. Churches found
within the city limits of
Newark are usually listed first
in any directory, including
post–World War II edifices
such as Our Lady of Fatima
(1956), St. Thomas Aquinas,
Our Lady of Perpetual Help
(1964), and Epiphany (1992).

ARCHDIOCESE OF NEWARK
CHURCHES

NEWARK
St. Patrick's Cathedral	Market 3-0497
Assumption the the B.V.M.	Bigelow 3-5586
Blessed Sacrament	Bigelow 3-1880
Holy Trinity	Market 2-6847
Immaculate Conception	Humboldt 3-4513
Our Lady of Good Counsel	Humboldt 2-0146
Our Lady of Mount Carmel	Market 2-2306
Our Lady of the Rosary	Bigelow 3-1005
Queen of the Angels	Or. 3-0720
Sacred Heart	Humboldt 2-3853
Sacred Heart (Vailsburg)	Essex 3-8089
St. Aloysius	Market 2-4136
St. Antoninus'	Market 3-0258
St. Ann's	Bigelow 3-5996
St. Augustine's	Humboldt 2-1817
St. Benedict's	Market 3-0234
St. Bridget's	Mitchel 2-2509
St. Casimir's	Market 2-4628
St. Charles Borromeo's	Waverley 3-6840
St. Columba's	Market 2-7712
St. Francis Xavier's	Humboldt 2-7170
St. James'	Market 2-0316
St Anne's	Fairlawn 6-0441
	Fairlawn 6-1070
St. Joseph's	Market 3-2650
St. Joseph's Mission	Market 3-2749
St. Lucy's	Humboldt 2-4477
St. Mary's	Market 2-5235
	Mitchel 2-1773
St. Michael's	Humboldt 2-3567
St. Peter's	Bigelow 3-7585
St. Philip Neri's	Market 2-2035
St. Rocco's	Mitchel 2-4652
St. Rose of Lima's	Humboldt 2-0682
St. Stanislaus'	Bigelow 3-7934
St. Stephen's	Bigelow 3-4552

ALLENDALE
Guardian Angel Mission	Ridgewood 6-0272

ARLINGTON
St. Stephen's	Kearny 2-0062

BAYONNE
Our Lady of the Assumption	Bayonne 3-0087
Mount Carmel	Bayonne 3-2070
St. Andrew's	Bayonne 3-1448
St. Henry's	Bayonne 3-0857
St. Joseph's	Bayonne 3-1122
St. Mary Star of the Sea	Bayonne 3-0166
St. Michael's	Bayonne 3-1412
St. Vincent's	Bayonne 3-1204

BELLEVILLE
St. Peter's	Belleville 2-1234

BERGENFIELD
St. John the Evangelist	Dumont 4-0101

BERKELEY HEIGHTS
Little Flower	Summit 6-5244

BLOOMFIELD
Sacred Heart	Bloomfield 2-2814
St. Thomas the Apostle	Bloomfield 7-9190
St. Valentine's	Bloomfield 2-0220

BOGOTA
St. Joseph's	Hackensack 2-0957

CALDWELL
St. Aloysius'	Caldwell 6-0221

CLIFFSIDE
St. John the Baptist	Cliffside 6-1016

CLOSTER
St. Mary's	Closter 321

COYTESVILLE
Holy Trinity	Fort Lee 8-0265

CRANFORD
St. Michael's	Cranford 6-0360

CRESSKILL
St. Therese of Lisieux	Closter 321

DARLINGTON
Immaculate Conception	Ramsey 976

DEMAREST
St. Joseph's	Englewood 3-0364

DUMONT
St. Mary's	Dumont 4-0557

EAST NEWARK
St. Anthony's	Harrison 6-0299

EAST ORANGE
Holy Name	Orange 4-1862
Our Lady of All Souls	Orange 4-0232
Our Lady of the Blessed Sacrament	Orange 3-6669
St. Elizabeth's Mission	Orange 3-0720
St. Joseph's	Orange 3-9043
St. Mary's Help of Christians	Orange 3-3146

EAST PATERSON
St. Leo's	Passaic 2-6640

EAST RUTHERFORD
St. Joseph's	Rutherford 2-0443

EDGEWATER
Holy Rosary	Cliffside 6-0135

ELIZABETH
Holy Rosary	Elizabeth 2-3150
Blessed Sacrament	Elizabeth 2-3708
Immaculate Conception	Elizabeth 2-6662
Sacred Heart	Elizabeth 2-7780
St. Adalbert's	Elizabeth 2-2791
St. Anthony's	Elizabeth 2-8716
St. Boniface's Mission	Orange 3-0720
St. Genevieve's	Elizabeth 2-4188
St. Hedwig's	Elizabeth 2-1448
St. Joseph's	Elizabeth 2-2926
St. Mary of the Assumption	Elizabeth 2-3154
St. Michael's	Elizabeth 2-7530
St. Patrick's	Elizabeth 2-1782
Sts. Peter & Paul	Elizabeth 2-2271

CARILLONS ON HIGH. The blessing
of bells that hang in the belfry at
St. Aedan's, Jersey City, show and
sound due honor to various blessed
figures in church history. These
images were taken by William
Maresca of Jersey City during the
mid-20th century. These chimes, the
proverbial sound track of a church,
are invoked to ring forth good news
and herald the top of every hour.

ST. JOHN'S, NEWARK. The first Catholic Church in Newark was founded in 1826. The original St. John's located on Mulberry Street was a small structure that measured 50 by 65 feet around and topped by a cross of Jersey Hickory that endured until a more permanent structure was constructed. Prior to the erection of St. John's, Catholics in Newark had traditionally celebrated their faith at the homes of local laymen and women as late as the 1840s. Builders of Irish extraction helped to build this spiritual crux and served as its core parishioner base during its first of many halcyon days. Ironically, the first pastor was an Englishman, the Reverend Gregory Bryan Pardow, who steered the inaugural chapter of St. John's, which became the earliest flagship parish in what ultimately became the Archdiocese of Newark. (Courtesy of the Archdiocese of Newark.)

JERSEY CITY. The largest municipality in Hudson County and a major center of Catholicism is Jersey City. Churches that dot "Pavonia" include St. Peter's (founded in 1831), St. Mary's (above, 1854), St. Joseph's (1856), St. Paul's (1861), St. Boniface (1861), St. Michael's (1867), St. Paul of the Cross (1868), St. Bridget's (1869), St. Patrick's (1869), St. Anthony (1884), St. John the Baptist (1884), St. Lucy's (1884), Holy Rosary (1885), St. Nicholas (1886), All Saints (1896), St. Aloysius (1897), St. Anne (1903), Sacred Heart (1905), O.L. of Mount Carmel (1905), St. Ann (1910), O.L. of Czestochowa (1911); St. Ann (1911), O.L. of Sorrows (1914), O.L. of Victories (1917), Christ the King (1930), and O.L. of Mercy (1963).

ST. PETER'S ANNUAL REPORT.

DR.			CR.		
To cash, Pew Rent,	- -	$1,388 82	By cash paid, Repairs,	-	$131 38
" Collection,	- -	376 69	" Choir,	- -	110 81
" Subscription,	- -	213 70	" Pastor,	- -	771 22
" Easter dues, &c.	-	141 78	" Current expenses,	-	193 43
" Monthly Collection.		324 37	" School,	- -	105 6?
			" Sexton,	- -	162 88
			" Interest,	- -	147 50
			" Old bills,	- -	25 29
			" Insurance,	- -	22 00
			" Episcopal dues,	-	100 00
			" Church furniture,	-	177 26
			" Improvements,	-	483 63
			By balance,	- -	14 35
		$2,445 36			$2,445 36

DEBTS DUE BY ST. PETERS, SUBJECT TO INTEREST.

Bond and Mortgage,	$2,000 00
Loan,	. . .	550 00
Do. for erection of Pastoral House,	. . .	2,000 00
Total amount,	**$4,550 00**

The auditors, FREDERICK BOYES and T. M'CARTHY, have carefully reviewed the details of St. Peters' Accounts for 1846, of which the above is an abstract, and have ascertained that it is entirely correct.

J. KELLY, RECTOR.

JERSEY CITY, Jan. 7, 1847.

The Irish Relief collection of $110, together with $53 of my dues, added thereto, which amount to $163, is not included above.

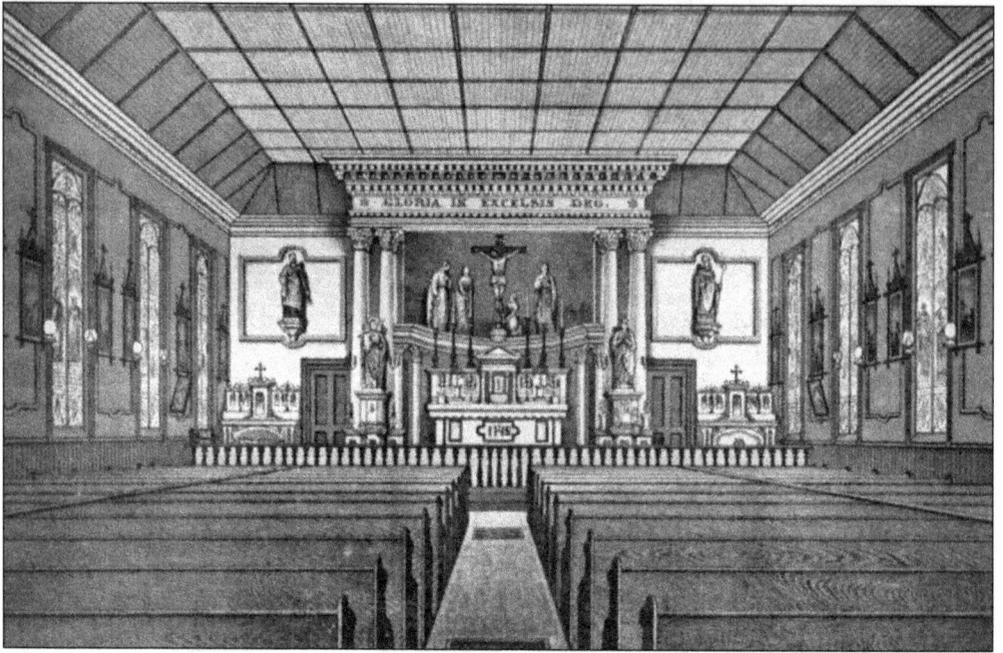

St. Peter's, Belleville. The third-oldest parish in the Archdiocese of Newark, St. Peter's, was founded in 1837. This edifice was constructed to allow congregants the opportunity to worship in one central location, since many faithful either celebrated Mass in private homes or made the trek to Newark or New York City for Communion. This c. 1853 interior drawing depicts a typical vintage sanctuary of the 19th century.

St. Mary's, Newark. Founded in 1854, St. Mary's, the second-oldest parish in Newark, became a haven for German Catholics and is counted among the first "ethnic" parishes where the immigrant population benefited from a familiar vernacular and cultural milieu. This depiction of the Virgin Mary shows a case of early prejudice toward Catholics, as nativist sentiment led to the vandalism of church property at such parishes as St. Mary's during the 1840s and 1850s.

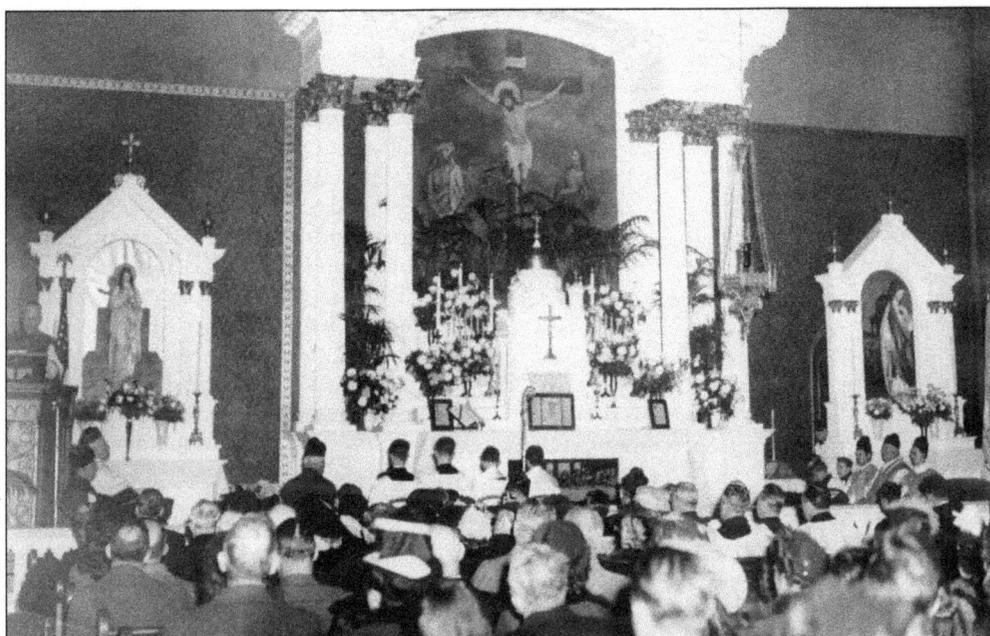

St. Mary's, Elizabeth. Many of the earliest churches in the See were named for the Immaculate Conception, including the oldest parish in Union County. Founded in 1844, St. Mary's is situated in Elizabeth, one of the oldest Catholic settlements in New Jersey. Many of her earliest parishioners had French or German surnames, which later led to a more cosmopolitan composition of churchgoers over the years. This structure soon shared geographical propinquity with St. Mary's, Plainfield (1851), and St. Michael's, Elizabeth (1852).

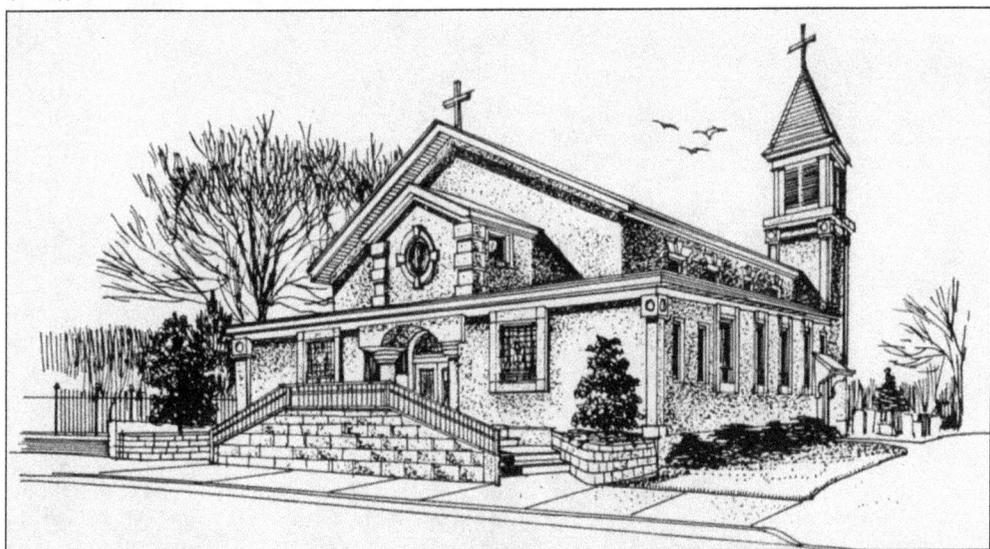

St. Francis, Lodi. The founding Catholic parish of Bergen County is St. Francis in Lodi (1854), which shares local distinction with Madonna-Fort Lee (1858); Holy Trinity, Hackensack (1861); St. Joseph's, East Rutherford (1872); O.L. of Mount Carmel, Tenafly (1873); St John the Baptist, Fairview (1873); O.L. of Mount Carmel, Ridgewood (1889); St. Andrew, Westwood (1889); St. Anthony, Northvale (1890); St. Francis, Ridgefield Park (1890); Immaculate Conception, Hackensack (1891); Corpus Christi, Hasbrouck Heights (1897) and St. Matthew, Ridgefield (1899).

St. Patrick's NEWARK, NEW JERSEY
PRO-CATHEDRAL

Rt. Rev. Msgr. James F. Looney, P. A. Adm.
Rev. John J. Walsh Rev. Joseph M. Quinlan
Rev. Thomas W. Heck Rev. James F. Conti
Rectory: 91 Washington St., Newark 2 MA 3-0497

Sunday Masses: 6:00, 7:00, 8:00, 9:00, 10:00 (High),
11:00 (Spanish), 12:00. Benediction after last
Mass.

Holy Day Masses: 5:30, 7:00, 8:00, 9:00, 10:00, 11:00,
11:45, 12:15, 12:45, 4:45, 5:15 p.m.

Week Day Masses: 7:00, 7:30, 8:00, 12:15, 5:15 p.m.

First Friday Masses: 6:00, 7:00, 7:30, 8:00, 12:15,
5:15 p.m.

Confessions: Saturdays and eve of First Fridays and
Holy Days—3:30 to 6 — 7:30 to 9:00 and after
each Novena service.

Rosary and Confessions: Tuesday
to Friday inclusive 8 p.m.

Miraculous Medal Novena: Mon-
day 8:00, 12:15 (Masses)
5:15 p.m.

First Friday Devotions: after
8:00 a.m. Mass.

First Saturday Devotions: after
8:00 a.m. Mass.

Baptisms: Sunday 2:00
p.m. Please arrange
at Rectory before-
hand.

ST. PATRICK'S PRO-CATHEDRAL. This Gothic structure is positioned between Washington Street and Central Avenue in Newark proper. The excavation for St. Patrick's Pro-Cathedral began in 1846 and reached completion four years later. Her inspiration is the patron saint of Éire, and this choice of honoring a Hibernian deity came as a nod to the large American Irish population that migrated to Essex County through the ravages of *An Gorta Mór* ("the Great Hunger") during the mid-19th century. This parish also has an annual memorial Mass in honor of the 1916 Easter Rising in Dublin. St. Patrick's has long welcomed individuals of all ethnic and cultural persuasions, and it predates the more famous cathedral of the same name in New York City by nearly three decades. This Newark landmark is on the National Register of Historic Places and serves as the American shrine of the Ecuadorian saint Our Lady of Quinche.

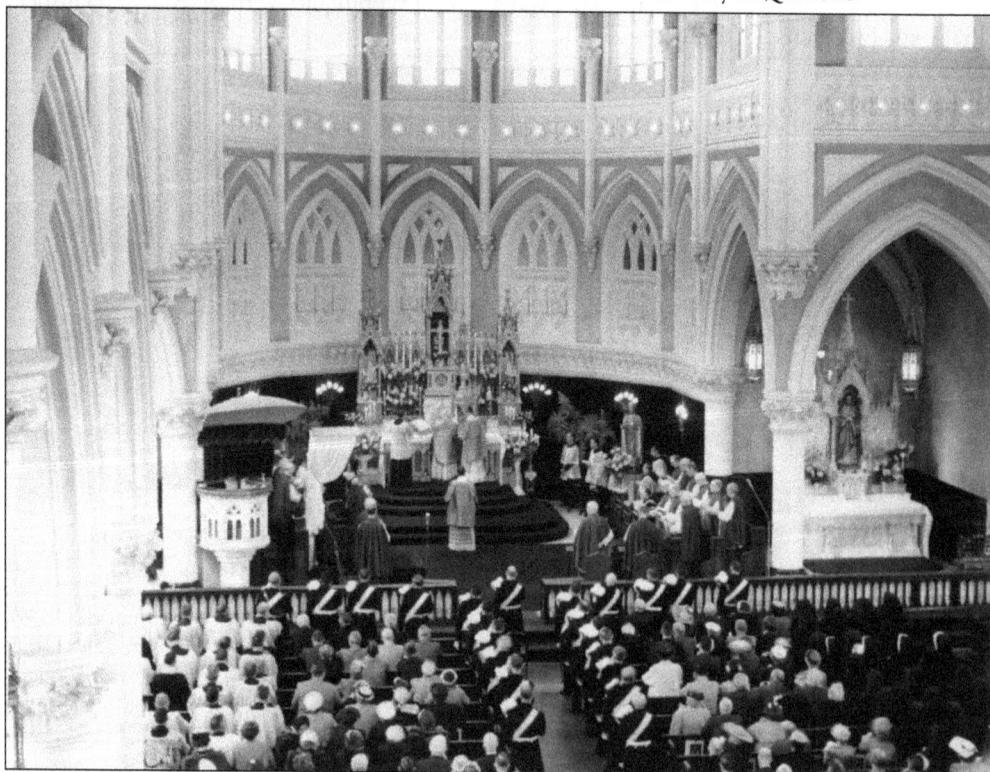

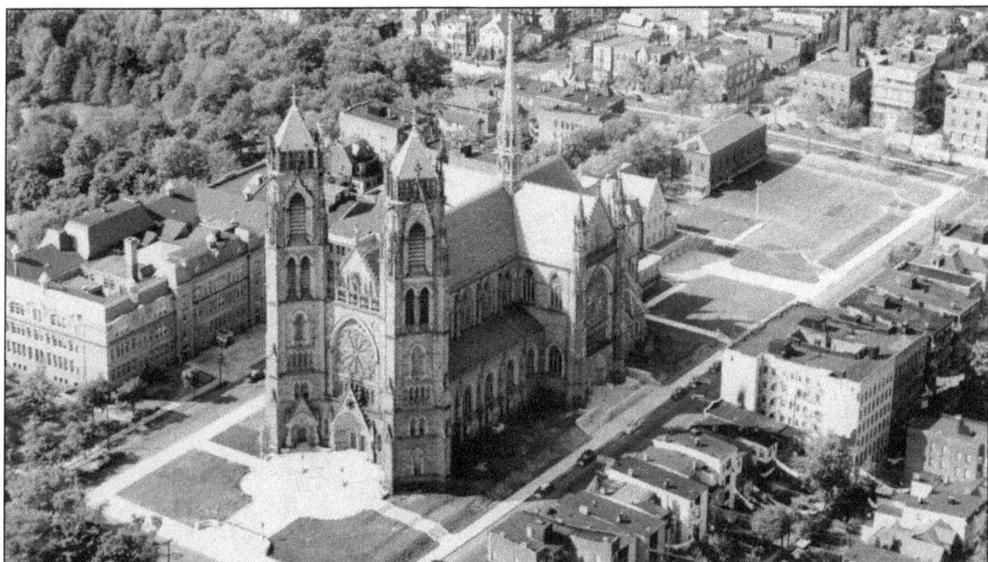

CATHEDRAL BASILICA OF THE SACRED HEART. Presently the fifth-largest cathedral in the United States, Sacred Heart is located on the edge of Branch Brook Park in Newark. This imposing hybrid English-Irish and French Gothic structure based on such models as Chartes and Rheims was originally conceived by Bishop Bayley in 1859. This parcel of land was purchased by the See of Newark on January 2, 1871. Due to various complications, work did not commence until 1898, and the cornerstone was not laid until June 11, 1899. By 1918, the greater part of the exterior structure reached completion. However, the official dedication would not bear fruit until October 19, 1954, with state and national landmark certification coming two decades later. This also came before the personal declaration of Pope John Paul II that Sacred Heart be elevated to basilica status in 1995.

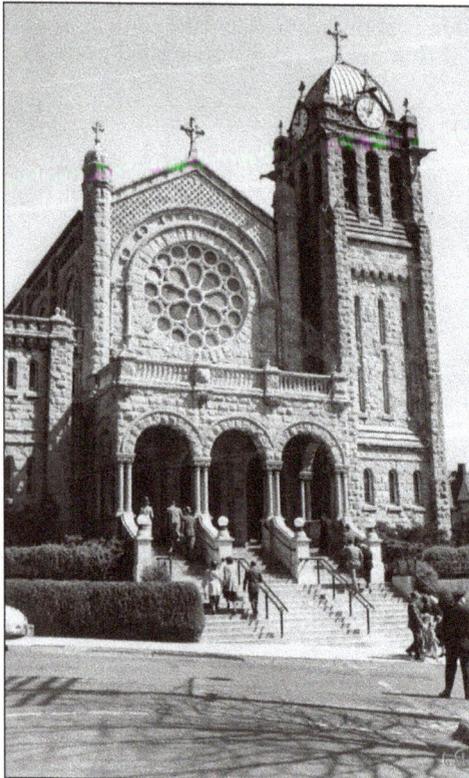

CHURCHES OF BERGEN. The beauty of the parishes found here is echoed in the lines of St. Luke's, Ho-Ho-Kus (1864), and St. Cecilia's, Englewood (1866). These structures were followed by St. Brigid, North Bergen (1900); O.L. of Mount Virgin, Garfield (1901); O.L. of Mercy, Park Ridge (1902); St Elizabeth, Wyckoff (1902); St. Joseph, Oradell (1903); Sacred Heart, Lyndhurst (1905); Holy Trinity, Fort Lee (1906); St. Anastasia, Teaneck (1908); St. Anne, Fair Lawn (1909); St. Joseph, Hackensack (1909); O.L. of Victories, Harrington Park (1910); Holy Name, Garfield (1911); St. John the Evangelist, Leonia (1912); St. Michael, Lyndhurst and Palisades Park (1912); O.L. of Grace, Fairview (1913); Sacred Heart, Haworth (1914); Heart of Mary, Mahwah (1915); Epiphany, Cliffside Park (1916); O.L. of Sorrows, Garfield (1917); Sacred Heart of Rochelle Park (1917); St. Francis, Hackensack (1917); St. Joseph, Lodi (1917); St. Stanislaus Kostka, Garfield (1917); Immaculate Conception, Norwood (1921); Queen of Peace, North Arlington (1922); St. Nicholas, Palisades Park (1923); St. John the Baptist, Hillsdale (1925); and Assumption, Wood-Ridge (1926).

CHURCHES OF BERGEN CETERUS.
Houses of worship such as Mount Carmel, Ridgewood (1889), and St. Mary's, Rutherford (1908), share the aesthetic distinctiveness with other impressive edifices including Immaculate Conception, Mahwah (1930); St. Anthony's, Moonachie (1931); St. Leo, Elmwood Park (1931); St. Paul, Ramsey (1931); St. Margaret, Little Ferry (1940); Most Sacred Heart of Jesus, Wallington (1942); Assumption, Emerson (1947); St. Peter the Apostle, River Edge (1948); Queen of Peace, Maywood (1950); Annunciation and Visitation, Paramus (1952); St. Gabriel, Saddle River (1952); Ascension, New Milford (1953); St. Catharine, Glen Rock (1953); St. Philip, Saddle Brook (1953); St. Pius X, Old Tappan (1954); Nativity, Midland Park (1955); O.L. of Good Counsel, Washington Township. (1959); O.L. of Perpetual Help, Oakland (1960); Blessed Sacrament, Franklin Lakes (1961); O.L. of Presentation, Upper Saddle River (1961); O.L. of Mount Carmel, Lyndhurst (1966); O.L. Mother of the Church, Woodcliff Lake (1967); St. Joseph, Demarest (1998); and Korean Martyrs, Saddle Brook (1998).

CHURCHES OF ESSEX. Shown left is Queen of Angels, Newark (1930), the first African American parish in the archdiocese. In juxtaposition to exteriors, the interior artistry evident in churches throughout the See include mosaics, stations of the cross and tabernacles along with ceiling décor shown at O.L. of Mount Carmel, Orange (1896) which shares proximity with early churches having their own brilliant history including, St. Rose of Lima, Short Hills (1852); Immaculate Conception, Montclair (1864); O.L. of the Valley, Orange (1873); St. Mary's, Nutley (1876); St. Venancius, Orange (1886); O.L. of Sorrows, South Orange (1887); St. Cassian, Upper Montclair (1895); O.L. of Mount Carmel, Orange (1896); O.L. of Mount Carmel, Montclair (1907); Holy Family, Nutley (1905); St. Catherine, Hillside (1912); O.L. of Lourdes, West Orange (1914); and St. Joseph, Maplewood (1914).

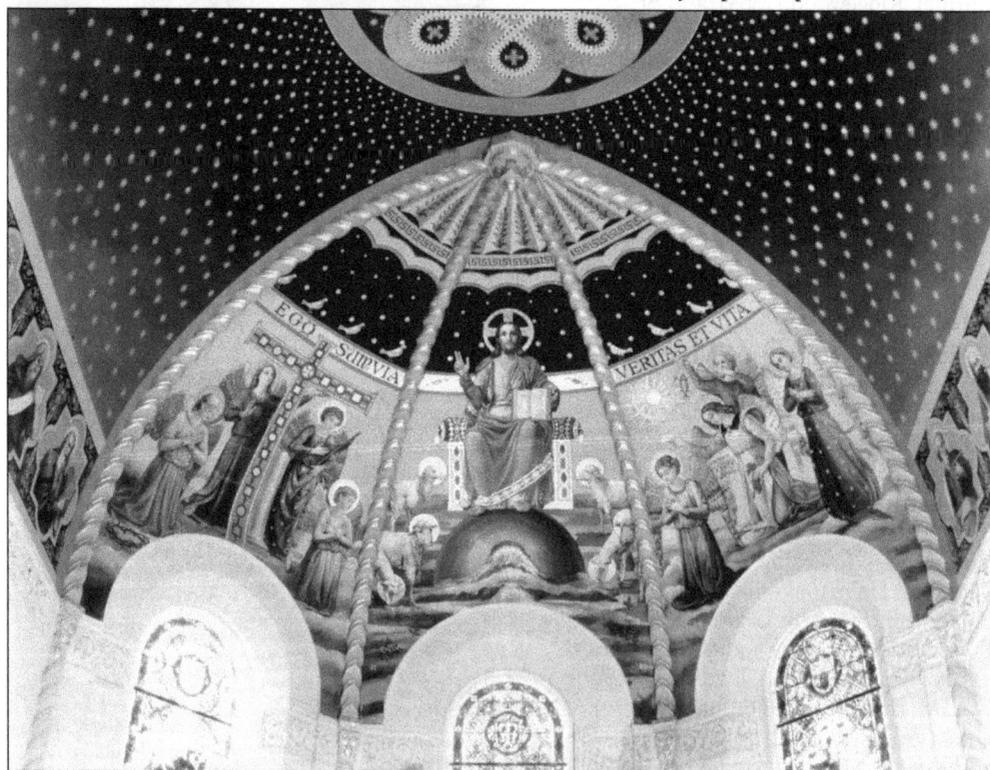

CHURCHES OF ESSEX CETERUS. The divergence of architectural modes that follow a similar purpose can be found in the popular Gothic style which contrasts to the more Art Deco–inspired blueprint evidenced in St. Leo's, Irvington (1878), and St. Peter Claver, Montclair (1932), respectively. Other buildings that have a proud history here include O.L. of the Lake, Verona (1923); O.L. of Mount Carmel, Nutley (1925); Sacred Heart of Jesus, Irvington (1925); St. Philomena, Livingston (1927); Holy Spirit, Orange (1931); St. Peter Claver, Montclair (1932); St. Joseph, West Orange (1934); St. Paul the Apostle, Irvington (1948); St. Catherine Siena, Cedar Grove (1949); Heart of Mary, Maplewood (1954); Blessed Sacrament, Roseland (1955); St. Rafael, Livingston (1961); St. Thomas More, Fairfield (1962); Notre Dame, North Caldwell (1963); and St. Andrew Kim, Orange (1972).

INTERIOR OF THE OLD CHURCH OF ST. MARY.

GOLDEN JUBILEE.

WE take great pleasure in presenting to-day the Jubilee number of the PARISH JOURNAL. The day we celebrate is indeed fitting the solemnity and importance attached to it. Fifty years have gone by since the establishment of our parish and this Golden occasion marks our cherished memory of the event and our many sweet recollections of the past.

Some will assist at the ceremonies to-day whose parents were pioneers in the infancy of the Church of Our Lady of Grace; many whose memories will go back to its early growth and all, surely, will rejoice that so much good has been accomplished, that the faith, beginning like the little grain of mustard seed, has taken root and developed to great propor-

CHURCHES OF HUDSON. The splendor of parishes within this county show strong ties to the people they serve, as several neighborhoods have been distinguished by respective landmarks embracing O.L. of Grace, Hoboken (1894), the first parish in this major city, and St. Lawrence of Weehawken (1887), for example. Nearby sister churches include St. Joseph of the Palisades, West New York (1854); Holy Family, Union City (1857); Holy Cross, Harrison (1865); St. Joseph's, Hoboken (1871); St. Augustine's, Union City (1886); St. Joseph's, Union City (1887); St. Francis, Hoboken (1888); St. Peter & Paul, Hoboken (1889); St. Cecilia's, Kearny (1893); St. Mary's, West New York (1895); O.L of Mount Carmel, Bayonne (1898); and St. Anthony of Padua, Union City (1899).

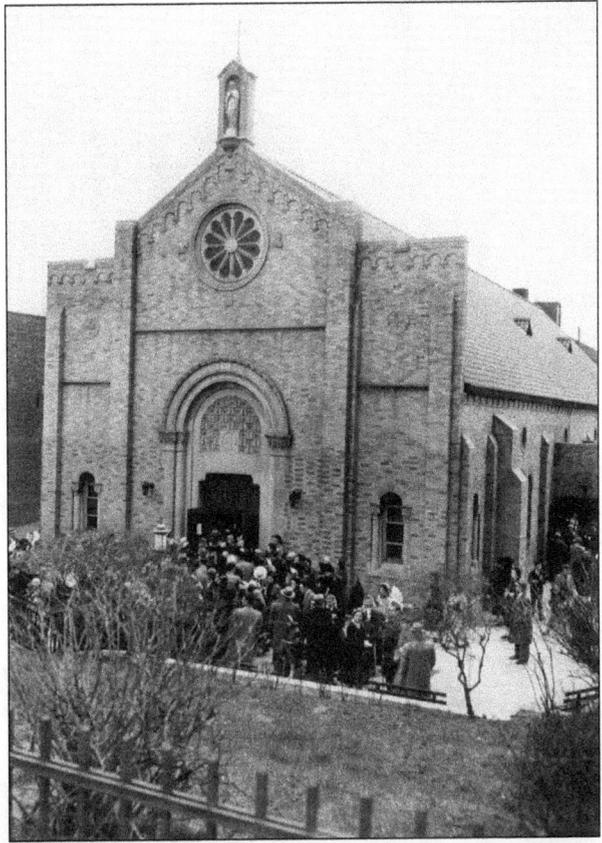

CHURCHES OF HUDSON CETERUS. The popularity of the Catholic Church in this area has shown a sustained level of physical and passionate growth through the years. Our Lady (Madonna) of Libera (1902) is a parish that has well served generations of congregants still in operation to this day. The same distinction of long-standing tradition can be found at St. Mary Star of the Sea, Bayonne (1861), the oldest parish in that city viewable in this c. 1952 image. Other churches in the area include St. Ann, Hoboken (1900); St. Stephen, Kearny (1904); O.L. of Czestochowa, Harrison (1908); Immaculate Conception, Secaucus (1908); Assumption, Jersey City (1909); St. John Nepomucene, Guttenberg (1910); St. Rocco, Union City (1912); O.L. of Sorrows, Kearny (1915); Sacred Heart, North Bergen (1917); and O.L. of Fatima, North Bergen (1963).

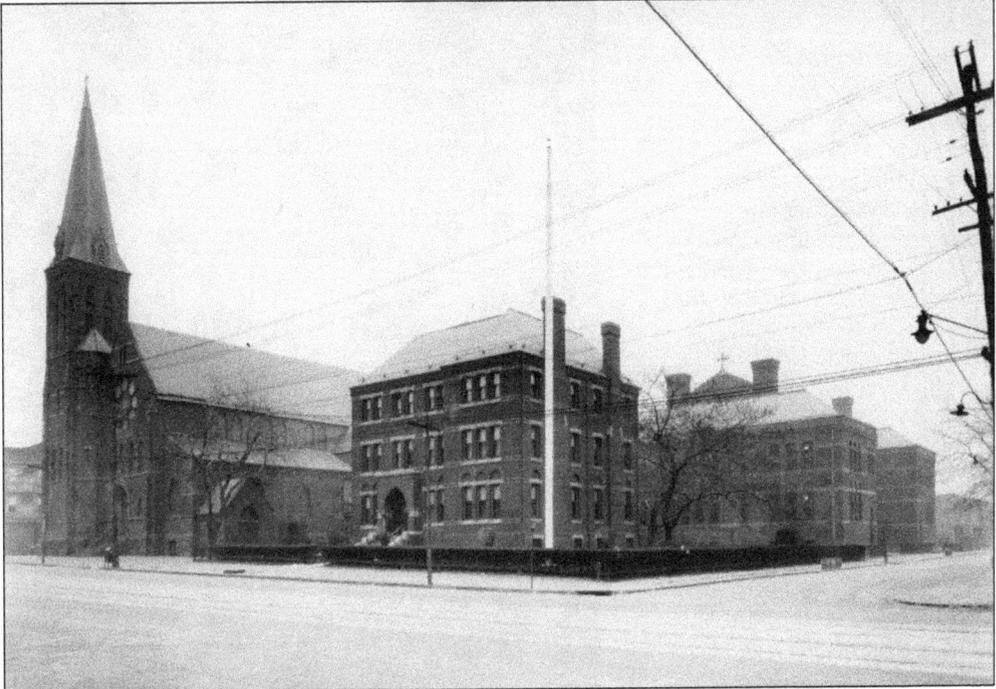

PARISH TRINITY. The southernmost county located within the See of Newark is Union, which features a number of different parishes with their own distinctive character, like those found beyond the reaches of this spiritual district alone. Shown here is another early bellwether parish in St. Patrick's, Elizabeth (1858), a structure that possesses twin majestic spires and a classic façade. Also evident from this early 20th century snapshot is an adjoining schoolhouse and rectory to the left.

CHURCHES OF UNION. This c. 1955 photograph of a groundbreaking in Linden at Holy Family shows Father Edward Kozlowski, Monsignor James Looney, and Archbishop Boland. Other churches situated within this deanery include Holy Trinity, Westfield (1872); St. Joseph, Roselle (1895); Church of the Assumption, Roselle Park (1907); Immaculate Conception, Elizabeth (1907); St. Elizabeth, Linden (1909); St. Catherine, Hillside (1912); St. Bernard, Plainfield (1921); St. James, Springfield (1923); St. Anne, Garwood (1925); St. Stanislaus Kostka, Plainfield (1919); and St. Michael, Union (1928).

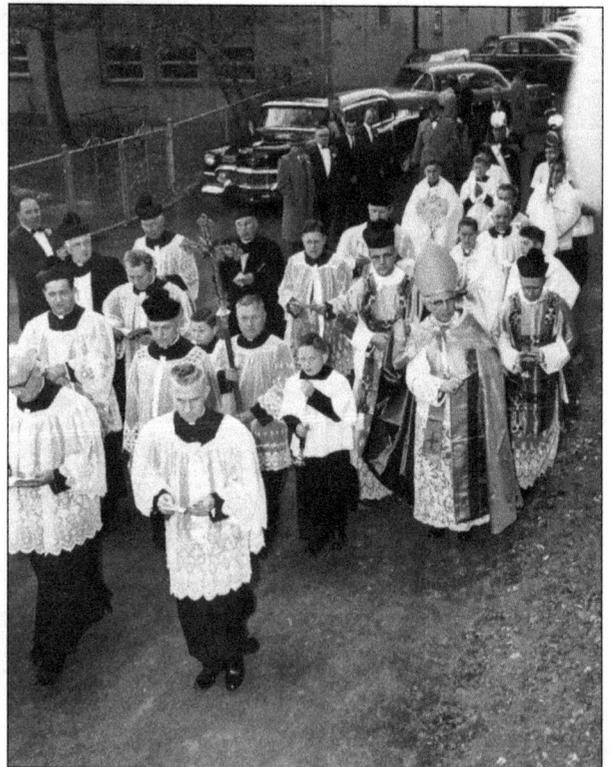

CHURCHES OF UNION CETERUS. This is an early 1950s view of St. Mark's, Rahway (1871). Other notable churches at the time were built in Union County, including O.L. of Peace, New Providence (1942); Immaculate Heart of Mary, Elizabeth (1947); Christ the King, Hillside (1948); St. Bartholomew, Scotch Plains (1948); St. John the Apostle, Linden (1948); St. Theresa, Kenilworth (1949); Holy Family, Linden (1955); O.L. of Lourdes, Mountainside (1958); St. Agnes, Clark (1961); Holy Spirit, Union (1963); Immaculate Heart of Mary, Scotch Plains (1964); St. Helen, Westfield (1968); and O.L. of Fatima, Elizabeth (1973).

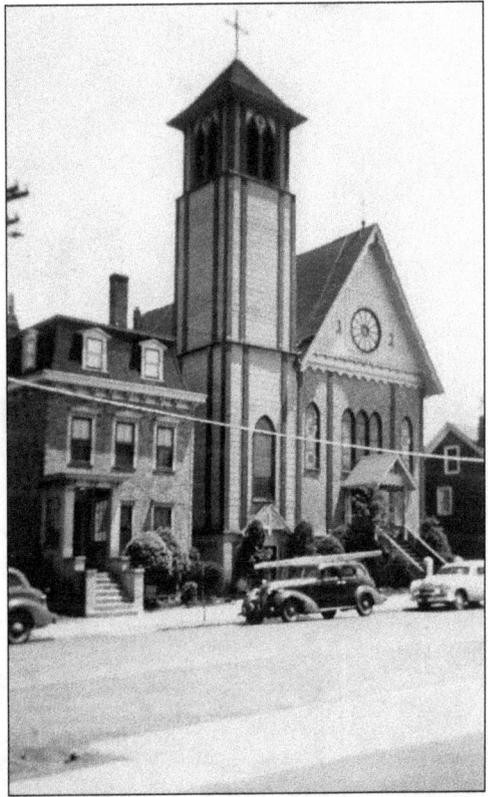

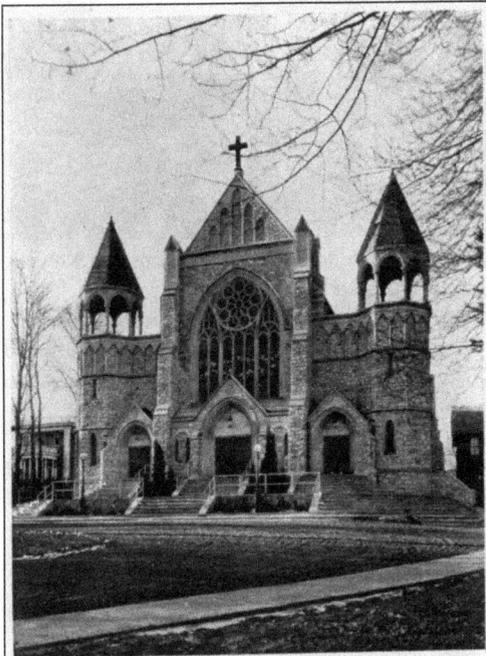

ST. TERESA'S CHURCH
SUMMIT, N. J.
Bernard E. Jamme, *Architect*

Front Elevation

CHURCH CARDS. This image was part of a series of postcard imprints featuring St. Teresa's, Summit (1863), among the earliest of parishes—not only countywide, but within the See proper. Sending and collecting postal greeting cards featuring local sites, including church edifices—either in still form, drawn, or color-tinted alike, such as these—was a popular late-19th-century activity that continues today.

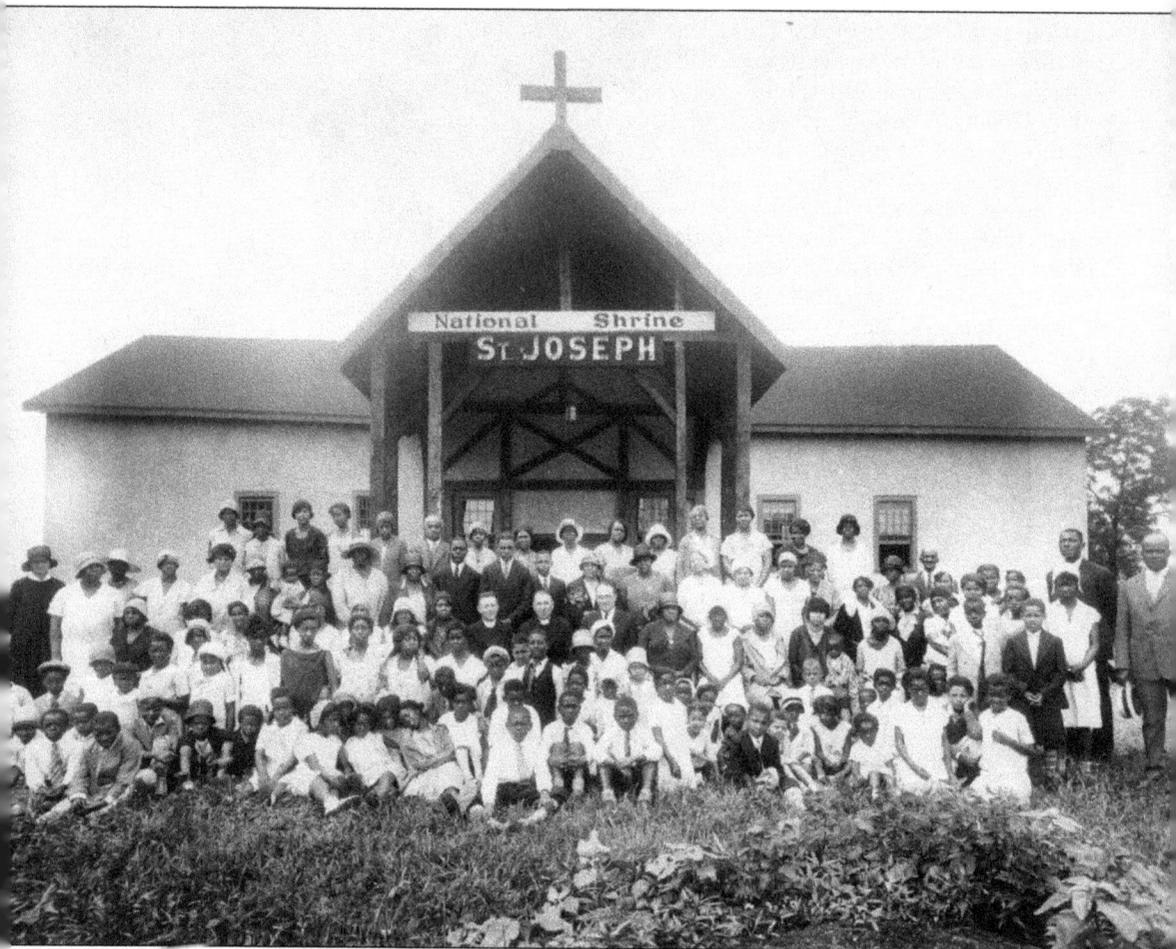

CHAPELS AND MISSIONS. Part of the landmark legacy that predates the Archdiocese of Newark rests in the first modest, yet welcoming, parish structures located throughout New Jersey. There were around 1,000 adherents statewide by 1814 when the first formal Catholic church building was erected at Trenton and christened St. Francis of Assisi. Incorporated parishes, chapels, and missions arose at Macopin, Mount Hope, Paterson, Morristown, Dover, Mendham, Basking Ridge, Springfield, Lambertville, Perth Amboy, and Princeton, among other locales between the 1830s and the outbreak of the Civil War. Shown here is the National Shrine of St. Joseph, Stirling, during the 1930s. Each of the aforementioned spiritual outposts were part of the Newark See at one time, and their origins are more than a footnote in the evolution of state parish boundary maps alone.

Seven

INSTITUTIONS

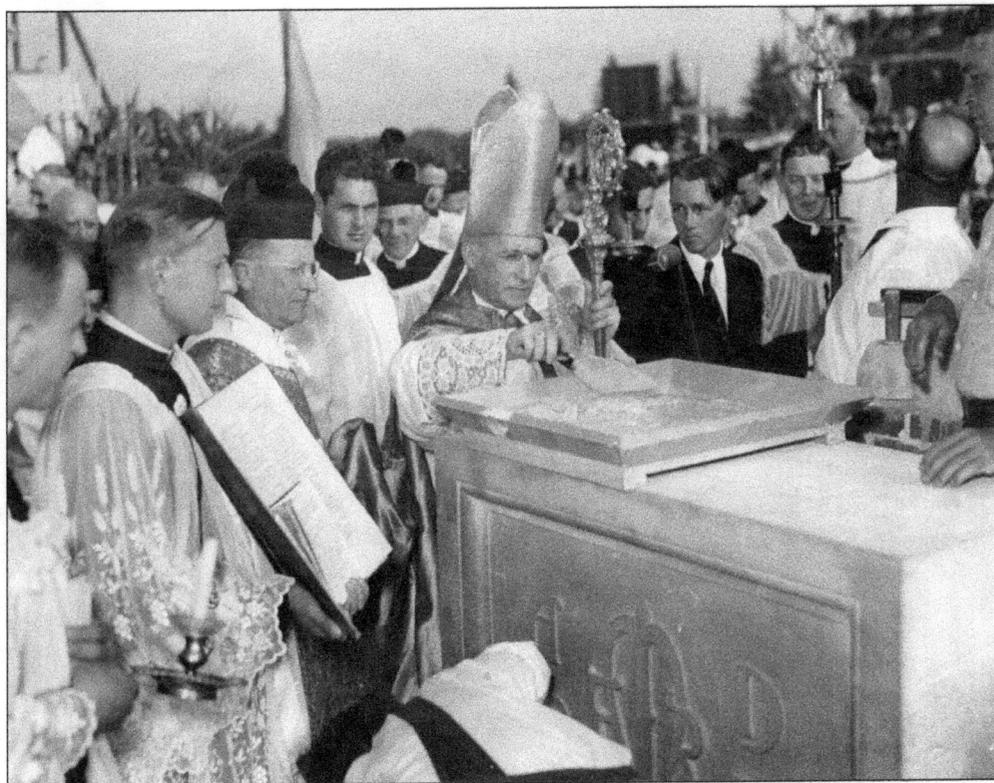

FOUNDATIONS. The manufacture of special-use buildings begins with a vision, blueprint, and proper framing materials. Within the Archdiocese of Newark, many of these functional and uniquely purposed structures have been built over the years. As with any construction, it is done with great solemnity, as evidenced through the actions of Archbishop Walsh who officiated at the christening of Christ the King Chapel, Immaculate Conception Seminary when it was located in Mahwah (Darlington). Onlookers show their devotion during the festivities in this 1937 photograph.

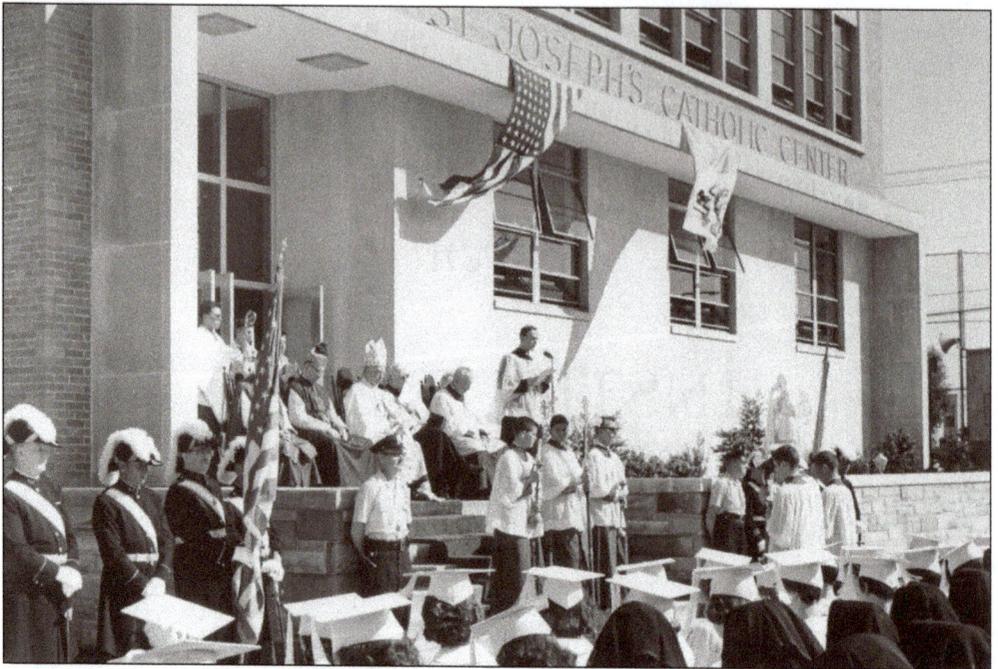

SPIRITUAL STRUCTURES. Above is a look at the St. Joseph's Catholic Center located in West New York, with Archbishop Boland presiding at the grand opening on June 22, 1958. The image below shows St. Mary's Orphanage, one of the earliest church-run institutional structures for child welfare when it was located on the corner of Washington and Bleeker Streets in Newark. It was built about a century prior to its similarly named counterpart in Hudson County. Other like centers of trust and refuge include Home for the Aged, Little Sisters of the Poor, Newark (1878); St. Joseph's School for the Blind, Jersey City (1899); St. Anne's Home, Jersey City (1911); and Mount St. Andrew's Villa, Paramus (1923).

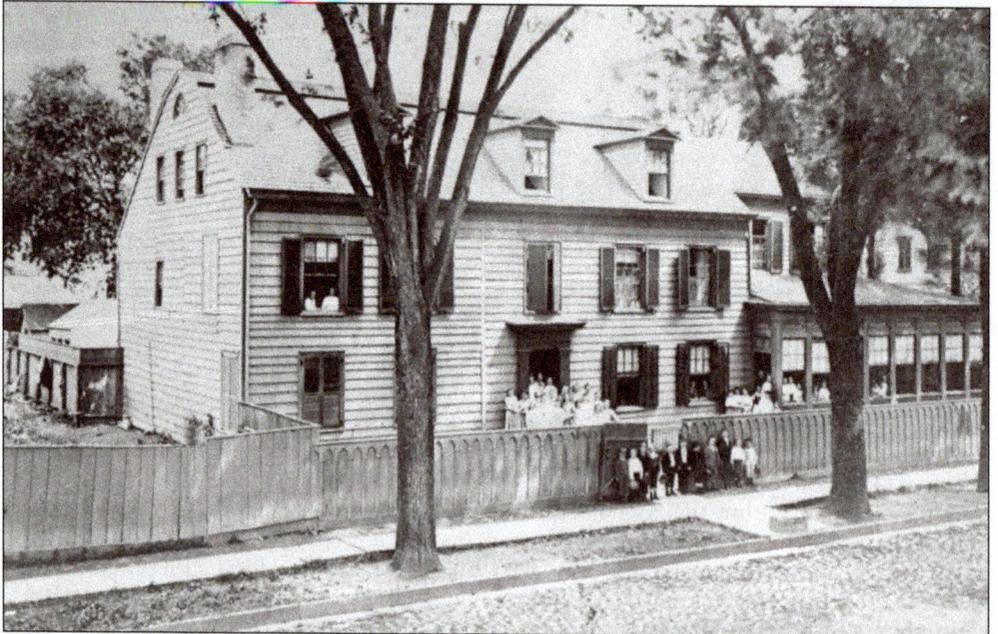

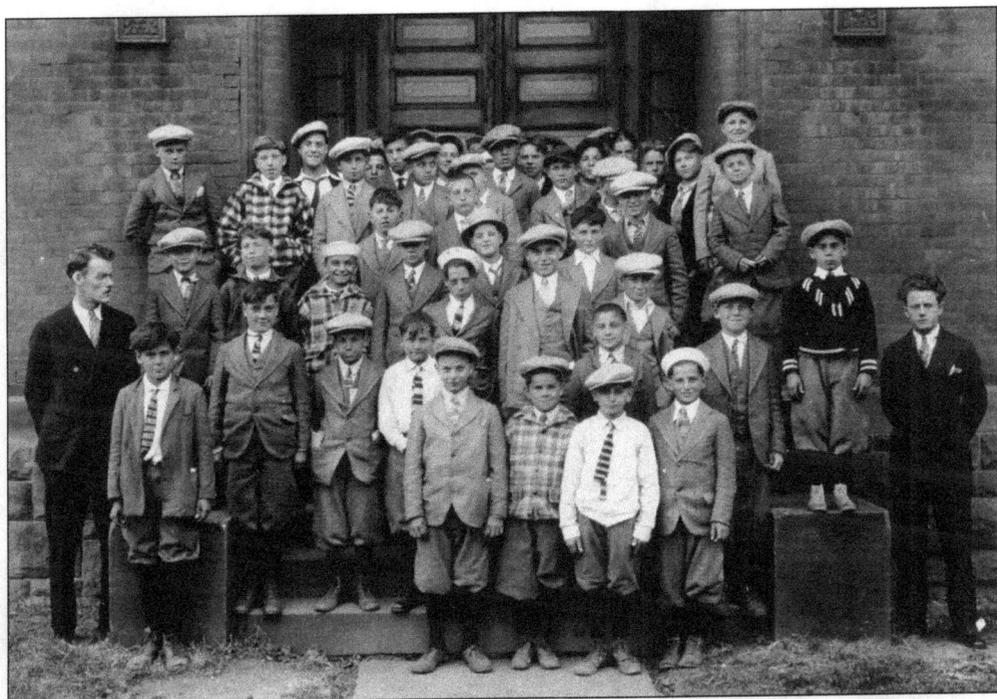

CHILDREN OF CHARACTER. Those young men and women who lost one or both parents became wards of fate and taken in by religious sisters who staffed and maintained neighborhood orphanages. Individuals shown on this page were residents of St. Joseph's, or St. Mary's Girls' Orphan Asylum of Jersey City during the early 1900s. Other charitable centers that fostered life skill encouragement included New Jersey Boys Town (1875) and the Catholic Protectory, Arlington (1880).

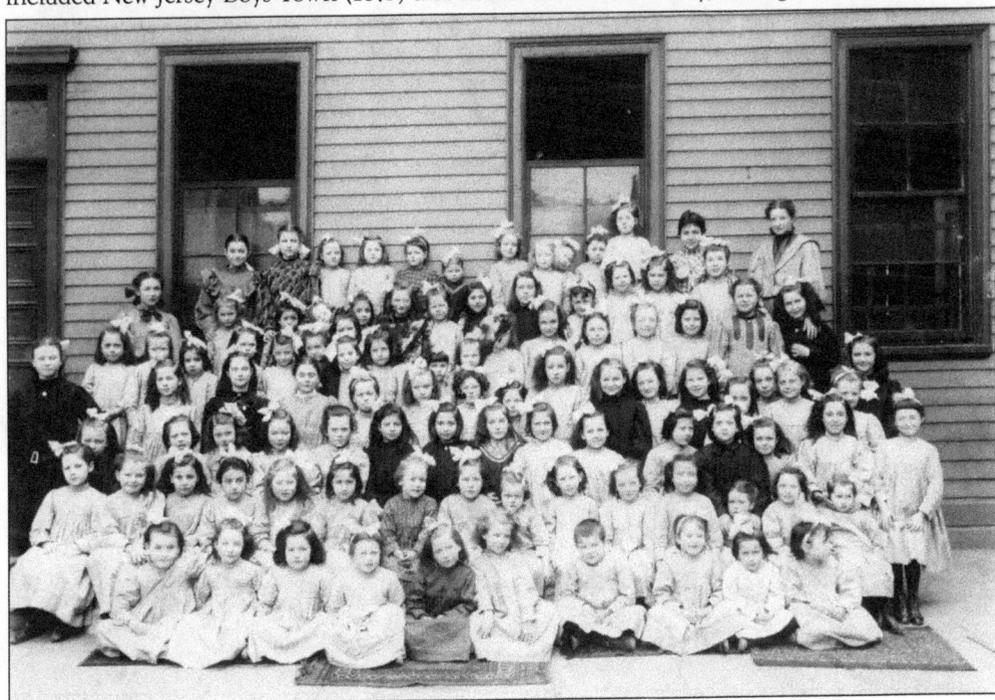

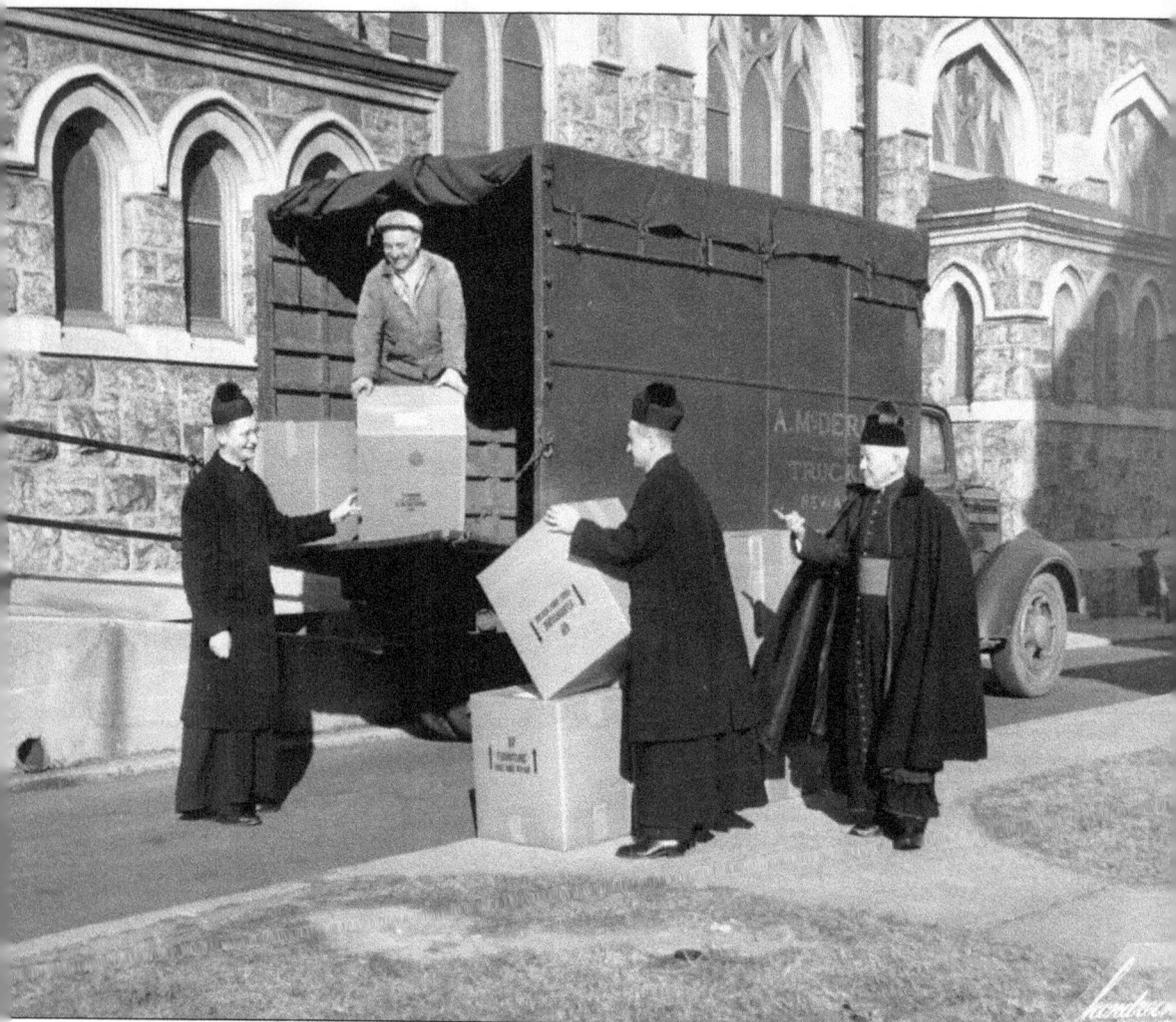

CHARITY DRIVE. Offerings made between parishes, institutions, and other entities at home and abroad marks the essence of Christian outreach. Shown in back of a vintage delivery truck, from left to right, are Fathers Francis Ignacuinos and John Wightman along with Monsignor Joseph Kelly as they prepare and stack boxes alongside other volunteers from St. Peter's, Belleville. These particular containers were filled with clothes to be sent to Europe during the Thanksgiving weekend of 1951, which is in line with the spirit of this popular American holiday that began as an officially sanctioned observance in 1863.

HOSPITALS. The pressing need for health and welfare refuges led to the creation of medical centers typically staffed by nuns and male religious orders who are devoted to this particular ministry. In the image right is an ambulance representing the first hospital, St. Mary's of Hoboken, established in January 1863 to serve all people who came to them for care. This trendsetting facility led to the inauguration of St. Francis in Jersey City and St. Michael's of Newark during the 1860s. In past years, there have been connections to general hospitals in Jersey City and Orange, as well as special medical centers affiliated with the Catholic Church in Newark, Elizabeth, and Teaneck.

New Jersey Catholic Records Newsletter

VOLUME II NO 3 Spring,

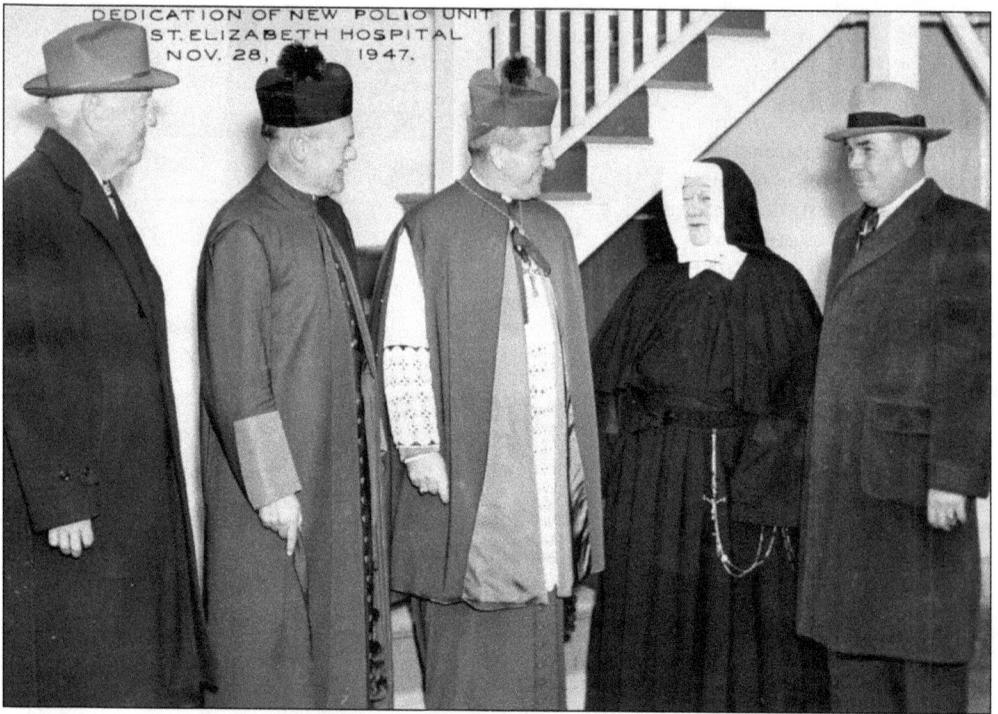

CHARITABLE ADMINISTRATORS. The sum success of hospitals comes in the partnership between those involved in its sustained care and upkeep. This often involves a close relationship with trustees, staff, professionals, and the patients in their care. Shown here from left to right at the dedication of St. Elizabeth Hospital in Elizabeth are City Engineer Thomas E. Collins, Monsignor Ralph Glover, Bishop McNulty, Sister Alicia Regina, and the enterprising mayor of Elizabeth, James T. Kirk on November 28, 1947.

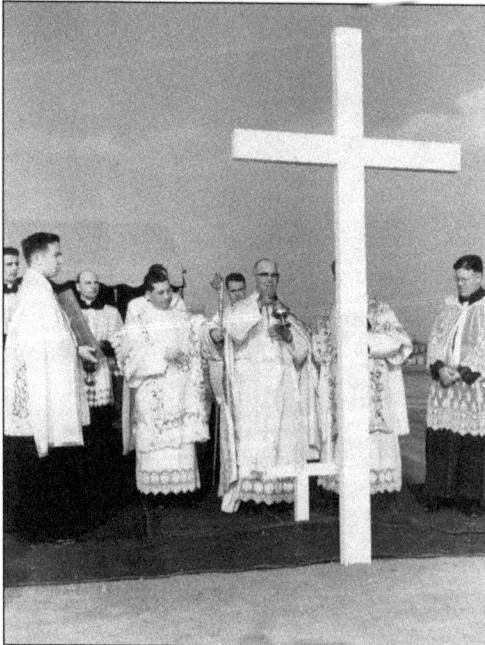

CEMETERIES. The consecration of ground for sacred burial and preparing the faithful for the sacrament of last rights is a necessary part of Catholic ritual. The earliest established cemetery within archdiocesan boundaries was St. Peter's in Jersey City (1849), followed a decade later by Holy Sepulchre in East Orange. Other comparable memorial grounds are located in North Arlington, Colonia, East Hanover, Franklin Lakes, Mahwah, North Arlington, and River Vale. An additional burial site, Holy Name in Jersey City, is seen here at its formal unveiling in 1956.

CATHOLIC PRESS. Print-based media became an important means of heralding information in regard to church centered news, events, and teachings throughout Catholic New Jersey over the years. The *Catholic Messenger* printed in Elizabeth during the 1890s, and the early 1900s century published *Catholic Monitor* (shown here) had a devoted local following in their time. Later, the New York City–based *Catholic News* featured a regular New Jersey section outlining news on the Newark See at regular intervals throughout most of the first half of the 20th century into the early 1950s.

THE MONITOR

The Official Catholic Weekly of New Jersey

NEWARK, N. J. SEPTEMBER 15, 1906.

Corner-Stone

Silver Jubilee

PIUS X.
A Study in Contrasts

THE ADVOCATE. The *Catholic Advocate* has been published continually by the Archdiocese of Newark from its inaugural December 31, 1951, issue onward. Featured here is the first editorial illustration from the pages of this weekly, which originally sold for 10¢. In terms of longevity, as current editor Michael Gabriele noted, "The *Catholic Advocate* in 2011 is proudly celebrating 60 years as the community newspaper for the Archdiocese of Newark."

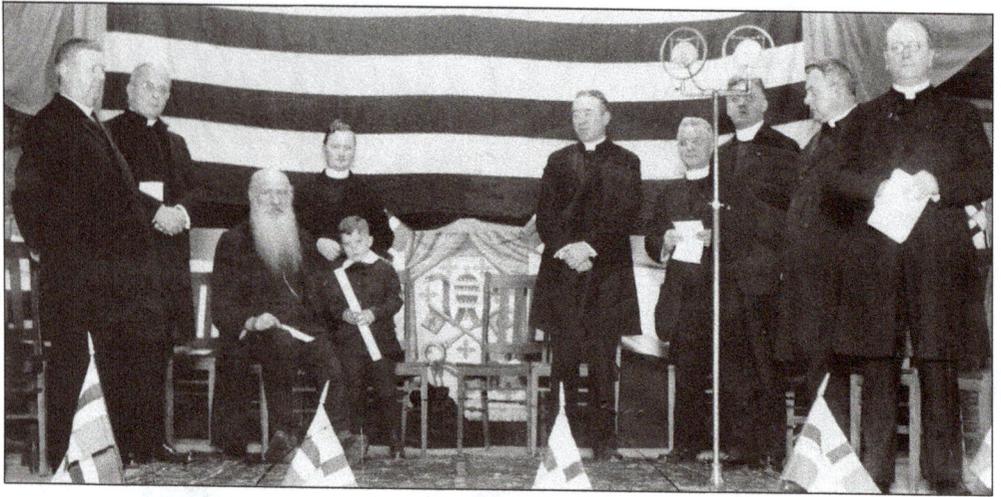

YOUNG SCHOLARS. Approximately 1,500 pupils were enrolled in Catholic schools throughout the area around the mid-19th century. This number escalated every year as more Catholic families were established, settled, and raised children within the heart of northern New Jersey. The situation was illustrated in wistful terms by the former superintendent of Parish Schools, Monsignor William F. Lawlor, when he wrote in 1928, "Suffice it to say that the record argues a vibrant sensitivity to things Catholic—a spiritual something that can be depended upon to render a whole-hearted co-operation whenever the voice of authority calls for Catholic support. In other words, our momentary backward glance is accompanied by a present assurance that the educational future holds no vital problem which we need hesitate grapple." This scene from the second-annual Catholic Students Mission Crusade on October 25, 1927, at the Newark Armory featured various advocates for educational enlightenment, aside from Lawlor, include Monsignors Edward Quirk, John Clary, John Weisbrod, Lawlor, along with Bishops McLaughlin and Griffin.

STUDY HALLS. The earliest parochial academies within the See of Newark were attached to its first parishes of St. John's and St. Patrick's Pro-Cathedral in Newark during the 1850s. There was a slow, yet steady, growth of church-based grammar schools, including Immaculate Conception, established in 1899 and pictured here around 1930. By 2003, there were over 90 grade schools within the archdiocesan system, from Bayonne to Wyckoff. As former student Jim Lowney noted, "My faith was formed in classes taught by Dominican nuns at St. Catherine School in Elizabeth. I loved reading the old *Baltimore Catechism*."

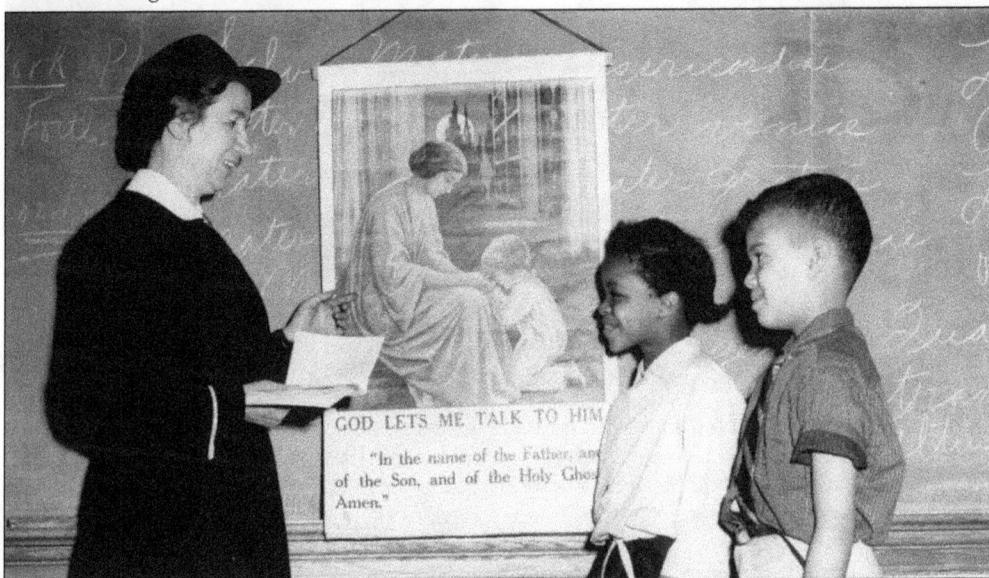

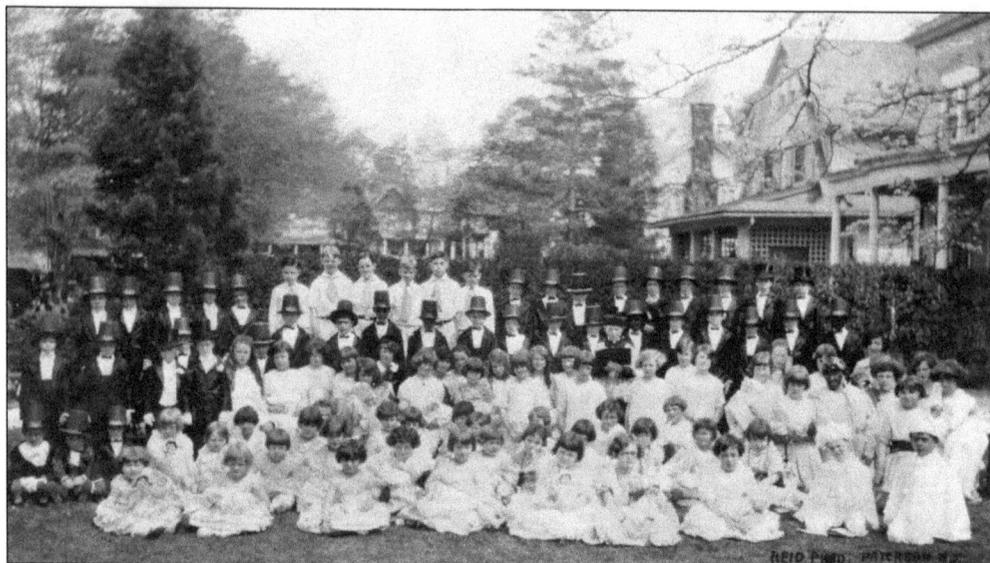

SCHOOL PAGEANTRY. The extracurricular choices in various parochial schools often included spiritual-based activities along with special events, such as this Thanksgiving-inspired gathering at the Our Lady of Mount Carmel School in Ridgewood during the late 1920s. Over the years, a host of activities, from spelling bees to dramatizations, were staged at most schools by their respective student bodies, but nearly at every point a religious theme was ever-present.

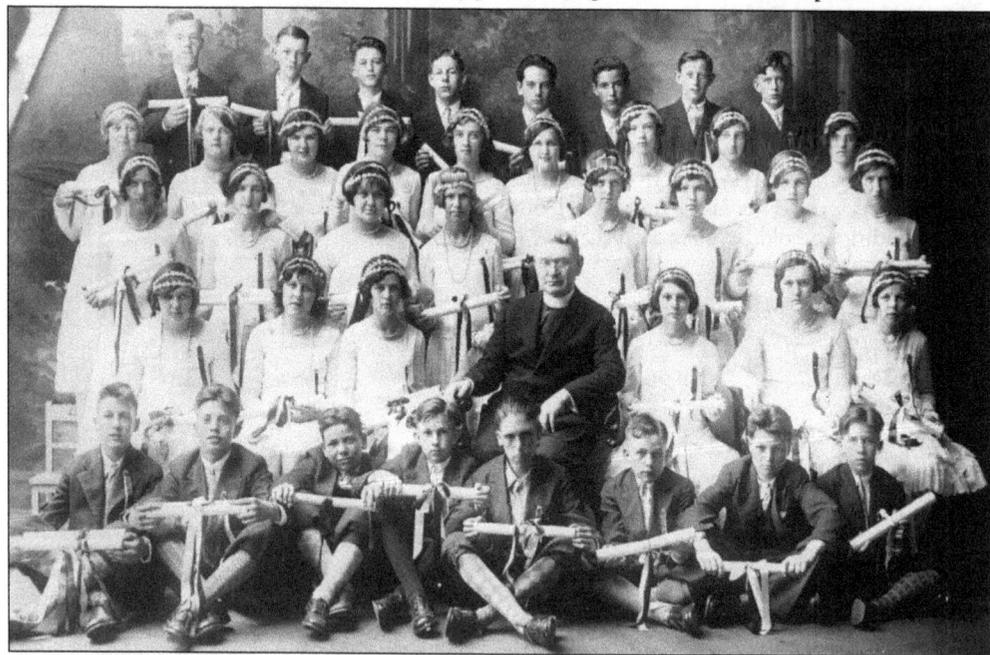

POMP AND CIRCUMSTANCE. Completion of studies is the end objective for those who embark upon a parochial-based education. These graduates represent the 1929 class of St. Henry's, Bayonne. The solemn faces and large diplomas show a serious, yet academically sound assemblage of aspiring professionals who either went on to further education, worked in the secular world, or followed a religious vocation as many of their fellow co-religionists who preceded them have, and future generations continue to decide.

112

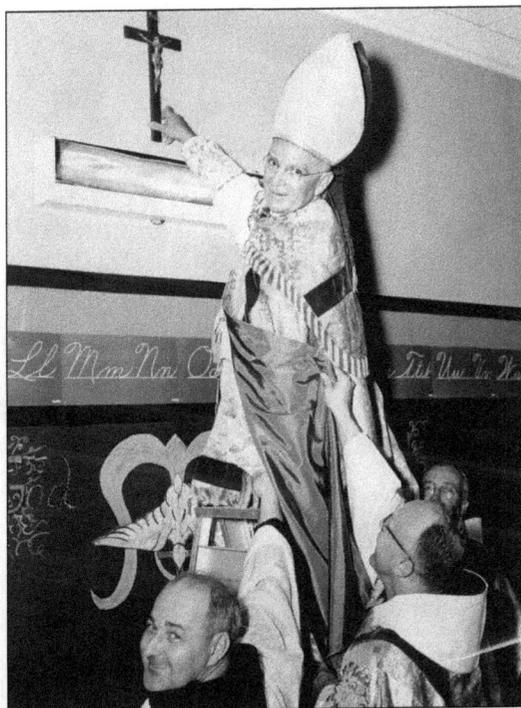

CLASSROOM BLESSING. The symbolic addition of a crucifix lends a distinctive touch to any classroom setting for those who experience lessons centered on Theology 101 and beyond, as the old-fashioned chalkboard partially reveals. Archbishop Boland also shows himself to have proper balance as he performs a traditional blessing while posing for the camera in this c. mid-1950s image.

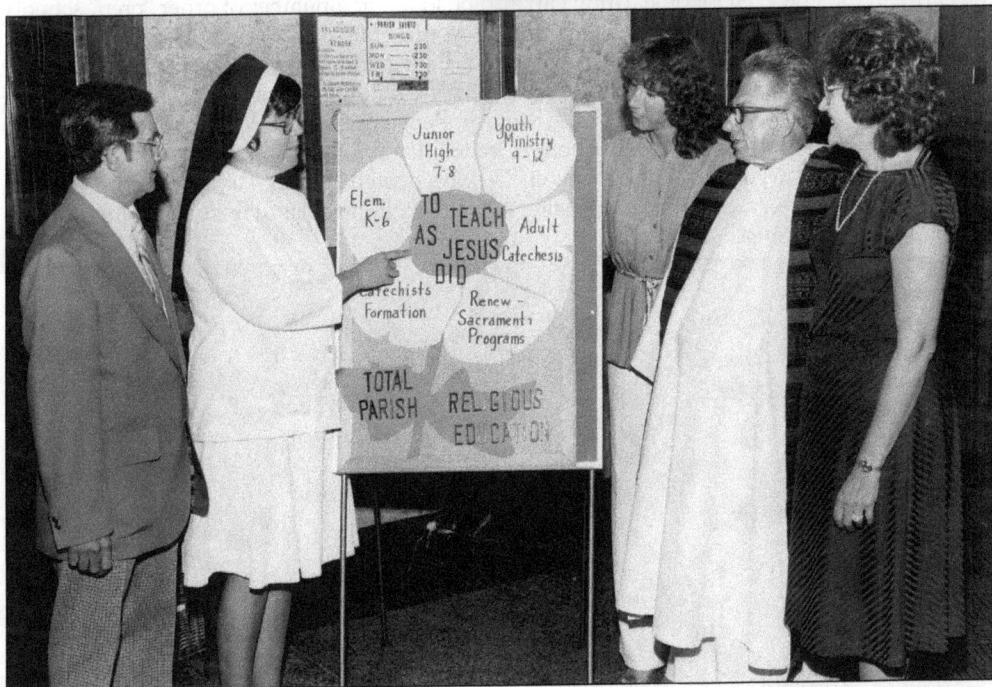

GRADE POINTS. During the late 1970s, enrollments at parochial academies fluctuated as public school attendance increased among adherents. The presence of the Confraternity of Christian Doctrine (CCD) offered through many parishes became a popular option for grade-school children, while Newman Center participation among college students offered further spiritual-academic perspective.

113

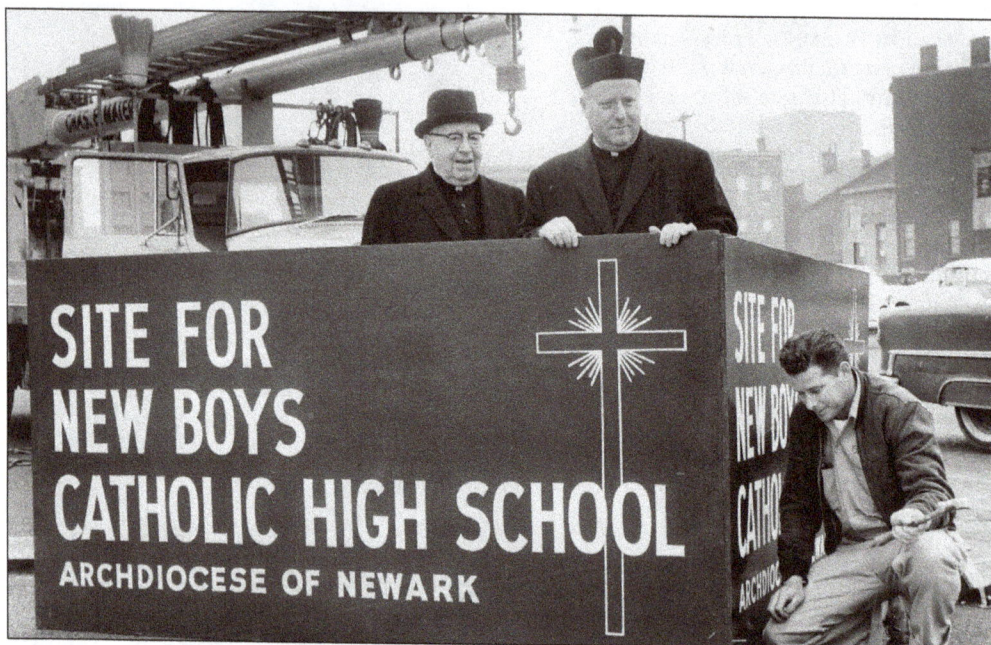

PREPARATORY PREFECTS. Above is a view of the building blocks for what became Hudson Catholic High School in Jersey City, and below an earnest class is hard at work on an examination during the early 1960s. The exercise of learning can also be found at a number of other "prep" schools within the archdiocese, including Holy Family, Bayonne; Mt. St. Dominic, Caldwell; Mother Seton, Clark; Holy Angels, Demarest; Assumption, Benedictine, and St. Patrick, Elizabeth; St. Anthony, St. Dominic, St. Mary, and St. Peter's, Jersey City; Immaculate Conception, Lodi and Montclair; St. Joseph's, Montvale; Christ the King, St. Benedict's, and St. Vincent, Newark; Queen of Peace, North Arlington, Bergen Catholic, Oradell; Paramus Catholic; Don Bosco, Ramsey; Roselle Catholic; St. Mary, Rutherford; Union Catholic, Scotch Plains; Marylawn, South Orange; Oak Knoll and Oratory, Summit; Lacordaire, Montclair; Immaculate Heart, Washington; and Seton Hall, West Orange.

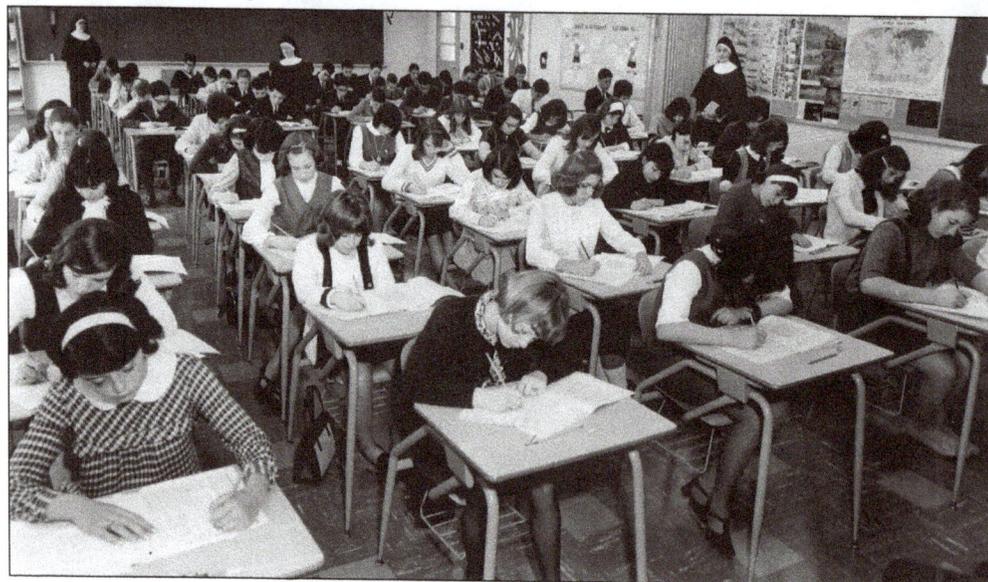

RESEARCH SKILLS. The nature of study shows the seriousness of purpose among those who utilized old school card catalogs and had the guidance of a sister librarian to teach them about the wonders of literature, social studies, and other subjects of note. These students from St. Leo's High School, Irvington, take advantage of their school library during the 1950s.

EDUCATIONAL COLLABORATIVES. The nature of assignments included on a syllabus, sites discovered on class trips and tutorial aid are some of the pedagogical highlights that awaited a parochial school student. Shown admiring a practical tome on world history at Essex Catholic High School during Catholic Press Month in 1960 are, from left to right, Father John Sheerin, CSP, former editor of the *Catholic World*, history teacher T.C. Murray, and students Virginia Kendall and Brian Clark.

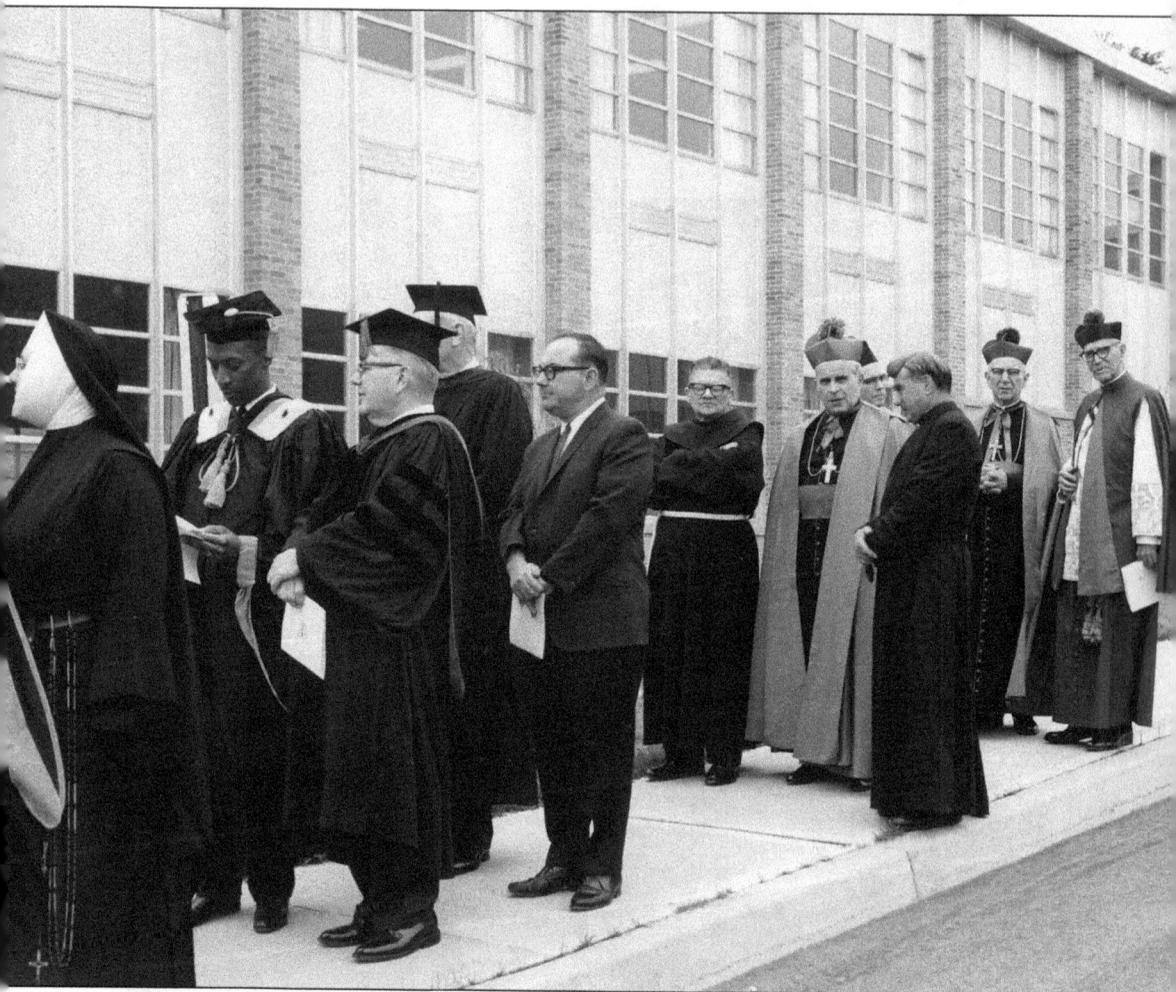

POST-SECONDARY HISTORY. The development of combined preparatory and collegiate academies within the See of Newark has evolved from seven-year curricular programs, found at Seton Hall and Saint Peter's Colleges during the 19th century, to separately incorporated secondary and post-secondary schools of today. During the early 20th century, the College of St. Elizabeth, founded in 1899 and located in Convent Station, served as the all-women's college for the See until it was absorbed by the Diocese of Paterson in 1937. The creation of Caldwell and Felician Colleges filled this particular void, but presently each four-year, church-affiliated school within the Archdiocese of Newark has since become fully coeducational. Another legacy in this chapter of parochial higher education history includes the presence of now defunct junior colleges within the boundaries of the archdiocese, such as St. Alphonsus College for Women of Woodcliff Lake, which was operated by the Sisters of St. John the Baptist. Seen here at their commencement exercises of May 21, 1967 is an order of dignitaries, which included the first African American professor at Seton Hall University, Dr. Francis Monroe Hammond, Bishop Dougherty, and Monsignors William Furlong and Charles Murphy, among others.

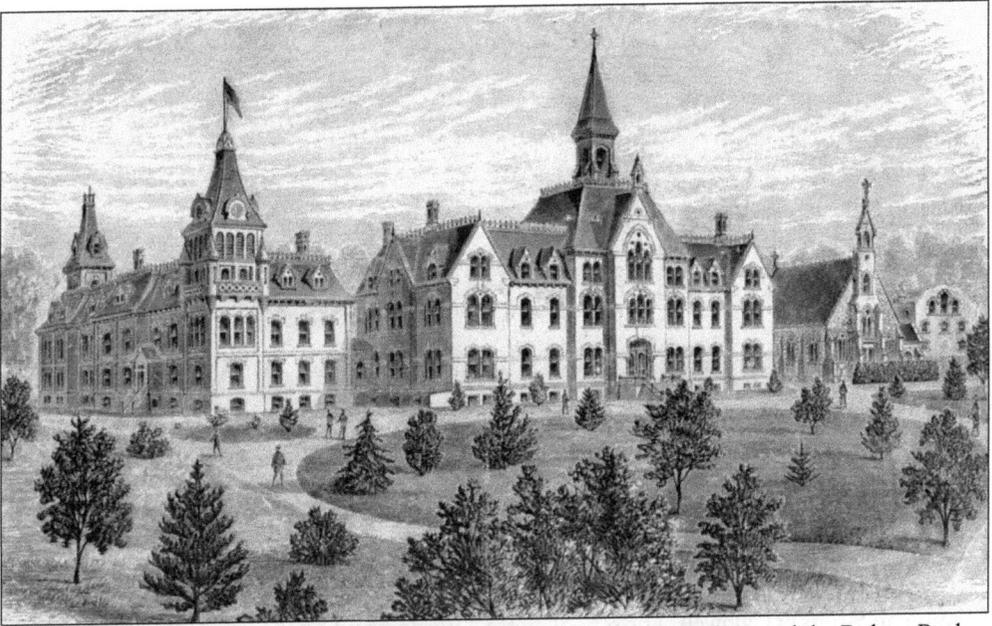

SETON HALL UNIVERSITY. Founded in 1856 as the diocesan college of Newark by Bishop Bayley, Seton Hall University was named in tribute to his aunt, and first American-born saint, Elizabeth Ann Seton. Initially located in Madison, the campus moved to South Orange in 1860 and achieved university status in 1950. This illustration of "Setonia" from the 1880s shows the campus green offset by the college building, seminary, and chapel.

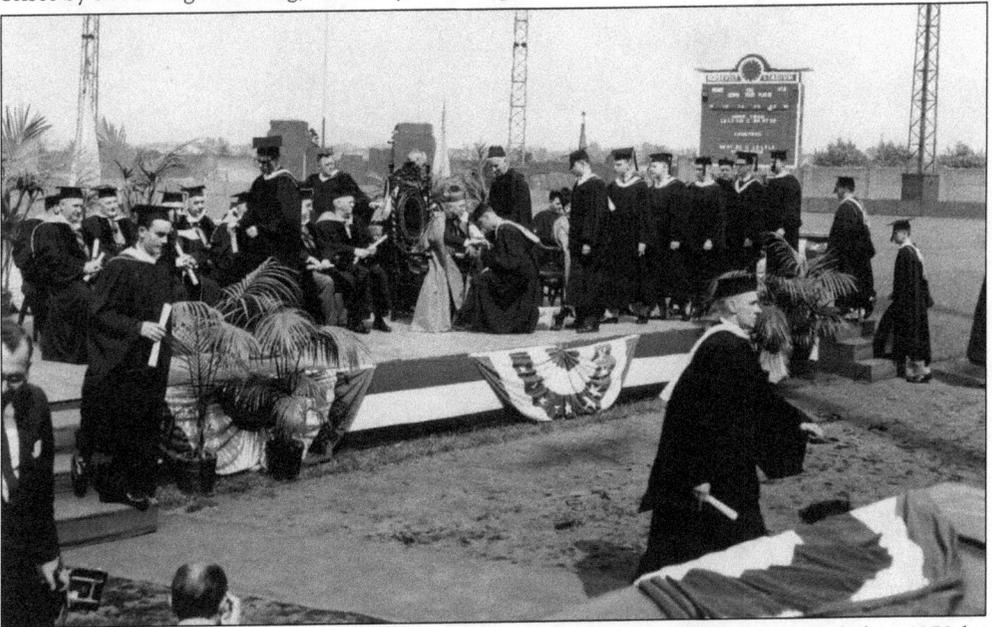

SAINT PETER'S COLLEGE. Located in Jersey City, Saint Peter's College was founded in 1872 by the Society of Jesus as a post-secondary school of liberal arts. Chartered in 1878, Saint Peter's experienced consistent growth until its closure in 1918 due to low enrollments caused by World War I. A renaissance occurred with the reopening of the school in 1930. Shown here are graduates at the commencement exercises of 1956 held at Roosevelt Stadium in Jersey City.

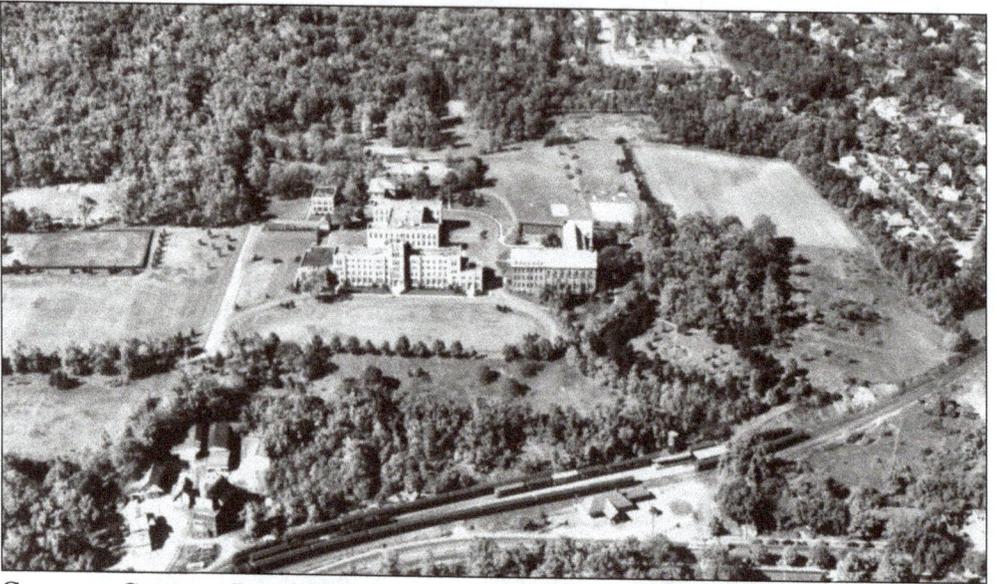

CALDWELL COLLEGE. Founded in 1939, Caldwell College is administered and staffed by the Dominican Sisters of Caldwell. The school motto, "Wisdom and Knowledge," became a hallmark of the college when accreditation from the Middle States Association was granted in 1952. Started as an all-female academy, Caldwell eventually became fully coeducational in 1985. This is an aerial view of the school around the time of its establishment.

FELICIAN COLLEGE. Located in Lodi with a companion campus in Rutherford, Felician College began operations in 1923 as the Immaculate Conception Normal School. This institute of higher learning became a junior college in 1942 and offered its first associate of arts degrees two decades later. The current name of Felician, adopted in 1967, represents the religious order of sisters who operate this school. Felician became coeducational in 1989. (Courtesy of the Archdiocese of Newark.)

Eight

UNIVERSAL

GLOBAL AND LOCAL HONOR. A prayer for peace became the rallying theme recited in every parish throughout the duration of World War II. Symbolism reigned as flags representing each allied nation served as the backdrop to this 1944 church function held in Newark. The term "Catholic" was first applied centuries prior by St. Ignatius of Antioch, who intoned that the faith belongs to all individuals regardless of ethnic, cultural, or racial distinction.

MOTHER TERESA. Counted among the most beloved individuals of recent years is the Nobel Prize–awarded Missionary of Charity from Calcutta. Mother Teresa visited the archdiocese on June 26, 1981 to establish a convent for her order at St. Augustine, Newark. She departed New Jersey in typical selfless style, noting, "I leave you my sisters. Go together in search of the poor. Go and find them. Having nothing, we can give everything."

FAMOUS FIGURES. The Archdiocese of Newark has produced or hosted a number of individuals from stage, screen, sport, and sacred renown. Among the divergent personalities forever linked here include former heavyweight boxing champion James J. Braddock (the "Bulldog of Bergen"), F. Scott Fitzgerald (studied in Hackensack), Will Durant (attended both Saint Peter's College and the Immaculate Conception Seminary), Vince Lombardi (taught in Englewood), and many others, including Bishop Fulton J. Sheen, famed television orator and frequent visitor, who is found in the center of this c. 1950s photograph.

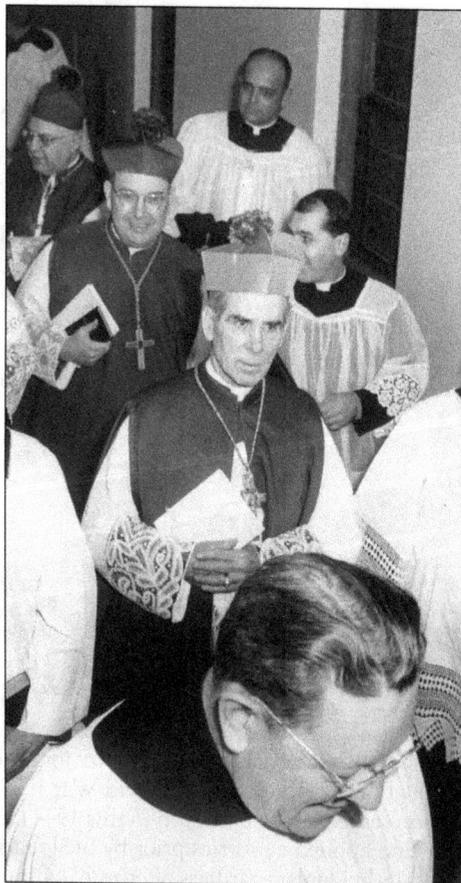

PARADE OF PRAISE. A celebratory and commemorative float entry from the parish of Our Lady of Perpetual Help in Newark is on display in the midst of a local Puerto Rican Day Parade in 1975. Those on the float acknowledge the applause of the crowds as they simultaneously honor a church structure that opened in 1964 but closed three decades later.

VISION OF DEVOTION. The beauty and symbolism shown in this constitutional was made in commemoration of the cultural diversity found within the Archdiocese of Newark. As church historian Monsignor Robert Wister has aptly proclaimed, "From its beginning in 1853, the Archdiocese of Newark has reflected the many cultures that make up the Catholic Church in the United States." He further noted that these followers represent "an ever-changing kaleidoscope."

CHILDREN OF THE WORLD. Youthful ambassadors of good will representing a wealth of global cultures meet to express their pride of ancestry and share family experiences with each other during the late 1970s. The ubiquitous symbolism of costume can also be found in religious ceremonies when, for example, youngsters might have dressed up as a member of the Holy Family during a Nativity recreation, or as their favorite saint to celebrate All Hallows Eve, for example.

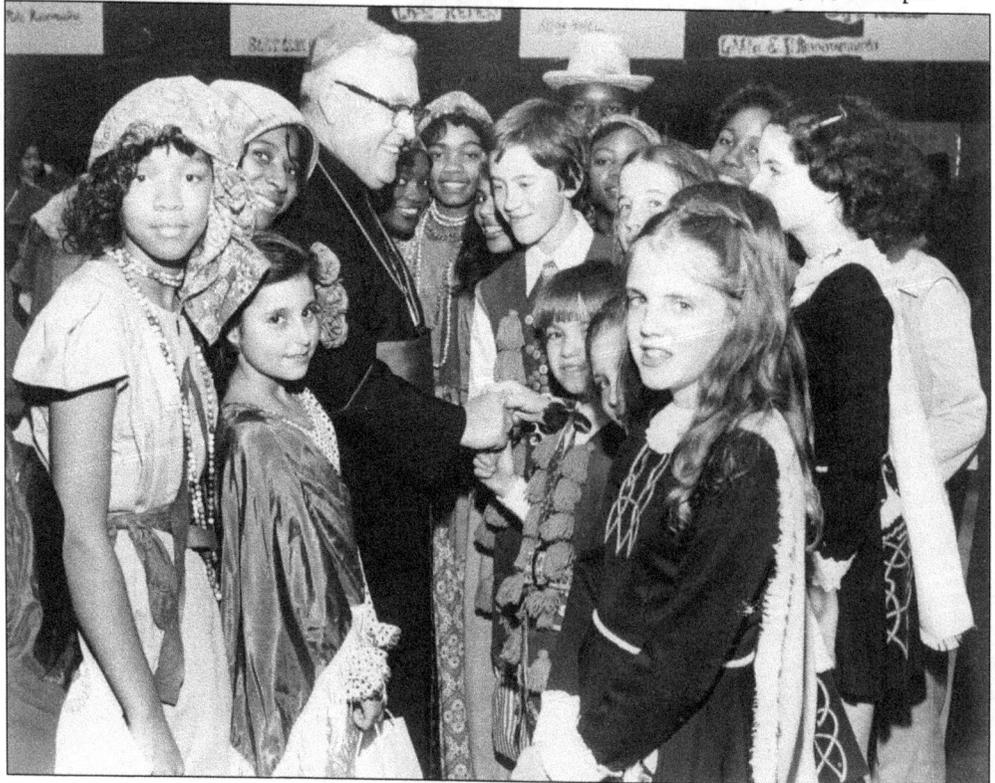

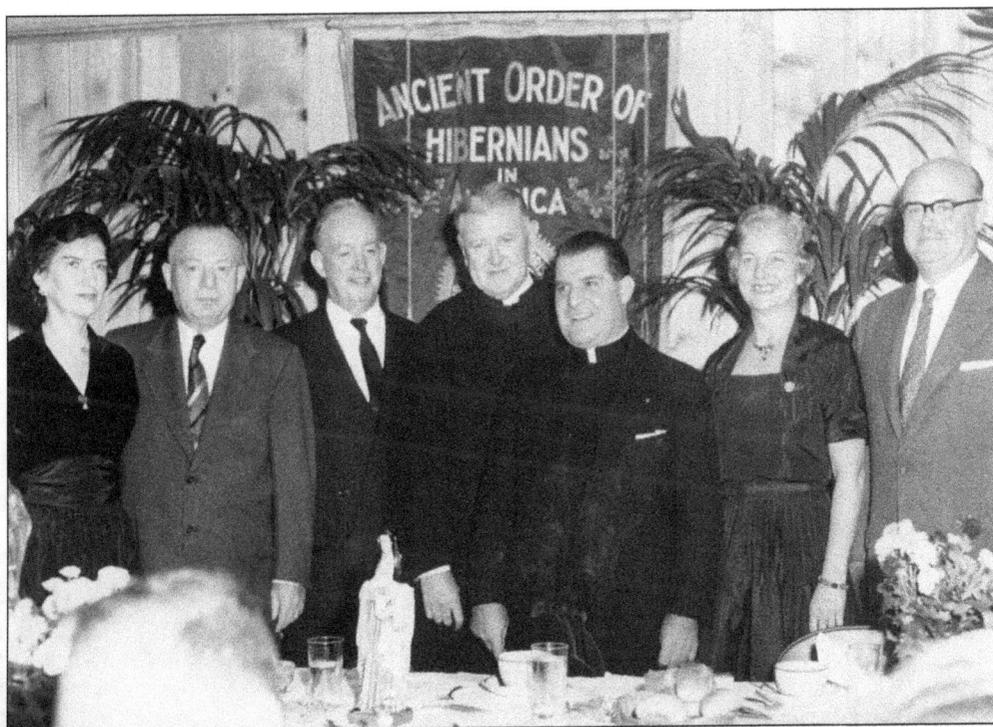

CULTURE OF CHARITY. Those with roots in Ireland have been among the first individuals to build and lead the Catholic Church in the United States. Founded in 1836, the Ancient Order of Hibernians promotes allegiance to their homeland through the principles of family, fraternity, and faith. The AOH has been a popular and active presence in the Archdiocese of Newark, as shown here is a Hudson County division event from the 1950s.

HONORING TRADITIONS. An event that inspires passion among its followers is the annual Feast of St. Gerard Majella celebration held at various Italian parishes throughout the archdiocese including St. Lucy's, Newark. This parish has been recognized as the National Shrine and a welcoming beacon for this holy icon. Pictured here in the traditional pinning of devotional tender during the 1976 ceremony, from left to right, are Gerald Spatola O'Connor, Albina (Bina) Spatola, and Rocco Ferrante. (Courtesy of Gerald O'Connor and Albina Spatola.)

PEOPLE OF NEWARK. From its origins onward in place and time, the Archdiocese of Newark as part of the Garden (symbolic of cultivation) State is one of the most densely populated Sees in the nation and has served in global concert to millions throughout the course of its history and reflected beauty. Counted together within the course of its century and a half, the worldwide assemblage of cultures represented include African Americans, Brazilians, Cameroonians, Chinese, Colombians, Congolese, Croatians, Cubans, Czechs, Dominicans, Egyptians, English, Filipinos, French, Germans, Haitians, Indians, Irish, Italians, Hungarians, Jamaicans, Kenyans, Koreans,

Latin Americans, Lebanese, Mexicans, Nigerians, Lithuanians, Palestinians, Polish, Portuguese, Puerto Ricans, Slovaks, Slovenians, Syrians, Ugandans, Ukrainians, Vietnamese, and Zambians, among others. In many instances, the need for a closer sense of immediate community, ceremony and language at various ethnic and national parishes arose over the years. The Latin (or Roman) rite of the Catholic Church is followed by most within the fold, but various other rites, including Armenian, Byzantine, Armenian, Chaldean, Coptic, Ethiopian, Maronite, and Syro-Malabar, remain part of the same family tree.

HISTORICAL LEGACY. The cover from this commemorative edition of the *Catholic Advocate* shows a portion of the illustrative panorama that has comprised the life story of the Archdiocese of Newark since 1853. The ellipses also serve as a symbolic prelude to future milestones, as Archbishop Myers proclaimed: "Most of all, though, these past 150 years tell a story of people—of loyal and devoted Catholics . . . like you, your children and all who join this Church of Newark will shape our future." (Courtesy of the Archdiocese of Newark.)

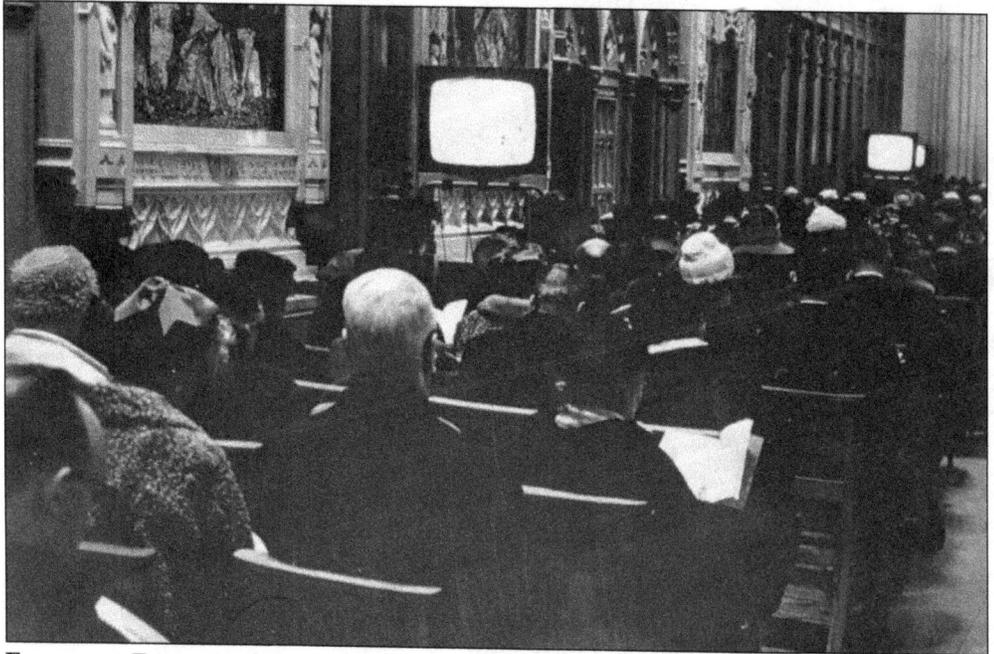

FUTURE OF FAITH. Looking at the 21st century and beyond, the tandem image of television and the celebration of Mass, as seen in this early 1960s view from the Cathedral Basilica of the Sacred Heart, show the expanse of technology and its benefit for religious illumination that has evolved over the past few decades. Further history from illustrative book and beyond awaits the Archdiocese of Newark in the years ahead.

BIBLIOGRAPHY AND ADDITIONAL READING

The individualized list of resources found below were used in conjunction with various editions of the *Catholic Almanac, Catholic Encyclopedia*, statute and minute books of the Archdiocese of Newark, and archdiocesan-produced almanacs and directories to provide helpful context and highlight specific informational notes found within this volume. A number of biographies and other works that focus on aspects of liturgy, education, and administration were likewise utilized. Specific diaries, letters, reports, and other written matter along with photographic resources considered for this work can be found within the Archdiocese of Newark Archives Collection located at Seton Hall University.

Catholic Advocate. December 1951–April 2011.

Catoir, John T. *A Brief History of the Catholic Church in New Jersey*. Clifton, NJ, 1965.

Ciccarino, Christopher. *Seeds of Faith, Branches of Hope: The Archdiocese of Newark, New Jersey*. Strasbourg, France: Éditions du Signe, 2003.

Corrigan, Michael Augustine. Joseph F. Mahoney and Peter J. Wosh, eds. *The Diocesan Journal of Michael Augustine Corrigan, Bishop of Newark, 1872–1880*. Newark and South Orange: New Jersey Historical Society and New Jersey Catholic Historical Commission, 1987.

Curley, Augustine J. *New Jersey Catholicism: An Annotated Bibliography*. South Orange, NJ: New Jersey Catholic Historical Records Commission, 1999.

Flanagan, Bernard A. *Sacred Heart Cathedral: A Chronology of Events Leading to Its Construction and Completion*. Maplewood, NJ, 1987.

Flynn, Joseph M. *The Catholic Church in New Jersey*. Morristown, NJ, 1904.

Hinrichsen, Carl Derivaux. *The History of the Diocese of Newark, 1873–1901*. Thesis (PhD) Catholic University of America, 1962.

Loffedo, Carmine Anthony. *A History of the Roman Catholic School System in the Archdiocese of Newark, New Jersey, 1900–1965*. Thesis (EdD) Rutgers University, 1967.

Mahon, James H. *Styles of Ethnic Catholicism in the Archdiocese of Newark, New Jersey: A History of Conflicts and Control*. Thesis (PhD) School for Social Research, 1995.

The Bishops of Newark, 1853–1978: The First 125 Years of the Archdiocese of Newark as Seen through the Lives and Administrations of the Seven Men Who Have Been Its Leaders. South Orange, NJ: Seton Hall University Press, 1978.

Wister, Robert J. *People of Newark, Celebrating the 150th Anniversary of the Archdiocese of Newark*. South Orange, NJ: Walsh Library Gallery Catalog, 2003.

Wister, Robert J. *Stewards of the Mysteries of God—Immaculate Conception Seminary, 1860–2010*. South Orange: Immaculate Conception Seminary, 2010.

Visit us at
arcadiapublishing.com